The
Little
Swedish
Kitchen

The Little Swedish Kitchen

Over 100 recipes to
celebrate every season

RACHEL KHOO

MICHAEL JOSEPH *an imprint of* PENGUIN BOOKS

Contents

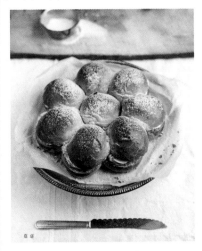

SPRING

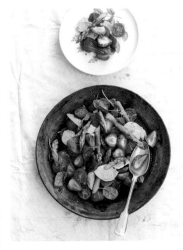

SUMMER

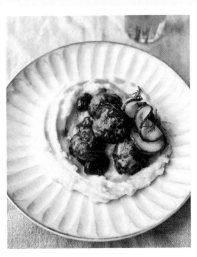

AUTUMN

WINTER

Introduction

Long before I ever had the remotest idea I would end up living in Sweden, Swedish culture made its mark on my life. I grew up watching *Vicky the Viking* and Astrid Lindgren's *Pippi Longstocking* on children's TV; my parents would buy Ikea flat-pack furniture (I have a vintage 1970s Ikea bamboo swivel chair from them); Abba played on our radio, and later Swedish House Mafia, Robyn and Avicii; and Skype – another Swedish export – revolutionized my life, as I spent a lot of my adulthood living far away from friends and family.

And now I find myself in my new little kitchen, in the heart of Stockholm, Sweden's capital. My love affair with Sweden was sparked, quite literally, by love. With Paris, it was love at first bite. But it was when I met my future husband eight years ago that I began to discover what would soon become my new adopted home country. Since then, I have come to know the country and its culture over many coffees and *kanelbullar* (cinnamon buns) – first of all sitting in a *bageri* (bakery) dotted along one of the many cobbled streets of Stockholm, and more lately in my own little Swedish kitchen.

I soon discovered that Sweden has more to offer than flat-pack furniture, the perfect shade of Stockholm White, and *fika* (coffee and cake breaks). The Swedish approach to life is all about finding balance and enjoying just the right amount of all the good things – or, as the Swedes put it, *lagom*.

There's a Swedish saying that there's no such thing as bad weather, just bad clothes. Despite the long, dark winters, Swedes are determined to seize every opportunity to be outside, and even in the middle of winter you'll see kids playing outside in sub-zero temperatures. And that's the secret of Swedish food too. It's food that makes you feel good even when it's dark and gloomy outside. Food that brings a bit of sunshine into your home.

Swedes love to celebrate every season, from dark snowy winters filled with candlelight, *pepparkakor* (gingerbread) and *glögg*, to spring picnics on the archipelago, barbecues at the *sommerstuga* (summer cabin), and *höstmys* (autumn cosiness) with slow-cooked dishes that warm you up from your toes to the tips of your fingers. The weather might be slightly chilly, but you can make the most of the sunshine with a fire, which not only keeps you warm, but also offers the best way to grill some freshly caught perch: the perfect ingredient for a Swedish-style taco. The short but deliciously sweet Swedish summer offers glorious *midsommar* celebrations, and the chance to make the most of the annual glut of lingonberries, blueberries, cloudberries, raspberries and wild strawberries – a delicious base for both savoury and sweet recipes. Finally, the end of summer/beginning of autumn brings crayfish parties, followed by foraging for *karljohansvamp* (Swedish porcini), and hearty game recipes.

One might think that a short growing season would be a disadvantage for most chefs and home cooks. I certainly miss the open fresh-food markets that I was accustomed to in Paris and London. But a resourcefulness and determination to make the most of what's available has become intrinsic to the Swedish approach to cooking. Cooks and chefs around the country have to rely on their cooking experience and imagination to make the most of what the season has to offer. Obviously now it's possible to get more or less anything your heart desires, but this limitation has influenced the history of Swedish food, and can be seen in the wide variety of traditional preserving methods used to this day, such as pickling, smoking and brining.

I will be the first to admit that I'm no expert in Swedish cooking (neither do I think I'm an expert in French cooking – there's just so much still left to learn). However, over the past seven years I have experienced a wide range of Swedish food, from Michelin-starred restaurants to humble home cooking.

Back in the summer of 2012, after my whole life was turned upside down with the success of *The Little Paris Kitchen* (which brought with it an intense whirlwind of interviews and PR opportunities), I decided that I needed to get back in the kitchen. But it was not any old kitchen I decided to get back to. Through a few connections I got in touch with Magnus Nilsson, chef of Fäviken (one of the most renowned restaurants in the world, located in the Swedish wilderness and which many of the high-end diners access by helicopter) to ask whether it would be possible to do an unpaid stage at his restaurant. So that summer I embarked on a culinary expedition. I don't think I've ever been so nervous (not even when doing live TV on the BBC to millions of viewers did I have the same amount of butterflies). I actually felt sick with nerves when I boarded the small plane from Stockholm to Åre. And while sitting at the local train station, after the flight and a train ride, waiting to be picked up for the final car journey (Fäviken is literally in the middle of nowhere!), I pondered why on earth I was putting myself through it. But sometimes I have these crazy whims. I had worked in professional kitchens before, but nothing at this level. This time, the fear of the unknown really scared me.

Despite it only being for two weeks, it was an intense affair. I thought I would end up washing dishes for the majority of the time (which I did do occasionally, as well as scrubbing the loos), but no, I was sent to fish for local brown trout, to pick meadowsweet and to gather twigs, leaves and herbs. There was a disaster: I messed up the reindeer-blood tartlets appetizer – oh, how I wished the earth could have swallowed me up. Pin-drop silence is ten times worse than someone shouting at you. But there were also many highlights, such as observing how beautifully and quietly the different chefs worked together, producing course after course meticulously put together, almost as if they'd been choreographed in a kitchen performance of *Swan Lake*. It all finished with us cooking up 200 moose kebabs at a game fair while listening to one of Sweden's most popular country bands.

Not only was this experience formative for me in terms of discovering what was happening in the Nordic restaurant scene, but it also planted a seed of thought on how to cook creatively with limited produce. It takes some confidence to be able to cook with few ingredients. Swedish cooking tends to use several core key ingredients (more about that in the pantry section on page 13), rather like the major keys on the piano. These keys can be used in numerous different ways to create a harmonious melody; the chords may be familiar, but the melody is different each time. Despite the recent international recognition of Nordic cuisine as championed by its top chefs, *Husmanskost* (literally 'houseman's food', or traditional home-cooked food) is the real basis of Swedish cooking. It is food that originates from the countryside, much like the Italian *cucina povera* (cooking of the poor), and consists of dishes that are simple and cheap to cook.

The majority of my research always begins in the home, and this time I had the perfect opportunity to quiz my new Swedish family and friends about their favourites, their childhood memories, and their well-kept and guarded family recipes. True to the way I've always written recipes, I served up all my experiments to any willing guest. All feedback was accepted: the good, the bad and the ugly. Everyone certainly had a thing or two to say about meatballs (see the recipe on page 178).

If the idea of meatballs does not tickle your tastebuds, fear not, as there are plenty of other recipes in this book to suit all seasons, moods and cravings. In essence, Swedish food is about cooking with a limited range of ingredients, but using those to find a balanced and simple approach to cooking all year around. Despite a lot of these recipes having a 100-year history, this seems like a very modern way to cook.

I did not set out to write a definitive guide to Swedish food (there are far too many books out there that already do that heroically – notably Magnus Nilsson's *Nordic Cookbook*) but to put together recipes that have a personal connection to my life in Sweden. This is my homage to the ebb and flow of the seasons here. They are intense and short-lived (apart from winter), and maybe not always clearly defined as four distinct periods, instead often flitting whimsically between two. It makes it all the more important to seize the moment – or the produce – and really celebrate it.

Most of my previous books have tended to document a certain chapter in my life, and this one is no different. Food and memories are so closely intertwined for me. As I flick through the pages, each recipe conjures up a different memory, particularly the DIY wedding cake (see page 134) and the yellow pea soup (see page 165). If there is one particular texture and flavour combination that encapsulates my favourite Swedish tastes, it would be that of a crunchy crisp *knäckebröd* (see page 28), slathered with thick sour cream, fresh dill and pink pickled onions (see page 286).

I do hope that you find recipes in this book that let you create your own joyful memories, in the same way that they have filled my little Swedish kitchen with so much happiness. *Smaklig måltid!* (Bon Appetit!)

Rachel

Swedish pantry

Sweden has a long history of preserving ingredients, thanks to the short growing season and the necessity of having to make whatever you harvested in the summer last for the rest of the year. Pickling, smoking, brining, salting, drying ... all of these play a big part in Swedish cooking.

Although preserving food like this is less vital today, given the use of freezers and a large proportion of fresh foods being imported to the country, you'll still find a wide variety of preserved foods in Swedish fridges and cupboards. Those key ingredients and flavours form the base notes of many of my recipes. Like a catchy chord in an Abba record, they just keep popping up. Below is what you'll find in my Swedish pantry.

Good places to shop in the UK for Swedish ingredients are Ikea, ocado.com and scandi-kitchen.co.uk, which stock a vast range of Swedish staples.

Flour

If you ever mention that a Swede *'inte har rent mjöl i påsen'* (literally 'doesn't have any clean flour in the bag'), it means you think they're up to something suspicious. I have never encountered such a wide range of flours as I have in Sweden – even when I lived in France, with its rich history of baking. At my local supermarket I find not only regular white flour (strong or plain), but also hardier flours like rye, barley and spelt, which I've completely fallen in love with (as you can see in many of my bread and cake recipes). There's also a new wave of 'healthier' flours like lentil, bean and coconut. It's not a surprise, considering the long history of home baking Sweden has. As the country is so big, with such a small population for its size, for the most part households had to be self-sufficient when it came to making bread.

Knäckebröd

A stack of these crisp flatbreads (see recipe on page 28) is a must in any Swedish household. Like the French and their devotion to a basket of baguette, the Swedes serve *knäckebröd* with soft butter at every meal.

Frozen berries

Most supermarkets in Sweden will have a freezer chest just for frozen fruit that you can scoop out like a pick-and-mix and pay for by weight. I always have a bag or two of different berries for pies, jams, sauces and most importantly *rårörda lingon* (sweetened lingonberries), which get served with almost everything.

Pickles

Ättika, a white spirit vinegar that is particularly strong (its acidity level is between 12 and 24 per cent, whereas a cider vinegar is usually around 6 per cent), is the vinegar most commonly used in Sweden for preserving (though not for salad dressings). It's also great for cleaning kitchens, bathrooms and windows, although it leaves a rather strong smell.

Pickled onions

I can't get enough of the iconic pink pickled onions (see page 286) — they have to be my favourite Swedish condiment. The bright pink rings wake up your tastebuds and add a zing to your dish like a fresh squeeze of lemon. I put them on almost everything. However, you can perhaps have too much of a good thing, as the Swedish saying *'atg lägga lök på laxen'* – 'to put onion on the salmon', meaning 'to spoil something' – demonstrates.

Pickled cucumbers

These sweet, sour, pickled-but-still-crunchy sliced cucumbers (see page 288) are most often found on a Swedish breakfast table, as a garnish to meatballs or as part of a late-night sandwich snack.

Kalles Kaviar

You'll either love or hate this salty fish roe paste. I belong to the group of people who can't stand the stuff, but if you're a Swede then you can't forgo breakfast with a soft-boiled egg and Kalles Kaviar-topped *knäckebröd*. If you fancy making my version of it, the recipe is on page 214.

Spices

Cardamom (pods, seeds and ground), black and white pepper, allspice and cinnamon (both usually ground) are classic spices that pop up in Swedish cooking more than the adverts on your free Spotify account.

Swedish anchovies

These say anchovies on the packaging, but they are actually sprats which have been brined in a salty vinegary solution with a blend of spices (the exact spices are a secret, but I'm guessing they include allspice). An absolute must for a Jansson's temptation potato bake (see page 252).

Mustard

If you ever have a snoop around a Swedish fridge, you'll probably encounter Johnny's mustard in a yellow squeezy bottle. It's the Swedish version of Coleman's, although without the eye-watering mustard sting and a lot sweeter. It's the perfect base for the gravlax dressing on page 92; however, if you can't get hold of a sweet mustard like this, you can make your own using a ratio of 1 teaspoon of runny honey to 1 teaspoon of Dijon mustard.

Eldercapers

These handy little spicy pickled berries (see page 287) make a great alternative to capers. Throw a handful into a salad or sprinkle into a white sauce destined to smother a cod fillet.

Horseradish

I love spicy food, and fresh horseradish can liven up the dullest of dishes. A few slivers of freshly grated horseradish over stew will give it the kind of kick you sometimes need on a dark gloomy day.

Apple chutney

Not a typical Swedish tradition, but with the abundance of apples in my garden I've made it one of my own (see the recipe on page 286). This goes really well with a chunk of Västerbotten cheese.

Fried onions

Fried onions are the crispy and very moreish cousins of the pink pickled onions. They are most commonly sprinkled liberally on to hotdogs (see page 115) but I find myself sprinkling them on dumplings (see page 37) and even salads.

SPRING

vår

I never used to look forward to spring quite as much as I do since I moved to Sweden. The winter days do drag, particularly after the plug has been pulled on the Christmas celebrations, and seem to stay around longer than the aftertaste of too much garlic in a pasta sauce. There are only so many candlelit lunches I can handle, however cosy they might be. Spring arrives later here than in the rest of Europe, making an excursion to London in March feel like a holiday to hotter climes, with spring well and truly sprung, while in Sweden it's still in hiding. But when spring finally arrives it brings celebrations in the form of blossoms bursting from trees, bright Swedish-flag-blue skies and sunshine that lasts into the early evening (rather than early afternoon, as in the winter). If you're ever in Stockholm when the cherry trees are in bloom around the end of April, head to Kungsträdgården ('the King's garden'), where you'll see locals and tourists all soaking up the glorious pink fluffy blossoms.

There is a new energy in the air with the longer days and the mercury rising. Occasionally there are some rather hot outbursts and everyone briefly sheds their layers for more summery attire before hastily throwing clothes back on when the weather remembers that it's actually spring. Nothing describes April weather better than the Swedish saying, *'Barnrumpan och aprilvädret är inte att lita på'*, which translates as 'A child's bum and April weather shouldn't be trusted.'

By late spring, new Swedish produce is popping up on the food scene. The first potatoes from the southern part of Sweden, Skåne, can fetch a few bob or two, but they are delicious and Swedes usually serve them simply boiled and tossed in butter and salt. It's '*hej då*' ('goodbye') to the large, bowling-ball-sized cabbages of the winter and '*tjena*' ('hello') to the smaller, crisper, sweet-tasting cabbages (you'll find plenty of cabbage inspiration on pages 22, 30 and 50, with recipes that don't involve any over-boiled soggy stuff) and stick-thin leeks (use them for burnt leek whipped butter – see page 24). Nettles start popping up in the garden (announcing that a whole bunch of other weeds will be arriving before long, too), so on go the washing-up gloves to gather a heap for a nettle and chicken pie (see page 42).

Just before you get your body ready for peeling off those winter layers, there's one more temptation – in the form of a bun (of course!) – which might persuade you to keep them on for a bit longer. *Semla* has to be one of my favourite Swedish buns. Walking past the *bageri* with a window full of these puffy, pillow-like buns filled with a tower of whipped cream, it's nearly impossible not to pop in and buy one. (See my recipe for the mighty *Semlortårta* on page 57.)

Spring is all about '*ge tillbaka för gammal ost*' (literally 'giving back the old cheese'), that is, taking revenge on winter for keeping us stuck indoors, by getting outside whenever you can and cooking simple dishes that celebrate seasonal produce.

Lemony caraway cabbage salad with grilled prawns

Grillade räkor med kålsallad, citron och kummin

Cabbage salads are a quintessential part of Swedish culture. In many restaurants they are considered as important as a basket of crisp *knäckebröd* and slices of rye bread, served to kick-start the appetite before the meal arrives. Even takeaway pizza places will send off cabbage salads – known as 'pizza salads' – in plastic containers as a side. The cabbage salad below is a great way to begin a meal, this time doused in a citrusy vinegar dressing and paired with grilled prawns in their shells, keeping all those lovely juices locked in.

1 head of pointed or hispi cabbage or
 1 small head of white cabbage (about 450g)

sea salt and black pepper

3 tbsp white wine vinegar

1 tsp sugar

3 tbsp olive oil

1 unwaxed lemon

1 tbsp caraway seeds

300g king prawns, in their shells

4 tbsp salmon roe

Serves 4 as a starter, 2 as a light lunch /
Dairy free / Gluten free /
Preparation time: 10 minutes / Salting time:
1 hour / Cooking time: 4–6 minutes

Slice the cabbage in half lengthways, then slice finely into thin ribbons, discarding the tough inner core. Place the ribbons in a large bowl or container, season with a generous pinch of sea salt and give them a good toss. Set aside for around 1 hour, then mix the vinegar with the sugar and 1 tablespoon of olive oil. Add the zest from the lemon to the dressing, then pour over the cabbage and toss well. Toast the caraway seeds for 1 minute in a dry pan over a high heat and add to the cabbage. Use a knife to slice away the pith from your zested lemon, then dice the lemon flesh, add it to the cabbage and toss once more. Set aside.

Preheat the grill to high. Scatter the prawns on a baking tray, toss in the remaining oil and season with salt and pepper. Place under the hot grill, turning after 2 to 3 minutes (depending on the size of your prawns).

Serve the cabbage alongside the prawns and dollops of the salmon roe.

Top tip / I like to salt the cabbage for an hour or so before dressing it to break down the toughness while keeping a good crunch, but you can skip this step if you are in a rush.

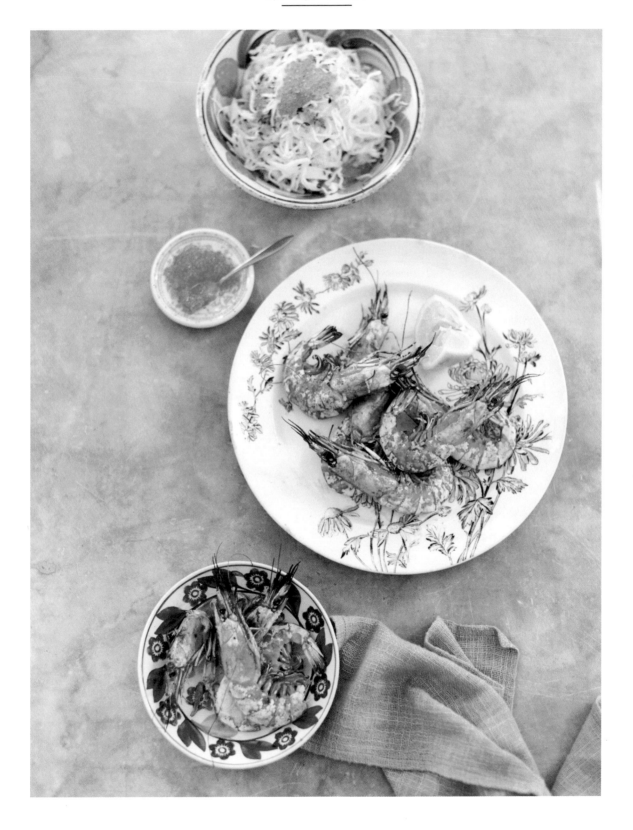

Burnt leek
whipped butter

Sotad purjolök med vispat smör

Long before fancy London restaurants were whipping their butters and smearing them on stones, tiles, you name it . . . the Swedes were at it. A little dish of whipped butter would always appear in a basket along with a selection of crispbreads. The butter was whipped partly because it made it so much easier to spread, but also because it made the butter go that bit further. Adding some charred leeks gives a slightly sweet and bitter note. The best way to eat this is to spread a thick enough layer on your bread that you'll see your teeth marks – that's if you dare!

Makes 250g / Vegetarian /
Gluten free without crispbreads /
Preparation time: 10 minutes /
Cooking time: 10 minutes

2 medium leeks, trimmed and
 washed (about 250g)

200g soft butter

a pinch of sea salt

crispbreads or radishes, to serve

Preheat the grill to high.

Halve the leeks and pull the leaves apart to separate them. Place on a baking tray lined with foil, spread well apart to make sure the leaves are not on top of each other (otherwise they will steam rather than grill). Place under the hot grill, with the fan setting on if possible. Turn the leeks over when they have gone a dark brown (but not black) on one side. You might have to remove some that have darkened quicker than others. Once browned and crisp, leave to cool slightly before chopping finely.

Using an electric or freestanding mixer, whisk the butter with the salt for 3 to 4 minutes until very soft and fluffy. Scrape down the sides of the bowl as you go.

Mix the chopped leeks into the soft fluffy butter, then serve with some crispbreads or radishes.

Top tip / The leeks can go from light brown to black in a matter of seconds, so don't leave them unattended.

Get ahead / The butter will keep in the fridge well wrapped for several days. However, you will need to let it soften to room temperature and then whip it up again.

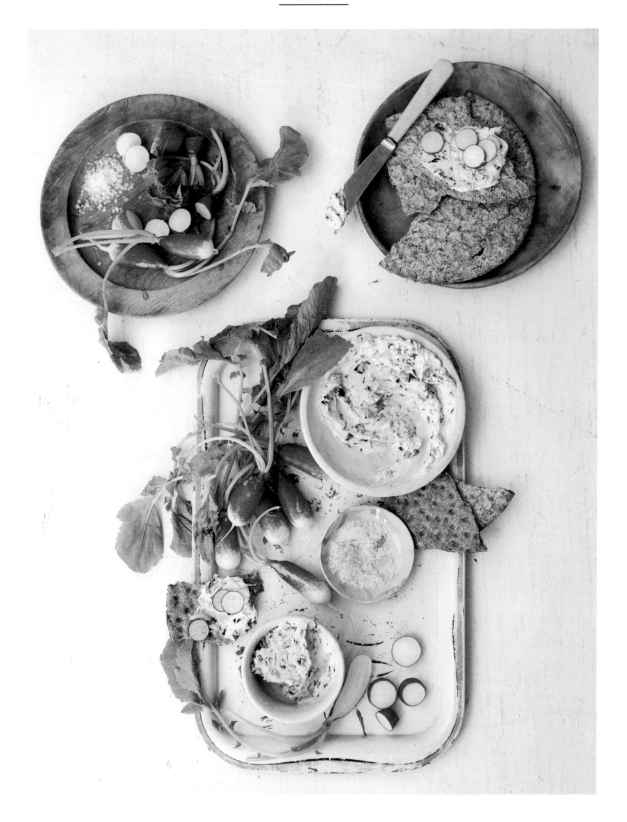

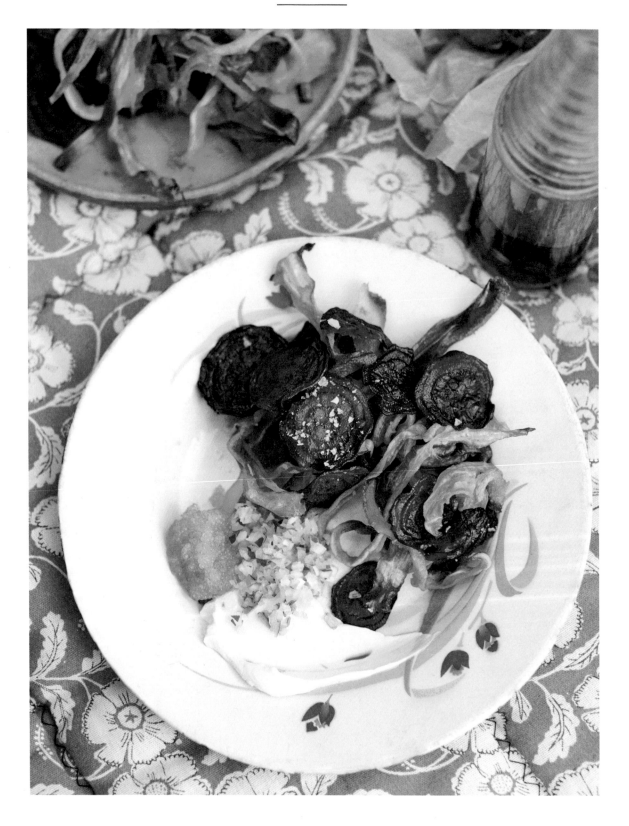

Root vegetable crisps with caviar and red onion

Chips på rotfrukter med löjrom och rödlök

Given all the root vegetables the Swedes consume, there's never a shortage of peelings in the kitchen, so it's always handy when you find a delicious use for them. While I have used whole vegetables for this recipe, you can just as easily substitute the equivalent quantity of vegetable peelings that you have hanging around. Accessorizing these with a dollop of caviar, creamy crème fraîche and some crunchy red onion transforms leftovers into a fancy snack or canapé.

Serves 4 / Gluten free /
Preparation time: 5–10 minutes /
Cooking time: 25–30 minutes /

1 medium beetroot

1½ tbsp olive oil

sea salt

1 large carrot

1 large parsnip

3–4 tbsp crème fraîche

1–2 tbsp Kalix or other caviar

½ a red onion, peeled and diced into small cubes

Preheat the oven to 160°C/fan 140°C/gas 3. Line two large baking trays with baking paper.

Using a mandoline, slice the beetroot into 2mm-thick rounds. Place in a bowl and toss with a drizzle of the olive oil. Spread the slices out evenly on the trays, trying not to overlap them. Scatter with salt and slide the trays into the oven. Bake for 15 to 20 minutes, then turn the slices over and bake for a further 10 minutes, or until crisp but not too coloured. Leave on a wire rack to cool.

Use a vegetable peeler to peel the whole carrot and parsnip into thin ribbons. Toss them in the remaining oil in the bowl (they just need a light coating), then place them on the baking trays, making sure they are well spread out. Bake for 15–20 minutes, then turn the ribbons over and bake for a further 10 minutes, or until crisp but not too coloured.

Serve the crisps with a few dollops of crème fraîche, the caviar and the finely chopped red onion.

Top tip / Be sure to give your vegetables a good scrub before you use them, then you can use all the peelings to make these crisps too.

Swedish crispbreads

Knäckebröd

I have to admit I wasn't always fond of the quintessential Swedish crispbreads. I had memories of rectangular cardboard crackers, but I soon discovered the wide variety of them that even a small supermarket stocks in Sweden. Seeds, spices, different flours, rounds, triangles . . . they come in all forms, flavours and sizes.

My favourite has to be the more rustic type, made from rye flour and sourdough. The sourdough adds a nice tang. No need for days of growing your own sourdough starter though: I simply use dried sourdough flakes, which you can buy online (in Sweden they sell sourdough yeast in the supermarket).

Makes 6 rounds /
Vegetarian /
Preparation time: 30 minutes /
Resting time: 1 hour 30 minutes /
Baking time: 10–15 minutes /

200g rye flour

50g stoneground white flour (or pizza flour), plus extra for dusting

1 tsp fine sea salt

1 tbsp caster sugar

4g (1 heaped tsp) instant dry yeast

20g dried sourdough starter

50g butter, slightly softened

145ml buttermilk

olive oil, for greasing the bowl

Combine the flours, salt, sugar, yeast and dried sourdough starter. Mix the softened butter into the dry ingredients, then add the buttermilk. Mix to a soft dough. Turn the dough on to a lightly floured surface and knead for 5 minutes, or until smooth – it does not require long kneading as you don't need to develop the gluten. Place the dough in a lightly greased bowl, cover with cling film and set aside in a warm, draught-free place for 1½ hours.

Turn the dough on to a lightly floured surface and knead to a smooth ball for a few minutes. Wipe your work surface down, then place a piece of baking paper big enough to fit the baking tray on top (the slightly damp work surface helps to secure it while rolling out the dough).

Preheat the oven to 220°C/fan 200°C/gas 7.

Form the dough into an even sausage and divide into 6 equal parts. Roll one part into a ball. Place the ball in the middle of the baking paper, dust your rolling pin with flour and roll the dough into a 2mm-thick round.

Slide the baking paper on to a baking tray and cover with a damp tea towel while repeating with the other balls of dough. You will probably need two baking trays for this. Use a fork to prick the crackers all over.

Place the baking tray in the middle of the oven and turn the temperature down immediately to 200°C/fan 180°C/gas 6.

Check the bread after 10 minutes – if your oven bakes unevenly and the edges are starting to brown too quickly, you can turn the pieces over (by now they should be hard enough to move without breaking up). Bake for another 5 minutes until evenly browned. Place on a wire rack to cool.

Get ahead / The crispbreads keep very well in an airtight container for 1–2 weeks.

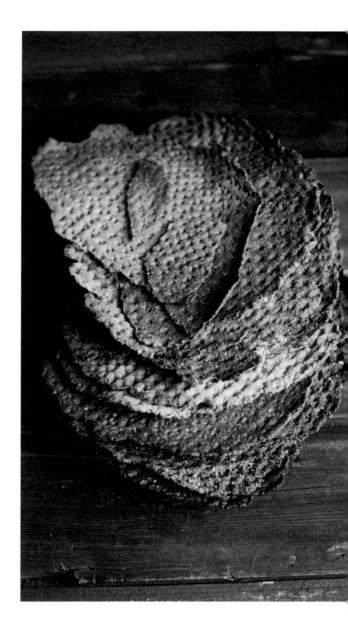

Spring cabbage vinaigrette

Vårens kål med vinaigrette

Traditionally, cabbage isn't considered the most glamorous of vegetables. For many of us, it is associated with the kind of pungent, unappetizing waft that used to come from the soggy, overcooked variety in bad school dinners. The key thing with cabbage is not to be too heavy-handed. It's often better when left uncooked, and even if you do cook it, you should have a gentle approach. Take a leaf out (like what I've done there?) of the Italians' book and approach your cabbage as they do their pasta, cooking it only to al dente. Or char its edges and dress with a tongue-tingling vinaigrette. There are cabbages aplenty in Sweden in all shapes and sizes, but my favourite is the pointy spring cabbage, often known as sweetheart or hispi, which, with its arrival, promises brighter and warmer days ahead.

Serves 8 /
Vegetarian / Gluten free /
Preparation time: 10 minutes /
Cooking time: 15 minutes /

1 spring cabbage, outer leaves removed (about 1kg)

4 knobs of soft butter

4 tbsp rapeseed or olive oil

6 tbsp cider vinegar

4 tbsp sweet mustard (see page 15)

a pinch of salt

3 medium hard-boiled eggs, peeled and grated

a small handful of fresh chives, roughly chopped

Preheat the grill to high.

Cut the cabbage lengthways into 8 pieces – try to cut it so that the core holds the leaves together. Smear liberally with butter on both sides, then place on a baking tray lined with foil and put under the hot grill. Once the cabbage starts to brown and blacken, turn over and continue to cook until all the edges are nicely charred. This should take about 15 minutes in all, depending on your grill. Keep an eye on it, as the cabbage can turn quickly.

Put the oil, vinegar, mustard and salt into a jar, pop the lid on and shake really well. Check the seasoning and adjust to your liking.

To assemble, spoon some of the vinaigrette on to the base of each plate. Place a wedge of cabbage on top, then sprinkle with the roughly grated eggs and the chives.

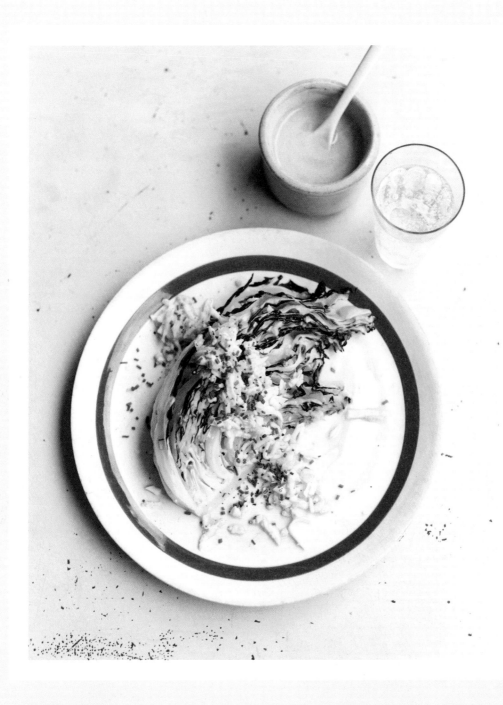

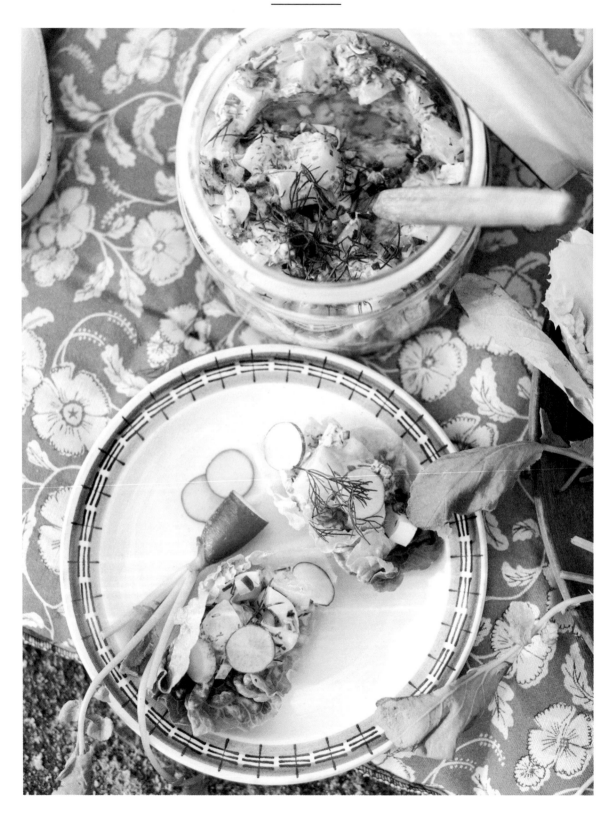

Old man's salad

Gubbröra

Gubbröra literally translates as 'old man mix', and I can just imagine a little old man rummaging around his cupboard and fridge to pull this dish together. There are many different versions of this, but the essential components are eggs, anchovies, potatoes and a creamy sauce. Everything else is just a bonus, so feel free to raid your fridge and cupboard and throw in a few other ingredients to your liking.

2 medium eggs

2 tbsp finely chopped fresh chives,
 plus 1 tsp to garnish

2 tbsp finely chopped fresh dill,
 plus 1 tsp to garnish

2 tbsp finely chopped capers

2 tbsp finely chopped red onion

100g crème fraîche

2 tbsp good-quality mayonnaise

zest of 1 lemon

100g anchovy fillets (see page 15)

4 medium boiled potatoes

sea salt and black pepper

2 little gem lettuces, washed and
 leaves separated

4 radishes, thinly sliced

Serves 4 /
Gluten free without toast /
Preparation time: 15 minutes /
Cooking time: 5 minutes /

Place the eggs in a small saucepan of cold water and bring to the boil, then set a timer for 5 minutes. When the time is up, remove the eggs and run under cold water before peeling.

Cut the eggs in half and scoop out the egg yolk. In a bowl, mash the yolk with a fork and mix together with the chives, dill, capers, red onion, crème fraîche, mayonnaise and lemon zest. Chop the remaining egg white, anchovies and potatoes into 2cm chunks. Mix together with everything else and season well with salt and pepper.

Divide the mixture between the little gem leaves, spooning it on to each one in a small pile. Add the radishes and finish with the remaining herbs.

Top tip / Try this without the salad leaves, heaped on to a piece of toast as a snack.

Smoked sausage potato cakes with prawn salad

Rökta potatiskakor med räksallad

Order an open-faced prawn sandwich in Sweden and you're most likely to be given a mini mountain of prawns: their helpings are certainly generous. Prawns don't just top breads and salads, though. If you ever walk past one of the many hotdog stands, you might spot someone tucking into a wrap filled with a sausage, mashed potato and what looks like prawn salad. For any foreigner it may seem like a bizarre combination, but in fact it's not far off the classic surf 'n' turf combo (seafood, meat and usually chips). In this recipe I've taken these flavours and turned them into deliciously smoky potato cakes.

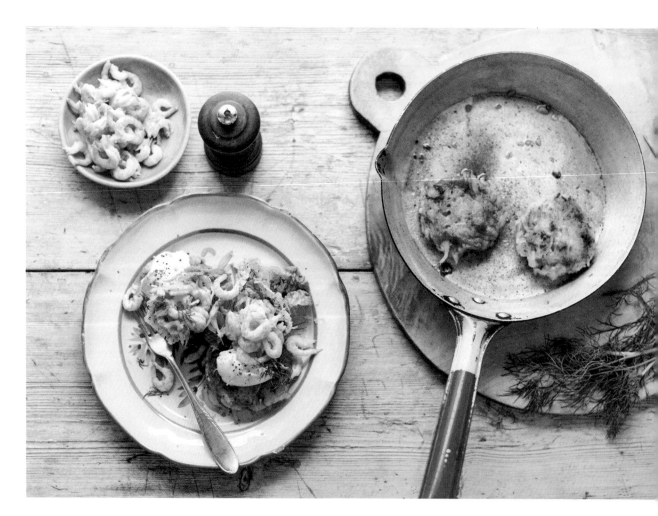

Serves 4 as a main, 8 as a starter /
Preparation time: 30 minutes /
Cooling time: 15 minutes /
Cooking time: 30 minutes /

2–3 large potatoes (350g)

1 smoked sausage (100g)

1 medium egg

1 tsp white pepper

a handful of fresh chives, finely chopped

1 tbsp butter

1 tbsp rapeseed oil

12–16 baby gem leaves

400g cooked shelled prawns

1 lemon

sea salt and black pepper

a handful of fresh dill, roughly torn

6 tbsp crème fraîche

Peel the potatoes and fill a large saucepan with cold salted water. Add the potatoes to the pan and bring to the boil, then cook until tender. Strain through a colander and leave to cool.

Meanwhile, grate the smoked sausage. Beat the egg with the white pepper and chives, and stir through the sausage.

Once the potatoes are cool enough to handle, grate and combine with the sausage mixture. Form into 4 large patties, 1.5cm thick (or 8 small patties if you're making them for a starter).

Put a large frying pan over a medium heat and add the butter and oil. Once the butter starts to sizzle and the oil is hot, add the potato cakes. You may need to cook them in batches, so as not to overcrowd the pan. Fry on one side for several minutes until golden, then turn over and repeat.

Wash and dry the baby gem leaves. Put the prawns into a bowl, add the zest and juice of the lemon and mix well. Taste for seasoning and add salt and pepper if necessary.

To serve, add a dollop of crème fraîche to the potato cake, followed by some baby gem leaves, the dill and a heap of prawns.

Get ahead / The potato cakes can be made a couple of days in advance and kept in an airtight container in the fridge.

Top tip / Isterband is a popular lightly smoked Swedish sausage made of pork, barley, groats and potato. I've used French Montbeliard sausages as well as smoked chorizo. The flavours are slightly different but just as tasty.

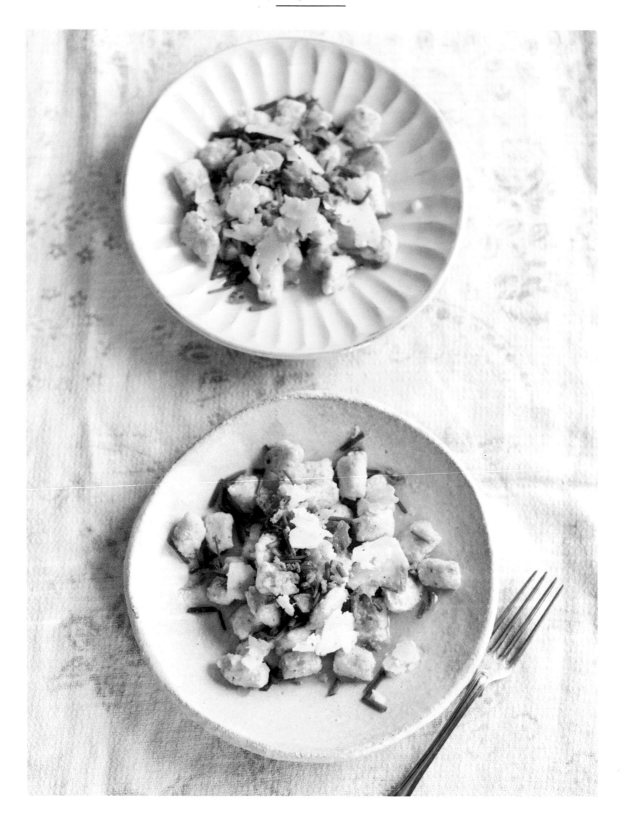

Horseradish and cheese dumplings

'Klimp' gjorda på pepparrot och västerbottenost

Normally these dumplings, called *klimp*, are made from a basic batter of flour, eggs and milk, and dropped into a bubbling meat soup (called *köttsoppa*) to cook. As the batter soaks up the lovely meat stock, the soup is given a bit of body while flavouring the dumplings. My version swaps the flour for wholesome oats and is given a kick from the horseradish, which means these tasty, cheesy dumplings sit quite happily on the plate on their own.

40g butter

1 egg

170ml buttermilk

100g buckwheat or fine porridge oats

100g Västerbotten or mature Cheddar cheese, finely grated, plus a handful to garnish

30g freshly grated horseradish

sea salt

a small bunch of fresh chives, chopped

8 tbsp fried onions (see page 15)

Serves 4 /

Vegetarian /

Preparation time: 15 minutes /

Resting time: 1 hour /

Cooking time: 10 minutes /

Wrap the butter in greaseproof paper and place in the freezer.

Mix together the egg, buttermilk, oats, cheese, horseradish and ½ a teaspoon of salt, then leave to sit for 1 hour while the oats absorb the flavours and their texture is broken down.

Put some water and salt into a large deep frying pan and bring to a simmer. Line a baking tray with a J-cloth.

Place the oat mixture into a piping bag or heavy-duty food bag. Once the water is simmering, snip off the corner of the bag, leaving a hole of 1.5cm. Use scissors to cut off 1cm-long dumplings while piping. Drop them directly into the water, and simmer until the dumplings rise to the top. Remove the dumplings with a slotted spoon and place on your lined tray to remove some of the excess water, then divide among four dishes or plates.

Grate some of the butter over each portion and top with the chives, remaining cheese and fried onions. Eat while the dumplings are piping hot.

Top tip / Don't over-boil your dumplings, as they will quickly disintegrate and you'll end up with oat soup.

Bavette with rye croutons and pickled mustard seeds

Bavette och rågkrutonger med picklade senapsfrön

Bavette is one of my favourite affordable cuts of beef. While it has a reputation for being somewhat chewier than a lean fillet, it is delicious when given a quick sear on the outside and kept rare inside. I use rye crumbs to soak up those juices and some pickled mustard seeds for a little acidity and pop.

350g bavette steak

sea salt

100ml apple cider vinegar

200ml water

2 tbsp caster sugar

30g yellow mustard seeds

4 tbsp rapeseed or olive oil

120g rye bread (about 4 thin slices), torn into small pieces

a 2cm piece of fresh horseradish

50g Västerbotten or other hard cheese such as Parmesan

10g fresh herbs (flat-leaf parsley or basil work well), leaves picked

Serves 2 as a main, 4 as a starter /
Preparation time: 15 minutes /
Cooking time: 55 minutes /

Remove the bavette from the fridge, place on a plate, pat dry and season generously with salt. Set aside while you make the pickled mustard seeds.

Measure out the vinegar and water into a small pan, add the sugar and a pinch of salt, and bring to just under the boil. Simmer for 5 minutes over a low heat, then add the mustard seeds. Simmer for a further 40 minutes to plump up the seeds, adding a little extra water if it dries out. Decant into a jar and set aside to cool while you cook the steak.

Heat a large, heavy-based frying pan over a medium heat, add 1½ tablespoons of the oil and, once hot, add the rye pieces. Fry until crispy and golden, tossing every so often. Set aside. Pat the bavette dry again, rub with 1 tablespoon of the oil and season generously with salt. Add the remaining 1½ tablespoons of oil to the pan and, once it's smoking hot, add the bavette and cook on each side for about 2 minutes. You want it really rare on the inside and with a dark crust on the outside. Transfer to a plate to rest while you assemble the dish.

Scatter the rye pieces on the base of each plate (they will soak up the juices from the steak). Slice the bavette thinly against the grain into bite-sized slices and distribute over the top of the rye pieces. Add the juices from the plate. Dollop some of the mustard seeds over the top, finely grate over the horseradish, then add a few slices of the cheese and sprinkle with the fresh herbs.

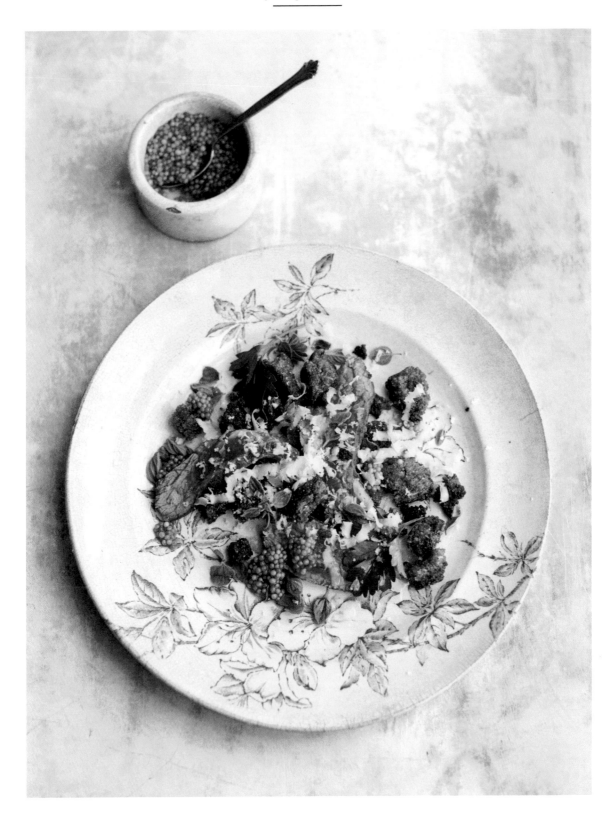

Beet à la Lindström

Rötbeta à la Lindström

I love a play on words, and this Swedish classic was simply asking for one. *Biff à la Lindström* ('beef by Lindström') is a mainstay on Swedish lunch menus. The story goes that the dish was named after Henrik Lindström (1831–1910), who was born and raised in St Petersburg, Russia. He often visited a hotel in the south-east of Sweden, where he instructed the chef to make a dish he used to eat at home: a beef mince patty stuffed with beetroot, onions and capers. It quickly became a popular dish on the hotel menu and beyond. I like to serve this vegetarian version with salad leaves, or some sliced avocado, cress and crumbled feta.

Makes 4 large patties for a main,
8 small patties for a starter /
Vegetarian / Gluten free /
Preparation time: 15 minutes /
Cooking time: 10 minutes /

3–4 tbsp rapeseed oil
4 eggs (if serving as a main)
4 heaped tbsp sour cream

For the patties:
100g cooked beetroot, roughly grated
150g cooked potatoes, finely grated
100g portobello mushrooms, roughly grated
50g onion, finely chopped
50g toasted hazelnuts, finely chopped
80g capers, roughly chopped
2 tsp cornflour
1 tsp sea salt
1 tsp white pepper

Put all the ingredients for the patties into a bowl and mix together thoroughly. Divide the mixture into 4 (or 8 if you're making this for a starter), then press firmly together into patties. Put the oil into a large frying pan and heat until medium-hot. Add the patties (do this in batches if you don't have a large enough pan), and fry for 3–4 minutes on each side, until golden brown.

Meanwhile, fry the eggs (if using) in another large frying pan.

Put a tablespoon of sour cream on each plate. Place a patty on top, cover with a fried egg and serve with a salad on the side.

Top tip / These patties make excellent vegan burgers. Serve in a vegan bun with the carrot ketchup on page 293 and some crispy cos.

Get ahead / The patties can be frozen. Place sheets of baking paper between the patties, then freeze in a container. Defrost fully before frying as above.

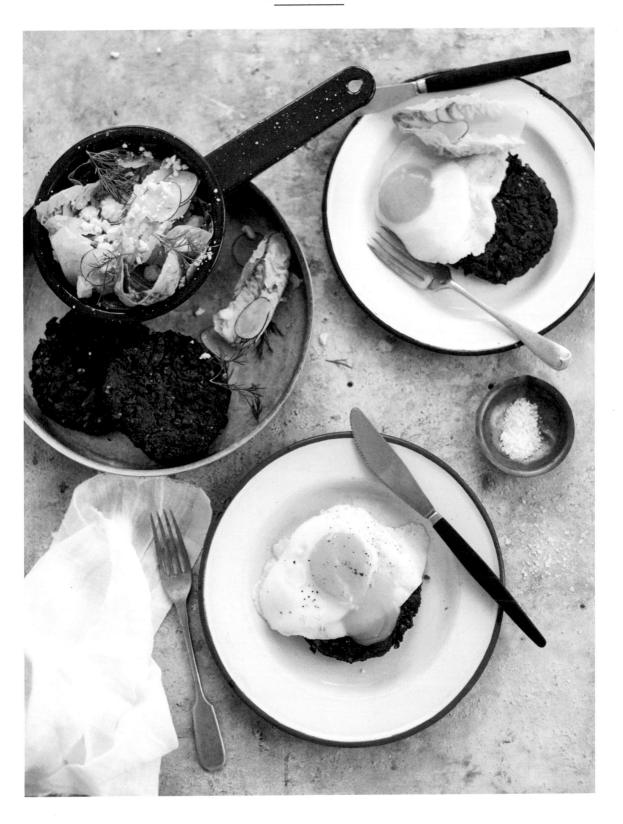

Spring nettle and chicken pie

Kycklingpaj med vårnässlor

As much as we await spring with eager anticipation, it also heralds the less-than-fun activities of spring cleaning and weeding. However, there are some bonuses to weeding – if you can eat the weeds. The French love *pissenlit* (dandelions, literally translated as 'pee on the bed'), and you'll find luscious piles of these vibrant green leaves at the market. In Sweden it's the *nässlor* (nettles) that mean spring is well and truly on its way. Pick the young leaves and you're in for an iron-packed treat (nettles contain more iron than your average Popeye-friendly spinach). Nettle soups crop up on menus regularly here (quite literally like weeds), with each restaurant competing to make a better one.

There's a good reason why nettles usually end up as a soup. Picking the young leaves from the stalks can be quite a pain; cooking and then blending them whole with cream is a lot simpler. Using the same technique creates a delicious gravy for my chicken pie. Despite adopting Sweden as my new home country, I still like to cook a roast at the weekend, so there'll usually be leftover roast chicken on the Monday, which makes it the perfect day for a pie.

Serves 4 / Preparation time: 1 hour / Cooling time: 30 minutes / Cooking time: 45–60 minutes / Equipment: 21cm pie dish /

2 knobs of butter

200g young nettles or baby spinach, washed

a generous pinch of sea salt and white pepper

a few gratings of nutmeg

375g good-quality puff pastry

1 egg, beaten

200g full-fat cream cheese

1 heaped tbsp cornflour

500ml good-quality chicken stock

200g leftover roast chicken, shredded

200g cauliflower (about ½ a head), broken into large florets, blanched

4 x 6-minute boiled eggs, peeled

Put a knob of butter into a large frying pan over a medium heat. Add the nettles to the pan and cover to let the nettles wilt, stirring occasionally. When the nettles have wilted, cook uncovered for 30 minutes until as much liquid as possible has evaporated. If using spinach, simply wilt in the same way but for 1 to 2 minutes. Season with the salt, white pepper and nutmeg before blending to a smooth paste. Set aside.

Roll the puff pastry into a large rectangle about 0.5cm thick. Brush the edges of the pastry with some of the beaten egg. Take 2 heaped tablespoons of the nettle purée and beat with the cream cheese. Spread the nettle cream cheese on the pastry (you may not need all of it), leaving a 0.5cm border along the top and bottom. Roll up tightly so you have a long sausage. Wrap in cling film and place in the freezer while you prepare the gravy.

Melt a knob of butter in a medium-sized pan over a high heat, then add the cornflour and beat quickly. Gradually whisk in the stock and continue to whisk until the stock begins to bubble. Boil for 5 minutes, then remove from the heat and add the rest of the nettle puree and any of the nettle cream cheese filling you might have left.

Preheat the oven to 220°C/fan 200°C/gas 7. Mix the chicken and the cauliflower with the nettle sauce in a bowl. Pour into your 21cm pie dish and add the eggs, then leave to cool for 30 minutes before putting the pastry on top.

Take the pastry out of the freezer and cut into 3mm-thick slices. Layer it on to your pie and brush with the rest of the beaten egg. Bake for 40–60 minutes, until the pastry is golden and puffy.

Top tips / Make sure you season your sauce heavily, as the filling ingredients will absorb the flavour.

You can use the pinwheel pastry top to make tasty aperitif snacks too. Simply bake on a tray lined with baking paper at 200°C/fan 180°C/gas 6 for 15–20 minutes, or until golden and puffy.

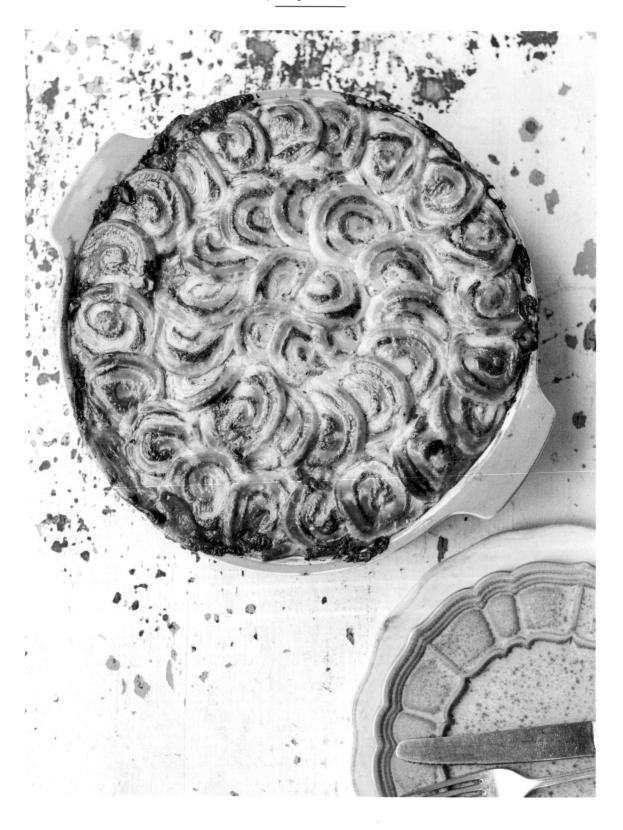

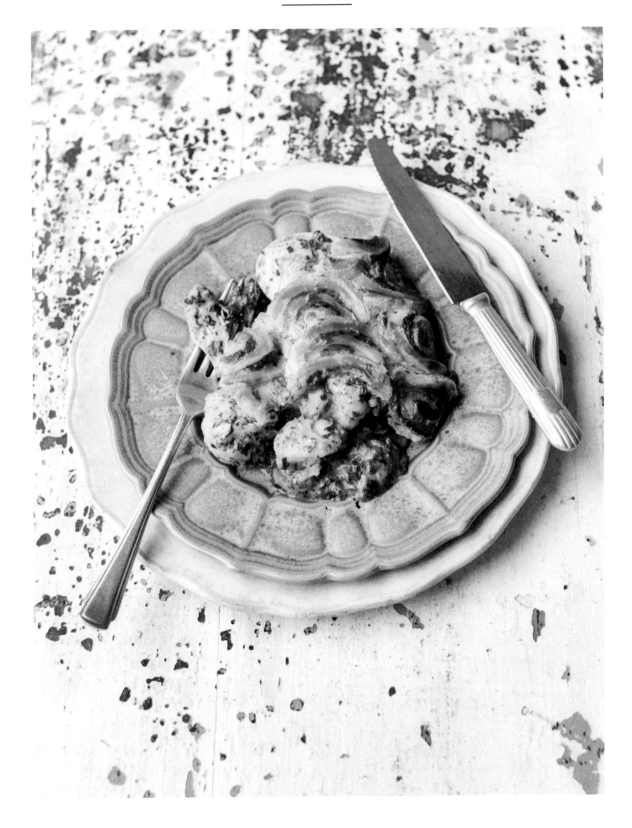

Cod with asparagus and smashed egg

Torsk med äggsås, sparris och persilja

Swedish dishes often mix flavours and textures that quite simply translate into the ultimate plate of comfort food, and this creamy egg sauce with a perfectly cooked piece of cod happens to be one of them. The sauce is reminiscent of something you might have on a cold day, but combine it with white asparagus (which is one of the vegetables that crop up towards the end of spring) and it signals the promise of warmer weather. I like adding a touch of horseradish for some heat, but feel free to leave it out if you prefer.

Serves 4 / Preparation time: 30 minutes / Cooking time: 15 minutes /

25g sea salt, plus extra for seasoning
500ml water
600g skinless cod fillet, cut into 4 pieces
2 heaped tbsp butter, plus extra for the vegetables
8 white asparagus
8 bulbous spring onions
white pepper
zest and juice of ½ a lemon

1 heaped tbsp plain flour
375ml whole milk
125ml single cream
a handful of curly parsley leaves
2 tbsp finely grated fresh horseradish, plus a little extra to garnish
4 medium hard-boiled eggs, peeled and roughly mashed with a fork

Preheat the oven to 220°C/fan 200°C/gas 7. In a large glass or ceramic bowl, whisk together the 25g of salt and the water until the salt has dissolved. Place the cod in the bowl, making sure it's submerged, and leave for 10 minutes. Remove the cod from the water and dab off any excess moisture with a clean tea towel. Put the cod into a baking dish and dot with half the butter. Cover with aluminium foil and bake for 10–15 minutes, or until the cod is cooked through and flakes slightly.

While the cod is cooking, trim and peel the asparagus. Trim the spring onions, and discard the green tops. Bring a large pan of salted water to the boil, and add the asparagus and spring onions. Cook over a medium heat for 5 minutes, or until the asparagus is al dente (insert a sharp knife into the base of the asparagus; if it slides through with

little resistance, it's ready). Remove with a slotted spoon and toss in a bowl with a knob of butter, a pinch of pepper and a squeeze of lemon juice while still warm.

Melt the rest of the butter in a medium-sized saucepan. Stir in the flour until it forms a lump and beat hard. Gradually whisk in the milk, cream and lemon zest. Bring to the boil and cook for 1 minute before taking off the heat and stirring in a generous amount of salt and white pepper. Check the seasoning and adjust to taste. Chop the parsley leaves and stir most of them in, then add the 2 tablespoons of grated horseradish and the mashed eggs.

Divide the asparagus and spring onions between four plates, place a piece of cod on top and pour over a generous ladle or two of the smashed egg sauce. Sprinkle over some freshly grated horseradish and the rest of the parsley, and serve with some new potatoes, if you like.

Top tip / Trim about 2cm from the woody end of the asparagus, then lay the spears flat on a board and peel the stems with a vegetable peeler.

Swedish schnitzel sandwich

Svensk schnitzelmacka

OK, you got me here: there is no such thing as a Swedish schnitzel. Instead, this is a classic Khoo dish. Being a culinary magpie, I'm using an Egyptian dukkah idea in conjunction with an Austrian schnitzel technique, adapted with spices and flavours that are very common in Sweden. Aniseed is one flavour that is hard to escape from in Sweden (and hopefully you won't want to!): every corner shop stocks at least a dozen versions of liquorice. Fennel and cumin both have these notes, but I'm blending them with some mustard seeds and a hit of sweetness from the cinnamon, making it a subtle, rather than in-your-face, liquorice experience.

Serves 4 /
Preparation time: 30 minutes /
Cooking time: 15 minutes /

For the dukkah crust:
1 tbsp fennel seeds
3 tbsp cumin seeds
140g walnuts
140g pumpkin seeds
2 tbsp brown mustard seeds
¼ tsp cinnamon

For the schnitzel:
2 large chicken breasts
4 tbsp plain flour
sea salt
1–2 egg whites, whisked
3–4 tbsp vegetable oil

To serve:
1 small apple
¼ of a cabbage, thinly shredded
juice of 1 lemon
1 tbsp walnut or olive oil
butter
4 large rolls or 8 slices of bread
carrot ketchup (see page 293), to serve (optional)

First make the dukkah crust. Toast the fennel and cumin seeds in a dry frying pan over a medium heat for about 1 minute, or until they release their aromas. Grind the walnuts and pumpkin seeds to a coarse powder in a food processor or spice grinder. Add the toasted spices, mustard seeds and cinnamon, and pulse once or twice to combine.

To make the schnitzel, cut each chicken breast horizontally in half through the centre. Line a chopping board with a large piece of cling film, place the chicken breast halves on top and cover with cling film. Bash the chicken breasts with a rolling pin until about 0.5cm thick. Set up three plates: top one with the flour mixed with 2 teaspoons of sea salt, one with the whisked egg whites and another with the dukkah. Dip the chicken pieces in the flour, then the egg whites and then the dukkah, placing them on a tray lined with baking paper as you go.

Put a frying pan over a high heat and pour in half the vegetable oil. Once hot, turn the heat down to medium and add the schnitzel, cooking in batches to avoid crowding the pan, and adding more vegetable oil as necessary. Fry on one side for about 3–4 minutes until golden, then flip and repeat, until cooked through.

Core and finely slice the apple, then mix with the cabbage. Toss in the lemon juice, walnut or olive oil and a pinch of salt.

Butter your bread, then assemble your sandwich with the schnitzel and the salad, adding some carrot ketchup, if you like.

Top tip / For a gluten-free version, use cornflour to dip the chicken breast in, and serve with an oven-roasted sweet potato instead of bread.

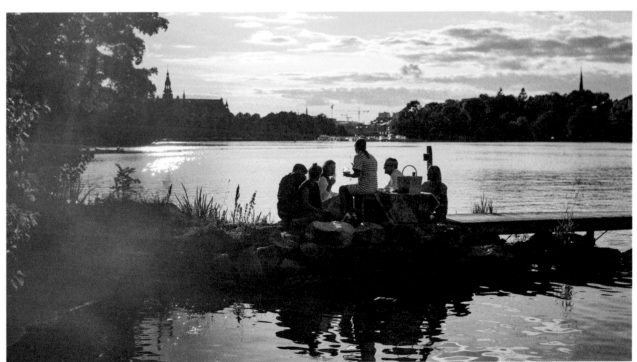

DIY *kåldomar*

Gör-det-själv-kåldomar

Sometimes, let's face it, the best recipes for entertaining are those that let people assemble their own dish. My twist on the classic *kåldomar* – cabbage leaves stuffed and steamed with a mincemeat filling – invites everyone around the table to get involved and make their own. I've simplified the cooking with a quick stir-fry method and opted for crunchy fresh cabbage leaves instead of boiling them, as there are only so many dishes I can handle with a heavy cream sauce. Stuffed cabbage-leaf parcels can be a kerfuffle to do if you're making more than half a dozen, but with my nifty version you'll have dinner on the table in under half an hour.

Serves 4 / Gluten free / Preparation time: 15 minutes / Cooking time: 15 minutes /

2 tbsp butter

1 tsp white pepper

1 tsp ground allspice

1 tsp sea salt

1 medium onion, peeled and finely chopped

250g minced pork

250g minced beef

a handful of finely chopped fresh chives

300g cooked rice

200g cold boiled potatoes, grated

12 green cabbage leaves, or 1 iceberg lettuce

200g sour cream or thick Greek yoghurt

lingonberry jam, to serve

Melt the butter in a large frying pan over a medium heat, then add the spices, salt and onion and fry for about 10 minutes until the onion is soft. Add the mince, breaking it up with a wooden spoon, and continue to fry until the mince is crisp. Remove from the heat and stir through the chives.

Meanwhile, preheat the grill, and spread the rice and grated potato out on a baking tray lined with foil. Place under the hot grill and toast until golden brown and crisp. You may need to toss the rice and potato around so it toasts all over. Keep an eye on it, as some parts will brown more quickly than others.

Separate the cabbage or lettuce leaves, then wash them and pat dry. Remove any tough stalks from the cabbage.

Place all the filling ingredients in separate serving bowls to let people help themselves.

To assemble a *kåldomar*, take a leaf, spread some sour cream in the centre, add some mince followed by the potato mix, top with a teaspoon of lingonberry jam and roll the leaf up.

Top tip / You can also cook the cabbage leaves if you prefer them more tender. I blanch them in a pan of boiling water for 1 minute, then drain immediately and place in a bowl of iced water so that they keep their colour and don't overcook.

Swedish stir-fry

Pyttipanna

Pyttipanna (which translates as 'small bits in a pan') feels like the Swedish answer to nasi goreng (the South East Asian dish of fried rice with a fried egg on top). Typically comprising onions, potatoes, minced meat, beetroot and a fried egg, *pyttipanna* is a dish that is quickly put together with whatever you might have foraged from the kitchen. There are no rules in my book when it comes to making this dish, so feel free to get creative with leftovers. I always seem to have rashers of smoky bacon in the fridge (in case of a bacon sarnie emergency), and lentils are always in the larder. Just don't forget the obligatory fried egg on top!

Serves 4 / Gluten free /
Preparation time: 20 minutes /
Cooking time: 30 minutes /

200g beluga or puy lentils
a handful of raisins
800ml good-quality chicken or vegetable stock
a bunch of spring onions
6 rashers of smoky bacon, finely chopped
2–3 parsnips (200g)
3 carrots (340g)
2 small beetroot

½ tsp white pepper
sea salt
3 tbsp pickled mustard seeds (see page 289)
2 tbsp pickling liquid, from any jar of pickles
4 eggs
2 tbsp butter

Put the lentils, raisins and stock into a pot and bring to a simmer uncovered. Cook according to packet instructions until the lentils are al dente. Drain, reserving the leftover stock.

Trim the spring onions, remove the green parts and set these aside for later. Finely chop the white parts and put into a frying pan with the bacon. Gently fry for 5–10 minutes until the onions are soft. In the meantime, peel the parsnips, carrots and beetroot and chop into 0.5cm cubes. Add these to the spring onions and season with the white pepper. Turn up the heat slightly and continue to fry for another 10 minutes.

Add the cooked lentils and raisins to the frying pan with a couple of tablespoons of cooking stock. Stir together and taste for seasoning, adding salt if necessary, then take off the heat and cover.

Finely chop the green parts of the spring onions and toss with the pickled mustard seeds and pickling liquid.

In a non-stick pan on a low heat, fry the eggs in the butter, until the white is set and the yolk still runny.

To serve, divide the lentil mixture between your plates or bowls, and top with a fried egg and the spring onions and mustard seeds.

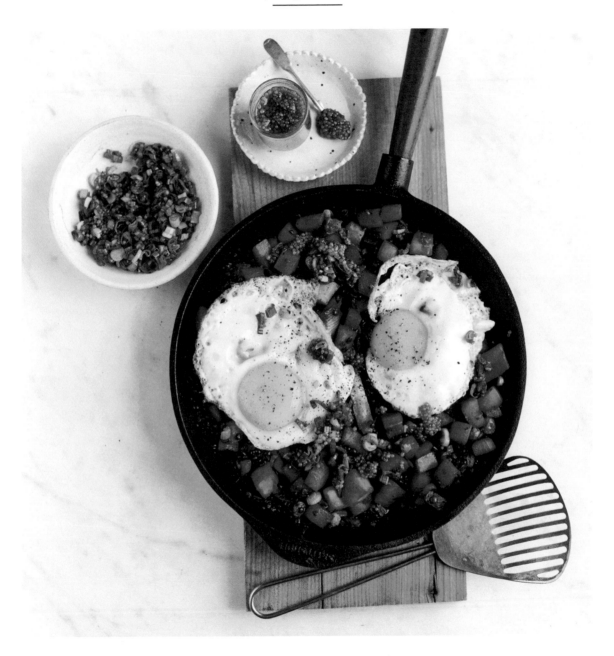

Top tips / Beluga or puy lentils are my go-to lentils for this dish, as they hold their shape the best. Leftover rice also works.

For a vegetarian version, omit the bacon and replace with a tablespoon of olive oil or butter.

For meat eaters, the bacon can be replaced with leftover roast meat or poached fish. Fry the meat with the spring onions and a tablespoon of oil. If using poached fish, flake that in at the end with the lentils.

Taco pizzas

Tacopizza

Tacos aren't the first thing that comes to mind when you say Swedish food. But since the popularity of taco kits in the 1980s they have become an established dish in Swedish homes, a bit like how curries now make a regular appearance on English dinner tables. Taco pies, which are essentially everything you would put into a Swedish taco but in pie form, are common too. Even a village shop in the Swedish countryside will make their own. The taco pie must have been born when someone decided to use up their leftovers from the Friday night taco dinner. Turning the taco into a sort of pizza was only a matter of time.

Serves 4 /
Preparation time: 30 minutes /
Cooking time: 20 minutes /

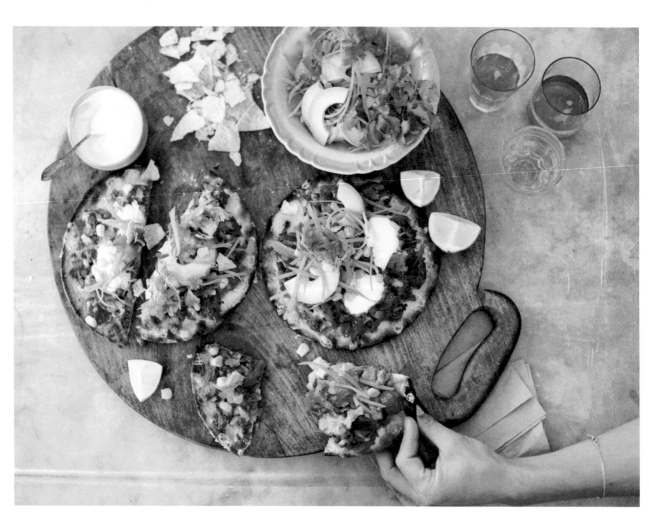

For the tacos:

1 tbsp sunflower oil

1 onion, peeled and finely chopped

1–2 tsp chilli powder (depending on how spicy you like it)

1 tsp cumin

1 tsp sea salt

250g minced beef

1 x 290g tin of cherry tomatoes

1 carrot, peeled and grated

4 Swedish tortillas or flatbreads

50g mature Cheddar cheese, grated

a handful of tortilla chips

4 tbsp sour cream

For the salad:

1 small tin of sweetcorn, drained

1 avocado, destoned and sliced

2 large handfuls of fresh coriander, leaves only

3 carrots, peeled and julienned

2 tbsp extra virgin olive oil

juice of 1 lime

a pinch of sea salt

Heat the sunflower oil in a large frying pan and add the onion, spices and salt. Fry over a low heat for about 10 minutes until the onion is soft, then add the mince. Fry until the mince is crisp and golden, breaking it up with a wooden spoon and coating it in the spices. Add the tomatoes, crushing them with your spoon, then add the grated carrot and a couple of tablespoons of water. Bring to a simmer and stir. Cook for 5 minutes, then take off the heat.

Preheat the grill and place the tortillas on a baking tray lined with baking paper. Put them under the hot grill to crisp up. Once the tortillas are crisp on one side, flip them over and repeat. Remove from the oven and spread a ladleful of tomato sauce over each tortilla. Sprinkle with the cheese and place back under the grill until golden and bubbly.

Toss together all the salad ingredients in a bowl.

To serve, place a heap of salad on each tortilla, followed by some crushed tortilla chips and a few dollops of sour cream.

Top tip / Throw a tin of drained mixed beans into the mince mix and you have a sort of chilli con carne.

Get ahead / The cooked mince will keep in the fridge in an airtight container for a couple of days. Alternatively, it can be frozen for several months.

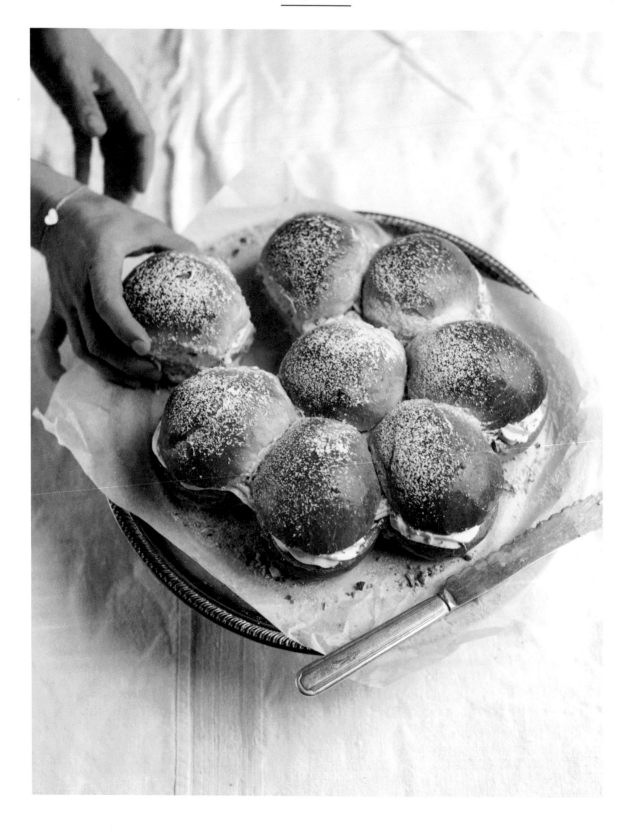

Cream bun cake

Semlor-tårta

If the southern French speciality *Tropézienne* and the Swedish Lent bun *semla* decided to join forces, they would probably end up a little like this. With its rich dough, which you would traditionally use to make individual marzipan buns, my sociable version feeds a crowd, with pillowy, cardamom-spiked whipped cream in the centre and a pistachio marzipan hiding underneath.

Makes 1 large cake to serve 8 /
Vegetarian / Preparation time: 1 hour /
Proving time: 2–3 hours /
Cooking time: 20–25 minutes /
Equipment: piping bag with a
 star-shaped nozzle /

For the dough:

375g plain white flour, plus extra for dusting

50g caster sugar

½ tsp fine sea salt

2 tsp dry instant yeast

150ml whole milk

1 tsp vanilla bean paste

2 medium eggs

75g very soft butter

For the pistachio marzipan:

100g marzipan

50g pistachio kernels, plus 2 tbsp finely chopped

2–4 tbsp milk

For the cardamom whipped cream

400ml whipping cream

40g icing sugar, or to taste, plus extra for dusting

a pinch of ground cardamom

To make the dough, put the flour, sugar, salt and yeast in a large bowl. Place the milk and the vanilla bean paste in a small pan and bring to room temperature over a very low heat. Make a well in the centre of the dry ingredients and add the warmed milk, 1 egg and the butter. Mix, then knead in a free-standing mixer with the dough hook attached for about 5–7 minutes, or by hand on a highly floured surface until the mixture doesn't stick and bounces back when touched.

Cover the bowl with cling film and leave to rise for about 2 hours, until doubled in volume. After it has risen sufficiently, dust your work surface with flour and scrape the dough on to it. Divide the dough into eight equal-sized balls and shape into buns.

Line a large baking tray with baking paper. Place one bun in the centre then, with 1cm spacing between them, distribute the remaining buns around the central bun in a circle. Beat the remaining egg and brush the tops with some of the egg wash. Lightly cover the buns with greased cling film and put in a warm place to prove for about 30 minutes. Meanwhile preheat the oven to 200°C /fan 180°C/gas 6.

Brush with egg wash once more, then put the tray into the oven. Bake for 20–25 minutes, until golden and the base sounds hollow when tapped. Leave to cool on a wire rack.

In the meantime, break the marzipan into pieces and pop into a food processor with the pistachio kernels and 2 tablespoons of the milk. Blitz to a fine spreadable paste, adding more milk if required to reach this consistency.

Whip the cream to soft peaks with the icing sugar and the cardamom.

Slice through the cooled bun cake horizontally, trying not to separate the buns. Remove the lid and spread the base with the marzipan paste, right to the edges. Put the whipped cream into a piping bag fitted with a star-shaped nozzle and pipe from the centre out in a spiral right to the edge of the bun cake. Scatter the edges with the finely chopped pistachios and pop the lid back on. Dust with plenty of icing sugar and serve within 1 day.

Top tip / For perfectly even-sized buns, measure the quantity of dough, divide by 8, then weigh each bun to make sure it's the same weight before shaping.

Get ahead / This is best made fresh on the day.

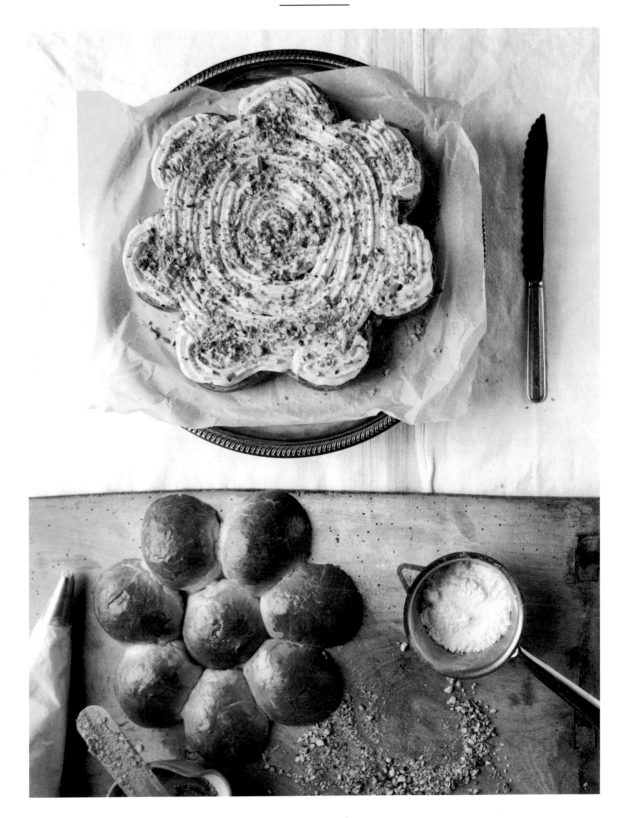

Roast rhubarb and custard magic cake

Magisk tårta med bakad rabarber och vaniljkräm

The magic cake was not discovered on some trip to the depths of the Swedish forest but on a mindless surf on YouTube (you watch one video, you end up clicking on another, and before you know it half the day has disappeared). I loved the idea of creating three different textures in one cake with only one batter. A creamy, oozy custard layer, a moist cake and an airy sponge. This rhubarb-and-vanilla-custard flavour combination is something that the Brits would claim as their own; however, upon quizzing my cousins-in-law about Swedish food, they all said that rhubarb with vanilla sauce is their sweet food memory of Swedish spring.

Serves 10 / Vegetarian /
Preparation time: 30 minutes /
Resting time: 2 hours /
Cooking time: 1 hour /
Equipment: 24cm springform cake tin /

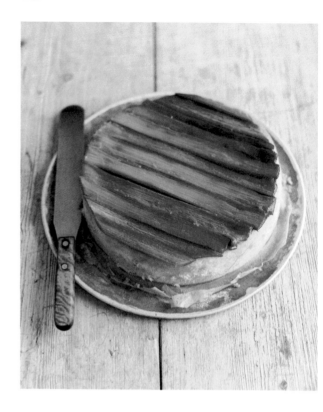

soft butter, for greasing the tin

360ml whole milk

a pinch of sea salt

1 vanilla pod, split in half lengthways

4 cardamom pods, crushed

¼ tsp ground ginger

125g butter, cubed

5 medium eggs, separated

100g caster sugar, plus 2 tbsp

100g plain flour

1 tsp baking powder

140ml double cream

350g rhubarb, trimmed in 25cm lengths

Preheat the oven to 170°C/fan 150°C/gas 3. Grease the cake tin with soft butter and line inside with baking paper.

Place the milk, salt and spices in a saucepan. Bring to the boil, turn the heat off, then add the cubed butter and stir to mix. Strain the butter mixture, discarding the spices.

Whisk the egg whites to stiff peaks. If using a mixer, decant the egg whites into another bowl, then put 100g of sugar and the egg yolks into the mixer bowl. Whisk the sugar and egg yolks until they're pale and almost white. Mix the flour and baking powder together in another bowl. Add the cooled butter mixture and cream to the egg yolk mixture, then sift in the flour. Fold together until combined, then fold in the egg whites. Don't overmix the egg whites, as you'll end up with a rubbery cake; it's OK to have a few small lumps of egg white remaining.

Pour the batter into the prepared cake tin and bake on the middle shelf of the oven for 45 minutes. The cake should still be slightly wobbly when you pull it out of the oven. Leave to cool in its tin for 30 minutes before refrigerating for at least 1½ hours.

In the meantime, toss the rhubarb stalks in 2 tablespoons of sugar and put on a baking tray lined with baking paper. Place in the oven and bake for 15 minutes or until the stalks are tender but not mushy (this will depend on the thickness of the stalks). Remove from the oven and set aside until needed.

Carefully transfer the cake to a cake platter. Cut the rhubarb in half vertically before laying on top of the cake.

Top tips / The cake can be topped with all kinds of fruits: fresh, stewed, roasted or in a compote. The cake can equally be eaten with nothing on top except a liberal dusting of icing sugar.

A different shaped tin will affect the result of the cake. Also, temperatures can vary between different makes of oven, but an additional oven thermometer will help ensure you bake the cake at the correct temperature.

Get ahead / The rhubarb keeps in the fridge for a couple of days. The cake also keeps for 2 days in the fridge.

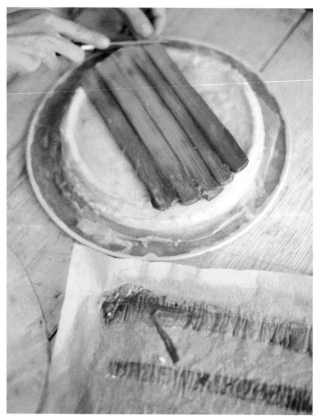

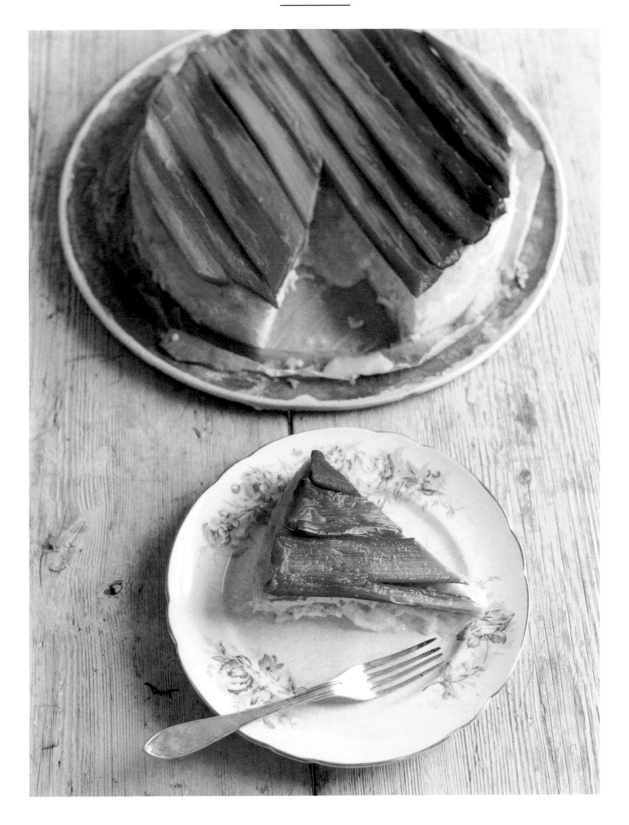

Chocolate balls

Chokladbollar

Despite how incredibly simple they are to make at home, these little Swedish chocolate balls are hugely popular shop-bought snacks. Even the fanciest of Stockholm bakeries offer their own versions alongside far more elaborate buns or pastries, yet all it takes to make them is a rummage in the cupboards, a spare 20 minutes and a little pair of helping hands. Mine are less sweet than the shop-bought ones, but you can easily adjust the sugar to your liking.

200g rolled oats

50g caster sugar

40g unsweetened cocoa powder

200g very soft butter

2 tsp really strong espresso or a few drops of coffee extract

a pinch of ground cinnamon

a pinch of vanilla bean powder

a pinch of fine sea salt

To coat:

3–4 tbsp shredded or desiccated coconut

3–4 tbsp finely ground praline (see page 277)

3–4 tbsp sprinkles or hundreds and thousands

3–4 tbsp freeze-dried strawberries or raspberry powder (optional)

Makes 20–25 / Vegetarian /
Preparation time: 20 minutes /
Chilling time: 15 minutes /

Place the oats in a food processor and pulse to roughly grind them – I like to leave some bits slightly chunkier than others, and not too powdery. Tip the oats into a medium-sized mixing bowl and add the sugar and cocoa powder. Add the butter and beat with a wooden spoon to combine everything. Add the espresso or coffee extract, cinnamon, vanilla bean powder and salt and beat until everything is incorporated.

Line a baking tray with cling film or baking parchment and, using your hands, roll about 1 tablespoon of the mixture into a bite-sized ball. Place on the lined baking tray and repeat with the rest of the mixture. To coat, place the different toppings in separate small bowls and toss the balls in the coating, placing them with space between them back on the baking tray.

Leave to set for 15 minutes in the fridge before eating.

Top tips / The espresso can be replaced with dark rum for a more adult version. Or omit the espresso altogether if you don't want its slightly bitter note.

For a dairy-free version, try using soft coconut butter.

Get ahead / These chocolate balls keep for 4–5 days in an airtight container in the fridge. Serve at room temperature, or cold if you want a firmer chocolate ball.

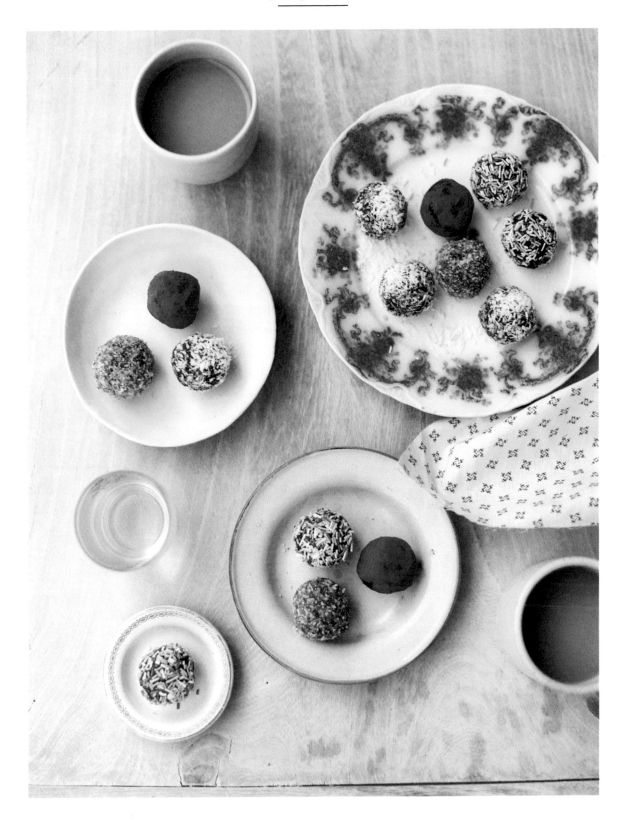

Swedish marmalade biscotti

Marmeladsnittar

Snittar (literally translated as 'cuts') are what you could call the Swedish version of Italian biscotti, although they are maybe not as tooth-breakingly hard. These buttery biscuits pop up in almost every coffee shop, mainly in either a chocolate or caramel version. They are the perfect biscuit to dip into your cup of coffee. Marmalade is not your traditional sweetener, but it does make these biscuits very moreish, with a fragrant citrus flavour.

Makes 20 / Vegetarian /
Preparation time: 15 minutes /
Baking time: 12–15 minutes /

100g soft butter

80g caster sugar

100g orange marmalade

zest of 1 lemon

225g plain flour

½ tsp baking powder

1 tsp fine sea salt

Preheat the oven to 190°C/fan 170°C/gas 5.

Beat the butter, sugar, marmalade and lemon zest together until fluffy and creamy. In another bowl, mix together the rest of the ingredients. Combine the ingredients together and mould into a ball. Divide the ball in half, and form both pieces into a 25cm-long log. Place on a baking sheet lined with baking paper. Make sure you place the logs far apart, as the mixture will spread. Press the logs down to form a 1cm high log, similar to the shape of a ciabatta.

Bake for 12–15 minutes, or until the biscuits are a light golden brown. As soon as they come out of the oven, cut into 1.5cm-thick slices using a metal dough scraper or a large knife (be careful not to damage your baking tray).

Leave to cool on a wire rack.

Get ahead / These biscuits will keep in an airtight container for a week.

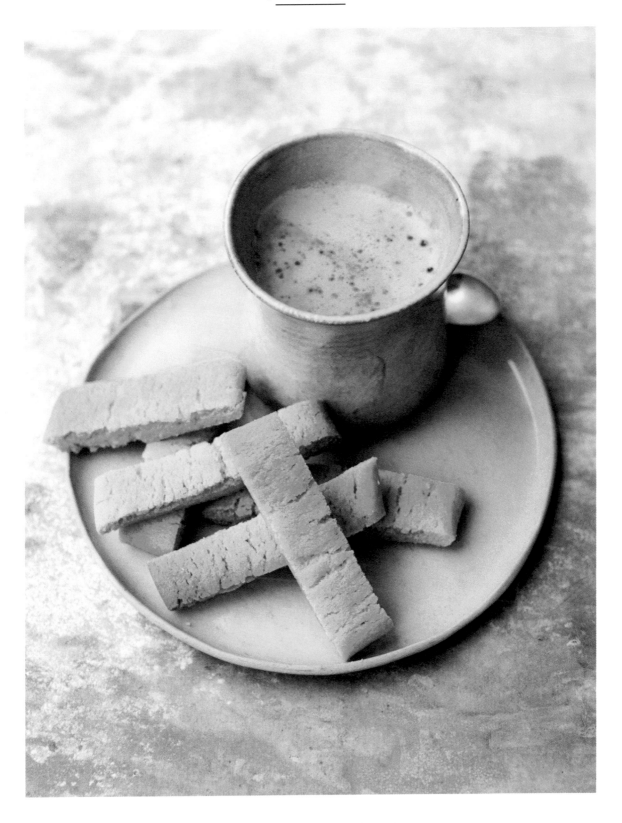

Almond and lingonberry buns

Mandel och lingonbullar

This wouldn't be a Swedish cookbook if I didn't have at least a few *bullar* recipes in here. Unlike the spelt and rye buns (see page 198), these are made with a simple plain-flour dough which takes far less time to rise. The quicker rise and the white flour does mean they are best eaten within 24 hours, but I think you'll find they don't hang around that long after they leave the oven (at least not in my house, anyway). The tartness of lingon-berries stands up well against the sweet almond paste, but cranberries are an excellent substitute if you can't find them.

Makes 12 / Vegetarian /
Preparation time: 30 minutes /
Resting time: 2 hours 15 minutes /
Baking time: 15 minutes /
Equipment: 2 piping bags, and a 12-hole
 muffin tin /

125g frozen lingonberries or cranberries
1 egg, beaten, for egg wash
2tbsp light brown sugar

For the dough:

375g plain white flour, plus extra for dusting

50g sugar

½ tsp fine sea salt

150ml whole milk

1 tsp vanilla bean paste

75g butter

25g fresh yeast

1 medium egg

For the almond paste:

100g ground almonds

75g soft butter

75g light brown sugar

1 medium egg

½ tsp fine sea salt

½ tsp vanilla bean paste

To make the dough, put the flour, sugar and salt into a bowl. Warm the milk with the vanilla paste and butter to room temperature (to speed up the process, place in a pot and put on the hob for a minute or two). Crumble the yeast into a small heatproof bowl, and add 2 tablespoons of the milk to dissolve it. Make a well in the centre of the dry ingredients and add the yeast, remaining milk mixture and the egg. Mix, then knead in a

free-standing mixer with the dough hook attached for about 5–7 minutes, or by hand on a lightly floured surface, until the mixture doesn't stick and bounces back when touched. Cover the bowl with cling film and leave to rise for about 2 hours, until doubled in volume.

In the meantime, place the frozen berries in a medium-sized pan, cover with the lid and place over a medium-low heat. If they dry out, add 2 tablespoons of water to get them going. Once the berries start to melt, stir and continue to boil with the lid on for 5 minutes, then remove the lid and cook for 5 minutes on a low heat until you get a rough jammy consistency. If your cranberries are drying out, add 50–70ml of water to help the cooking process. Mash with the back of a fork before transferring to a piping bag.

For the almond paste, beat everything together until you have a smooth, pale paste. Transfer to a piping bag and chill in the fridge until needed.

Preheat the oven to 240°C/fan 220°C/gas 9. Line your 12-hole muffin tin with muffin cases or grease the tin very well with soft butter. Tip the dough on to a floured surface. Roll into a long sausage and cut into 12 equal-sized pieces. Roll each piece into a ball and place in a muffin case. Cover with a tea towel and leave to rise for 15 minutes in a warm place.

Brush the tops of the buns with egg wash and sprinkle with 2 tablespoons of light brown sugar. Using your finger, poke a hole in the centre of each bun. Insert the tip of the piping bag into a bun. Rotate the tip a few times to make a well and pipe in some jam. Then do the same with the almond paste. Repeat with all the buns.

Lower the oven temperature to 220°/fan 200°C/gas 7. Bake for 15 minutes or until golden and well risen.

Get ahead / The buns can be frozen for several months in a sealed food bag once they have been baked and slightly cooled. Reheat at 170°C/fan 150°C/gas 3 for 30 minutes from frozen.

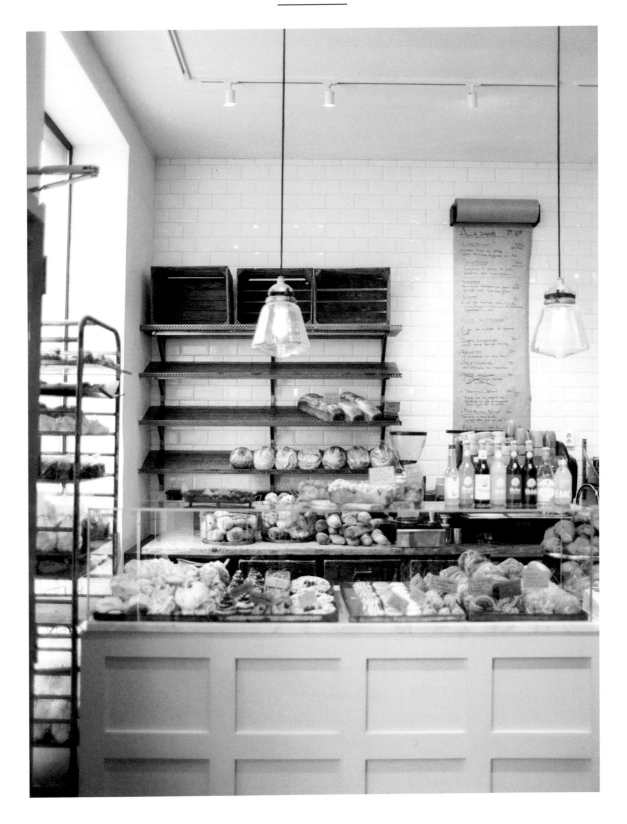

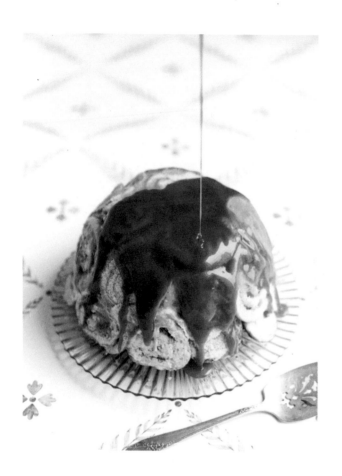

Cardamom bun bombe .

Kardemummabullar-bombe

If you happen to have day-old, slightly stale buns lying around, this is a good way of using them up. I've also made this dessert using bought buns when I've been short of time and need a quick and easy dessert for a dinner party.

Serves 6–8 / Vegetarian /
Preparation time: 30 minutes / Cooking time: 10 minutes / Freezing time: 4 hours /
Equipment: medium-sized bowl (capacity 1.5 litres) /

200g golden or date syrup

200g caster sugar

2 tsp ground cardamom

½ tsp fine sea salt

300ml double cream

2 litres good-quality vanilla ice cream

12–14 shop-bought cardamom or cinnamon buns

Start by making a caramel. Pour the syrup into a large, heavy-based pan, followed by the sugar, cardamom and salt. Place on a hot heat. Swirl the pot around every minute or so to help incorporate the sugar. Once the caramel starts to simmer, cook for a further 5 minutes or until a dark golden brown. Take off the heat. Gradually incorporate the cream – be careful, as the mixture will splutter and rise. Fill a bowl with water and ice, place the caramel pot on top of the ice and leave to cool.

Take the ice cream out of the freezer and put into the fridge to soften slightly.

Line your medium-sized bowl with cling film, leaving some excess to fold over the top to cover. Cut the cardamom buns in half and place some of them cut side down in the bowl, so the bowl sides are fully covered.

Beat the softened ice cream and swirl in a third of the cooled caramel. Set aside the rest for serving. Spoon the ice cream into the bowl and press it down. Cover the ice cream with the remainder of the bun halves. Wrap with the excess cling film and freeze for at least 4 hours.

To serve, take the bombe out of the freezer 15 minutes before serving. Open up the cling film at the top, place a serving plate over the bowl and turn upside down. Remove the cling film and leave to thaw slightly. Right before serving, pour over the remainder of the caramel sauce.

Top tips / Use a knife run under hot water to cut the bombe.

Cardamom can be replaced with other spices, such as cinnamon, ground ginger and allspice.

SUMMER

sommer

Expectations are always very high when it comes to a Swedish summer. Spring usually kicks off teasingly with a series of warm, sunny days that invariably turn back into a cold snap. Every year there is chatter about how this summer is going to be the best ever on record. I must say that most summers here don't quite live up to people's expectations (you could probably say the same about the ones in Britain), but when summer does decide to show itself off in all its glory, it is truly amazing. During my first summer in Sweden I spent plenty of time in the south, Skåne, on some beautiful golden sandy beaches. If you ignore the fact that the water was a rather refreshing temperature (read: deathly cold), we could have been in the Caribbean, minus the hordes of tourists. And *'grädde på moset'* ('the cream on the mash', meaning 'the icing on the cake') is certainly the long Swedish summer days, particularly after the hard winters: Stockholm averages 1,880 hours of sunlight a year, versus London's 1,410. On those long days, it feels like the sun has been out for ever, and in the north of Sweden it barely goes down. It really gives you another lease of life, especially if you've spent the whole day stuck in the office.

Midsummer is the highlight of the Swedish calendar. It is not only the longest day of the year, but also the beginning of the school holidays. Midsummer weather is usually cloudy and a bit drizzly, but with a few rays of sunshine peering through, if you're lucky. I've spent most midsummers wearing more layers than I do in March. I've attended quite a few midsummer celebrations, and all involve plenty of snaps, dancing around a maypole and singing songs such as *'Små grodorna'* ('The Little Frogs'). Girls spend the morning picking flowers for their flower crowns, or little, intensely sweet, wild strawberries. Later everyone will enjoy an abundant buffet of different types of pickled herring or mackerel (see page 96), boiled new potatoes, and strawberries (see page 120).

People try to spend all their free time outside during the summer. It's particularly noticeable when you're in the city. After the cold months, the city fills up with what feels like a sudden influx of new residents (or, better said, everyone comes out of hiding at home). Some companies offer summer working hours, so that people can finish work at around 3 p.m., and everyone heads straight out for picnics, barbecues, drinks on the terrace, playing games like boules, swimming (one of the many things I love about Stockholm is that the waterways are clean enough to swim in, even in the middle of the city) and other outdoor pursuits. It doesn't matter that it might be a bit chilly (cafes and restaurants lay out blankets and have plenty of heaters for outside seating) or if the fresh-water lakes and archipelago water isn't the warmest – every summer day is seized as if it were the last.

At the weekend or during the holidays, most Swedes will head to their *sommerstuga* ('summer cottage'). Whether it's out in the countryside by a lake, on the archipelago or by the sea, it'll usually be somewhere remote. This popular tradition of having a little summer cabin partly came about because, before travel became so accessible, the size of Sweden made it hard for people to get around quickly and efficiently. So an easier way had to be found for people to go on holiday. Usually these cottages are painted in the traditional *falu* red (this red originates from the copper mines and was used as a cheap way to imitate brickwork in the 17th century) and often have a Swedish flag flying (Swedes raise the flag for birthdays, national and celebratory days).

Facilities in the summer cabins are often basic: some don't have connections to mains electricity, instead relying on a wooden or gas stove, and many have no running water. Being resourceful and creative with your cooking is important, something I'm not too unfamiliar with. With that in mind come dishes like peas, potatoes and a chicken in a pot (see page 116), smoked sausage stroganoff (see page 122) or oat cookies (see page 124), recipes to make while the summer light lingers on.

Crayfish soup

Kräftsoppa

Crayfish are very much part and parcel of the Swedish year. They can only be fished during August and September (each year the dates are announced), but my mother-in-law is clever enough to freeze crayfish so we can enjoy her soup any time of the year.

Serves 4–6 / Gluten free /
Preparation time: 30 minutes /
Cooking time: 40 minutes /

1kg crayfish, cooked (see Top tip)

2 tbsp rapeseed oil

1 carrot, peeled and finely chopped

50g celery, finely chopped

1 onion, peeled and finely chopped

3 tbsp tomato purée

1 tsp ground paprika

a pinch of cayenne pepper

1 bay leaf

300ml dry white wine

1 litre fish stock

1 tsp white pepper

300ml double cream

sea salt

double cream or crème fraiche, to serve

finely chopped fresh chives, to serve

Carefully shell the crayfish, apart from the larger claws – hang on to these claws for garnishing, and keep the shells too.

In a large saucepan, heat the oil and add the carrot, celery, onion, tomato puree, paprika, cayenne pepper, bay leaf and crayfish shells. Gently fry until the onion is soft. Pour in the wine and let it reduce for a minute, then add the fish stock and the pepper. Continue to cook uncovered for about 30 minutes, until the soup has reduced by two thirds and has a strong flavour. Place a large sieve over a pot and pour the soup through it. Discard everything but the remaining liquid and place that back on the hob on a gentle heat. Stir in the double cream and crayfish meat. Check for seasoning and add salt to taste.

Divide the soup between bowls and stir a spoonful of cream through. Scatter with the chives and garnish with a few claws.

Top tip / Langoustine or even large prawns could be substituted for the crayfish.

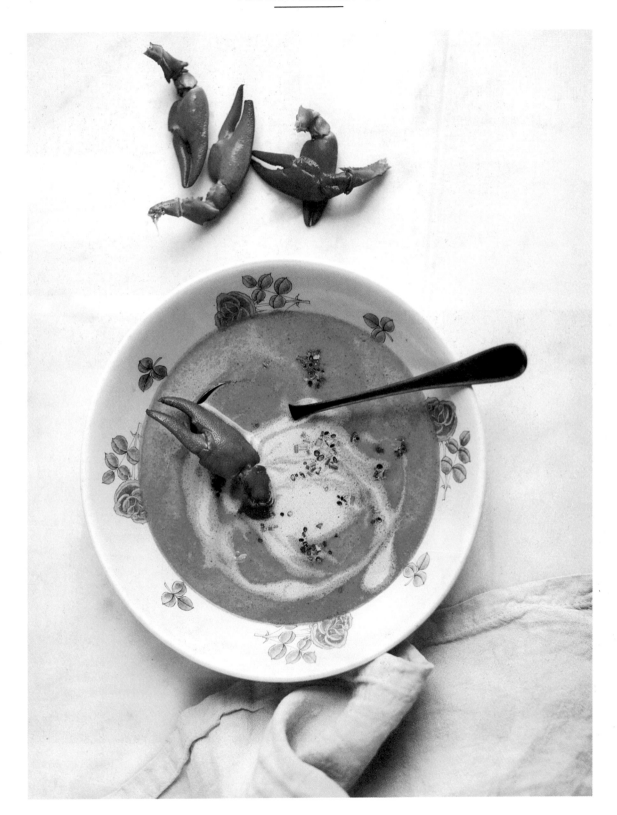

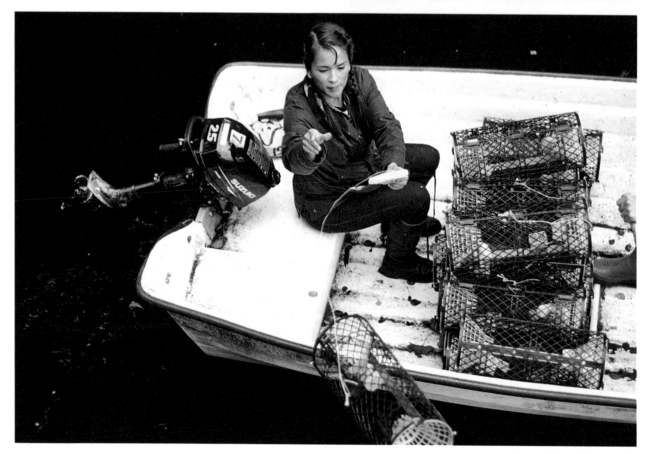

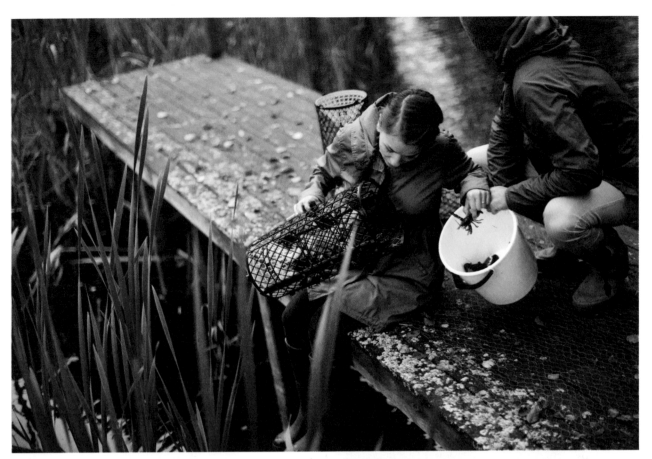

Pancakes

Pannkakor

Ubiquitous in Sweden, you'll often find pancakes on hotel dessert or brunch buffets, served with whipped cream and jam. But they're equally popular served with crispy bacon and lingonberry jam as a savoury dish. There are various types: *ugnspannkakor*, which are oven-baked and slightly thicker than French crêpes; *tunnpannkakor* ('thin pancakes'), which are more like crêpes; and *små plättar*, which are double the size of blinis and cooked in a special cast-iron frying pan with holes. It can all get rather confusing, but from what I understand, pancakes come in all different forms, thicknesses and sizes and, in essence, you just need some flour, eggs, dairy products, a good pinch of salt (the saltiness is key) and a generous amount of butter to fry them in. The ones in this recipe are in between American pancakes and French crêpes in size, but with a slight saltiness and crispy edges to make them extra moreish (even if you decide to serve them sweet).

Makes 6 /
Preparation time: 15 minutes /
Resting time: 15 minutes /
Cooking time: 20 minutes /

For the pancakes:

284ml buttermilk

130–150ml whole milk

1 medium egg

150g plain flour

1 tsp caster sugar

1 tsp bicarbonate of soda

a generous pinch of sea salt

soft butter, for frying

For the toppings:

12 rashers of smoked streaky bacon

150ml double cream

4 tbsp finely chopped fresh herbs (such as chives and flat-leaf parsley), plus a few sprigs to garnish

sea salt and black pepper

½ a red onion, peeled and very finely chopped

2–4 tbsp carrot ketchup (see page 293), to serve

In a medium bowl, whisk the buttermilk with 130ml of the milk and the egg until smooth. Mix the dry ingredients in a separate bowl, then fold into the wet ingredients until incorporated. Add the extra milk if required to reach a yoghurty consistency. Set aside in the fridge for 15 minutes.

Preheat the grill to high. Spread the bacon rashers on a foil-lined baking tray and grill for 4–5 minutes, or until crispy, turning them over halfway through.

Whip the cream to soft peaks, stir through the herbs and season well with salt and pepper. Set aside in the fridge while you cook the pancakes.

Preheat the oven to 140°C/fan 120°C/gas 3. Put a crêpe pan or non-stick frying pan on a medium heat with 1 teaspoon of butter. Add a ladleful of the batter and spread into a neat-ish circle of about 15cm, using the back of the ladle. Cook for 2–3 minutes on each side, then place the crêpe on a baking tray and keep warm in the oven while you make the others. You may need to add more butter to the pan.

To serve, place a pancake on each plate and top with a dollop of the herby cream and 2 slices of bacon. Scatter with the red onion and the remaining herbs, and serve with carrot ketchup.

Kohlrabi with toasted sunflower seed & dandelion leaf 'pesto'

Kålrabbi med pesto gjord på maskros och rostade solrosfrön

Kohlrabi is a vegetable I could quite happily just bite into, no cooking needed. Its crunchy, fresh and slight cabbage flavour makes it very moreish. It's a fantastic crisp alternative to carrots or cabbage in a slaw. It's not something that has been very easy to find in UK super-markets in the past (unlike in Sweden), but it's now becoming increasingly available. Boiling and tossing it in some butter is probably the simplest and one of the tastiest ways to cook kohlrabi. The addition of this simple sunflower and dandelion leaf (I have plenty of those in the garden, which I need to weed) pesto gives the dish a nice toasty and herby note.

Serves 4–6 / Vegetarian / Gluten free /
Preparation time: 15 minutes /
Cooking time: 10 minutes /

1 kohlrabi (around 600g)
2 handfuls of sunflower seeds (around 100g)
4 tbsp soft butter
2 handfuls of dandelion or parsley leaves, washed
sea salt

Bring a large pot of salted water to the boil. Peel the kohlrabi and cut into 1cm-thick sticks. Once the water is boiling, add the kohlrabi and boil for 3–4 minutes, or until the kohlrabi is tender and translucent. Drain.

Meanwhile, put the sunflower seeds into a large dry pan over a medium heat. Toast until they start to pop and smell nutty. Take off the heat and add the butter. Once the butter is melted, pour everything into a blender. Add the dandelion or parsley leaves and some salt, then blitz until you have a slightly rough paste. Taste, and season with extra salt if required (it should taste slightly salty).

Toss the warm kohlrabi sticks through the 'pesto', and serve immediately.

Top tips / You can replace the butter with extra virgin olive oil for a vegan version.

Add a handful of finely grated Parmesan cheese if you like and toss through some pasta.

Chilled cucumber soup with beetroot yoghurt granita

Kyld gurksoppa med rödbetsyogurt-granita

There are a couple of days in the Swedish year when the mercury in the thermometer hits temperatures that could compete with a warm summer day in southern Europe. And on those days, nothing beats a refreshing chilled soup.

Serves 4 / Vegetarian / Gluten free /
Preparation time: 15 minutes /
Chilling time: 2–3½ hours /

2 cooked beetroot (about 125g)

125g plain yoghurt

900g cucumber, chopped

4 tbsp chopped fresh dill,
 plus a few sprigs to garnish

4 tbsp cider vinegar

sea salt

1 beetroot, peeled, to garnish

Start by making a granita. Blitz the cooked beetroot with the yoghurt in a blender. Pour into a large, flat-bottomed container and place in the freezer. After 30 minutes, thoroughly stir through the mixture. Place back in the freezer for another 2–3 hours, or until fully frozen.

Meanwhile, blitz the cucumber and dill in a blender until very smooth. Add the vinegar and season to taste with salt. Place in the fridge to chill.

When ready to serve, julienne the remaining beetroot into thin strips. Use a fork to scratch the granita up into snow. Check the soup for seasoning, then divide it into bowls. Top with the granita, some beetroot matchsticks and the sprigs of dill.

Top tip / The colder a dish, the more you need to season it. Freezing dulls the taste and therefore extra seasoning is required.

Get ahead / The soup will keep for a day in the fridge. The granita will keep for a week in the freezer in an airtight container. Take out of the freezer 5 minutes before serving to make it easier to fork up the crystals.

Grilled char with fennel, dill and redcurrants

Helgrillad röding med fänkål, röda vinbär och dill

Catching my own dinner isn't something I did a lot in the past, but in Sweden we go fishing fairly often. With its many lakes, freshwater fish is king: we've reeled in char, brown trout, perch, and the odd pike (although they have too many bones for my liking). More often than not, the fish goes back in the water to live another day, but when I do take home a catch, the fish is so fresh I like to keep the other flavours simple.

Serves 4 / Gluten free / Preparation time: 20 minutes / Cooking time: 30 minutes /

2 whole char (about 500g each)
sea salt and black pepper
2 knobs of soft butter

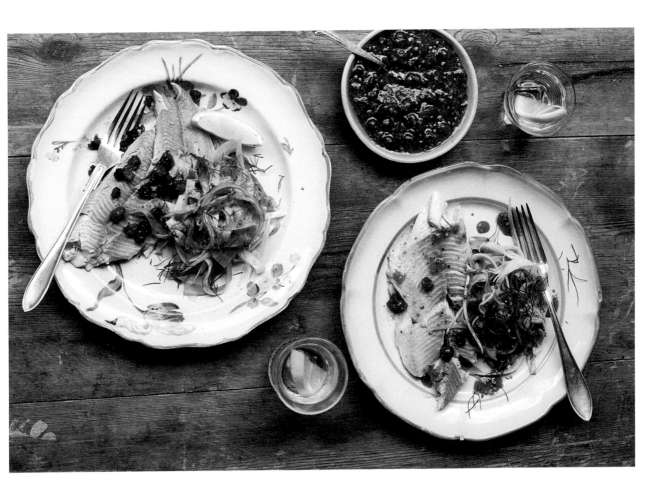

2 handfuls of redcurrants, stems intact

2 handfuls of redcurrants, stems removed

2 tbsp rapeseed or olive oil

1 large fennel bulb, keeping some of the fronds

1 tbsp finely chopped fresh dill

Preheat the oven to 190°C/fan 170°C/gas 5.

Pat the char dry, rub with salt and smear the soft butter inside the cavity and over the skin. Stuff with the redcurrants still on the stems. Put the char on a lined baking tray and place in the oven. After 20 minutes, turn on the grill. Grill on one side for a couple of minutes, or until slightly charred and crisp. Carefully turn over and repeat.

In the meantime, crush half of the stemless redcurrants and mix with the oil and 1 teaspoon of salt. Thinly slice the fennel and toss with the crushed redcurrants, dill and remaining whole redcurrants. Taste for seasoning.

Once the fish is cooked, serve immediately, with the fennel salad on the side.

Top tips / If you can't get char, you can use trout.

For a Swedish *knäckemacka* ('cracker sandwich'), top a piece of crispbread (see page 28) with some of the fish, fennel and redcurrants.

Hot smoked salmon salad with gravlax dressing

Sallad med Varmrökt lax och gravlaxsås

Sometimes the best dishes come to me when I have to make something quickly for lunch and have a peek in the fridge. This is the result of one of those speedy fridge raids. Gravlax dressing is as common as tomato ketchup in Sweden, where ready-made jars can be found in the condiments section at the supermarket. There really isn't much to making it yourself though, as you can see from this recipe. As well as being delicious with smoked fish, it can also be used to dress freshly boiled small potatoes or salads.

Serves 4 as a starter, 2 as a main /
Gluten free /
Preparation time: 15 minutes /

1 head of cos lettuce
8 radishes
1 carrot, peeled
200g hot smoked salmon

For the gravlax dressing:

2 heaped tbsp good-quality mayonnaise

2 heaped tbsp sweet grainy mustard (see page 13)

zest and juice of 1 lemon

2 tbsp finely chopped fresh dill

a pinch of sea salt

Shred the lettuce, thinly slice the radishes using a mandoline or a sharp knife, and slice the carrot into matchsticks or peel into ribbons.

Mix together all the ingredients for the dressing. Spread a tablespoon of dressing on each plate or a large serving platter. Place the salad on top and flake the hot smoked salmon over it. Drizzle over the rest of the dressing.

Top tip / The hot smoked salmon could be replaced with regular smoked salmon, smoked trout or even cold roast chicken.

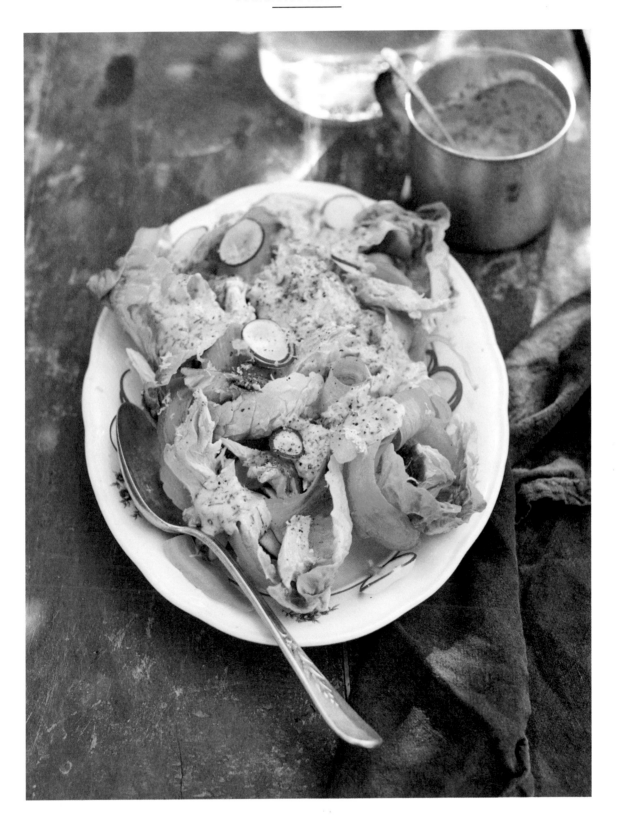

Carrot salad

Morotssallad

When heading to the countryside from Stockholm, there's a motorway restaurant that we often nip into on the way. It's nothing fancy, but what they do serve is classic Swedish *husmanskost* ('houseman's food', or traditional home-cooked food). Meatballs are always on the menu, of course.

As in most Swedish restaurants, there is a salad buffet that you can help yourself to before your main course. One of the salads on offer is invariably a bright orange carrot salad. It's the perfect start to a meal, and a nice way to brighten up a drizzly drive in the car. It's quite unassuming, but it's crunchy and has a good tart dressing. I've added a few capers and a red onion for an extra lively kick.

Serves 4 / Vegetarian / Gluten free /
Preparation time: 15 minutes /
Cooking time: 5 minutes /

6 tbsp cider vinegar

1 tsp sugar

1 tsp sea salt

1 red onion, peeled and finely sliced

3 large carrots (mix of colours if available)

2 tbsp eldercapers (see page 287) or regular capers

1 heaped tbsp finely chopped fresh dill, plus a few sprigs to garnish

2 tbsp mild rapeseed oil or olive oil

sea salt and black pepper

150g feta or goat's cheese (optional)

Put the vinegar, sugar and salt into a saucepan and bring to the boil, stirring occasionally. Once the sugar and salt has dissolved, turn off the heat, add the onion and leave to sit while you peel and slice the carrots into matchsticks.

Toss the carrots, capers and dill together in a bowl with the oil. Pour over the onions and toss together again. Taste and check for seasoning, adding salt and pepper if desired, and scatter over the sprigs of dill and crushed feta or goat's cheese .

Get ahead / I find this salad tastes even better the following day, once the ingredients have had time to marinate and the onions have mellowed slightly.

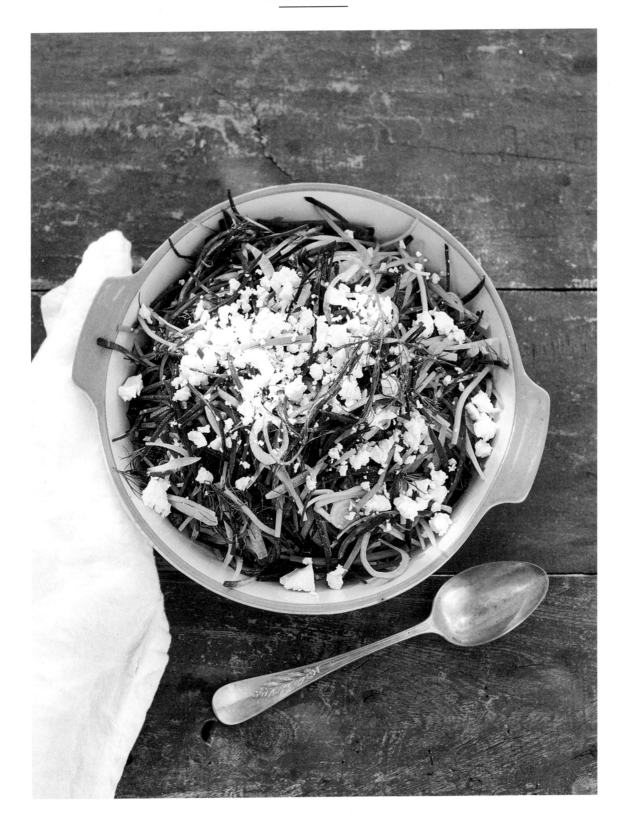

Pickled mackerel 3 ways

Inlagd makrill

Pickled fish wasn't unfamiliar to me before I ate it in Sweden, as I remember my Austrian grandma tucking into rollmops (rolled-up herring fillets in a tart pickling liquid with carrots, onions and juniper berries). A new discovery, though, was the many variants you can find. Most Swedes will simply pick up a jar from the supermarket, but with good-quality fresh herring or mackerel, it's something that can easily and enjoyably be made at home. I've picked out three of my favourite versions: a classic pickle; a colourful, slightly sweet berry one; and finally a rich creamy version. This, with some crispbread (see page 28), strawberry salad (see page 121) or potato salad (see page 102), is pretty much a full Swedish midsummer menu.

Serves 4–6 as part of a spread / Gluten free /
Preparation time: 30 minutes /
Resting time: 30–60 minutes, plus 1 day /

8 tbsp fine sea salt

6 super-fresh mackerel fillets, deboned

500ml white wine vinegar

250g caster sugar

4 bay leaves

For version 1:

1 tsp peppercorns

1 tsp mustard seeds

1 tsp juniper berries

For version 2:

150g redcurrants or lingonberries

2 shallots, peeled and sliced into rounds

For version 3:

2 tbsp finely chopped fresh chives

2 tbsp finely chopped fresh dill

2 tbsp finely chopped capers

2 tbsp finely chopped shallots

zest of 1 lemon

2 tbsp mayonnaise

100g crème fraîche

To cure the fish, scatter 4 tablespoons of salt evenly in the bottom of a glass or ceramic dish. Place the mackerel fillets on top and cover with another 4 tablespoons of salt. Leave for 30–60 minutes in the fridge.

Put the vinegar, sugar and bay leaves into a pan and bring to the boil, then set aside to cool fully while the mackerel cures in the fridge.

Rinse the salt off the mackerel and pat dry. You can either leave the mackerel fillets whole, or slice them into 3cm pieces.

For versions 1 and 2, submerge the mackerel fillets in a 1-litre Kilner jar, dotting the ingredients from either version between the fillets, then pour the pickling liquid over the top. Keep this in the fridge for at least 1 day before using and up to 4 days.

For version 3, put the mackerel into a 1-litre Kilner jar, pour over the pickling liquid and keep in the fridge as above. When ready to serve, drain from the pickling liquor and pat dry. Measure out the remaining ingredients and toss to coat the mackerel pieces. Eat within 2–3 days.

Top tip / For easy pin-boning, grab a pair of old tweezers, run your fingers down the fish fillet and pluck out any pointy bones.

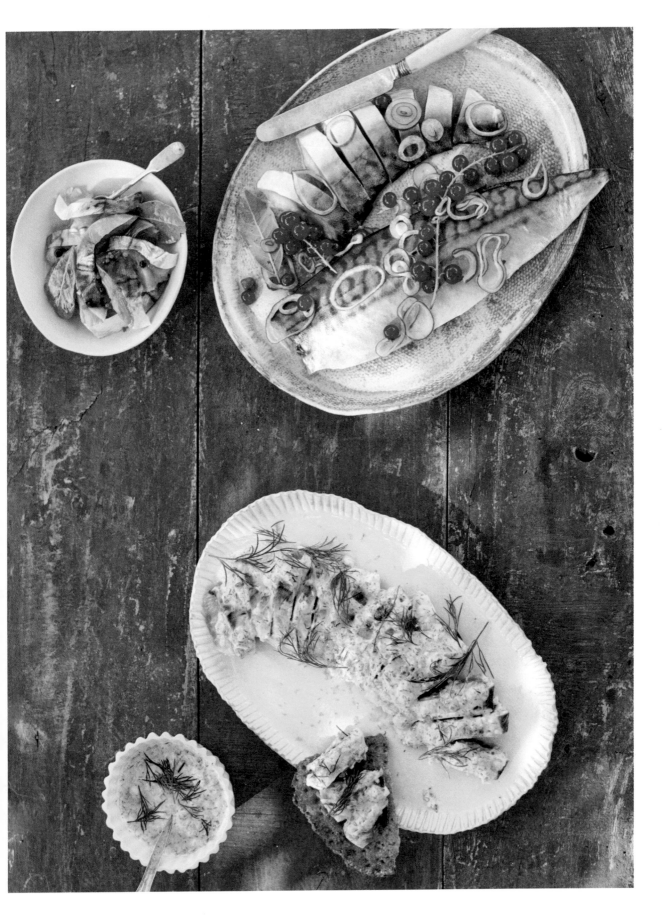

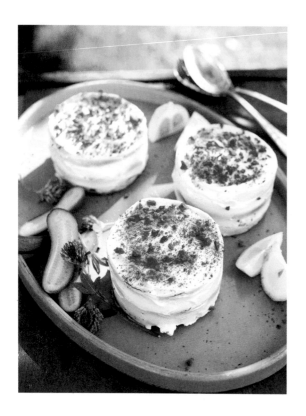

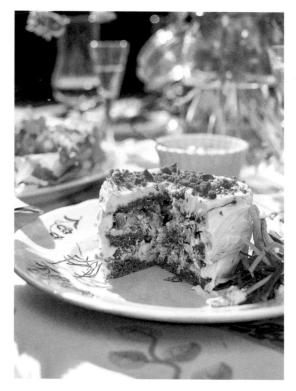

Red caviar cakes

Röd romtårta

This is a cross between *romtårta* (fish-roe cake) and *smorgåstårta* (sandwich cake). *Romtårta* is a savoury cheesecake made with prawns, lumpfish caviar and red onion that is set with gelatin and has a rye-bread base. *Smorgåstårta* is a cake that uses sandwich bread as the layers and is filled with anything from cheese, ham and pâté to tomatoes and melon. Throw in some red beetroot flatbreads (see page 285), and you have something that looks deceivingly like red velvet cake; it's a total, utter mash-up, but absolutely delicious.

Makes 4 small cakes /
Preparation time: 30 minutes /
Baking time: 15 minutes /
Equipment: 8cm cookie cutter or
 a glass with the same diameter /

6 beetroot flatbreads (see page 285) or
 12 slices of rye bread
200g cooked shelled small prawns
½ a cucumber
zest of 1 lemon
250g cream cheese
½ a red onion, peeled and finely chopped
a handful of finely chopped fresh chives
sea salt
4 tsp lumpfish caviar

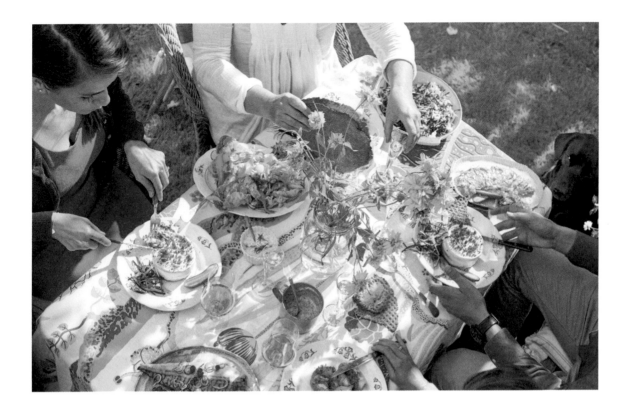

Preheat the oven to 170°C/ fan 150°C/gas 3. Cut the flatbreads in half horizontally and use a cookie cutter to stamp out 8cm rounds. If you're using rye bread, just stamp out the rounds.

Place the crusts that remain from the cut-out pieces on a baking tray lined with baking paper and place in the oven for 15 minutes, or until dried out but not brown. Remove from the oven and leave to cool before blitzing in a blender or food processor to make chunky breadcrumbs. You can also roughly chop them with a knife.

Pat the prawns dry with a clean tea towel and roughly chop. Remove the seeds from the cucumber, discard, and chop the rest into small cubes. Put the prawns, cucumber, lemon zest, 1 tablespoon of the cream cheese, the red onion and the chives into a bowl. Stir together, then taste to see if it needs any salt.

Take one round of your bread, put a smudge of cream cheese on the base and place on a plate. Put a heaped tablespoon of the prawn mixture on the round, followed by 1 teaspoon of the lumpfish caviar. Repeat with another piece of bread and mixture. Finish with a final piece of bread on top. Do this another three times, so you have 4 small cakes in total.

Beat the remaining cream cheese until it's smooth and use it like icing to cover the cakes on the sides and top, smoothing it with a palette knife as you go. Sprinkle the breadcrumbs on top of the cakes, and serve with a green salad.

Top tips / Traditionally, *romtårta* uses a very dark rye bread, but you can use whatever you have to hand. The key thing is that the bread doesn't have too many holes, else the filling will fall through.

Smashed potatoes with green sauce

Krossad potatis med grön sås

If there are no potatoes on the table at the midsummer party, it simply isn't a midsummer party. Potatoes are a staple in Sweden, much like they are in Ireland (both have a similar history with potato famines, which caused mass immigrations to America). It's all about celebrating the new small potatoes that come from Skåne in the south of Sweden, and this is one of my favourite ways of showcasing them.

750g new potatoes

3 tbsp salted butter

For the green sauce:

2 tbsp extra virgin olive oil

4 tbsp cider vinegar

2 tbsp capers

1–2 tsp caster sugar, to taste

sea salt

a small bunch of fresh dill, leaves picked and roughly chopped, plus a few sprigs for garnish

a small bunch of fresh parsley, leaves picked and roughly chopped

a small bunch of fresh tarragon, leaves picked and roughly chopped

Serves 4–6 as a side /
Vegetarian / Gluten free /
Preparation time: 10 minutes /
Cooking time: 10–15 minutes /

Put the potatoes into a large pan of salted cold water. Bring to the boil and cook for 10–15 minutes, or until tender. Drain and let them steam in a colander. Smash them roughly with the back of a fork and dot the butter over the top.

In the meantime, make the sauce. Whizz all the ingredients for the sauce in a small blender until smooth. Taste and adjust the seasoning.

Place the potatoes on a serving plate and drizzle the sauce over the top. Serve immediately.

Get ahead / The potatoes and sauce can be made a few hours in advance and covered. The green sauce will lose its greenness, however, so I prefer to make that just before serving.

Red cabbage and apple coleslaw

Sallad med rödkål och äpple

This ingredient and flavour combination is something you would typically see on the Swedish *julbord* (Christmas buffet). The cabbage and apples are normally stewed in a fragrant, sweet vinegar solution until soft and tender, but leave out the stewing part and you have a fresh, crunchy coleslaw that either contrasts well with rich Christmas fare or makes a colourful addition to a summer barbecue. I like to crumble in some local hard salty goat's cheese (similar to a feta, but a bit drier), but that's just my cheese-oholic side coming out, as it's perfectly delicious on its own too.

Serves 4–6 as a side /
Vegetarian / Gluten free /
Preparation time: 15 minutes /
Cooking time: 5 minutes /

½ a red cabbage (about 500g)

1 red onion

2 crunchy eating apples

75g redcurrants

200g hard salty goat's cheese or feta (optional, to serve)

For the dressing:

2 tbsp redcurrant jelly

1 tbsp cider vinegar

2 tbsp light rapeseed oil or olive oil

½ tsp ground allspice

½ tsp black pepper

a generous pinch of sea salt

Heat the redcurrant jelly in a pan, whisking until smooth. Put into a bowl and whisk together with the remaining dressing ingredients.

Remove and discard the core from the cabbage, then thinly slice the rest of the cabbage. Peel and thinly slice the red onion. Core, then thinly slice the apples using a mandolin or sharp knife. Remove the redcurrants from their stalks. Put all the ingredients into a bowl and toss in the dressing until well coated.

Top tip / Use an apple variety that is crisp and crunchy, such as Granny Smith or Braeburn.

Get ahead / This salad stands up well to being made several hours in advance and doesn't go soggy – but either omit the apple or add it just before serving.

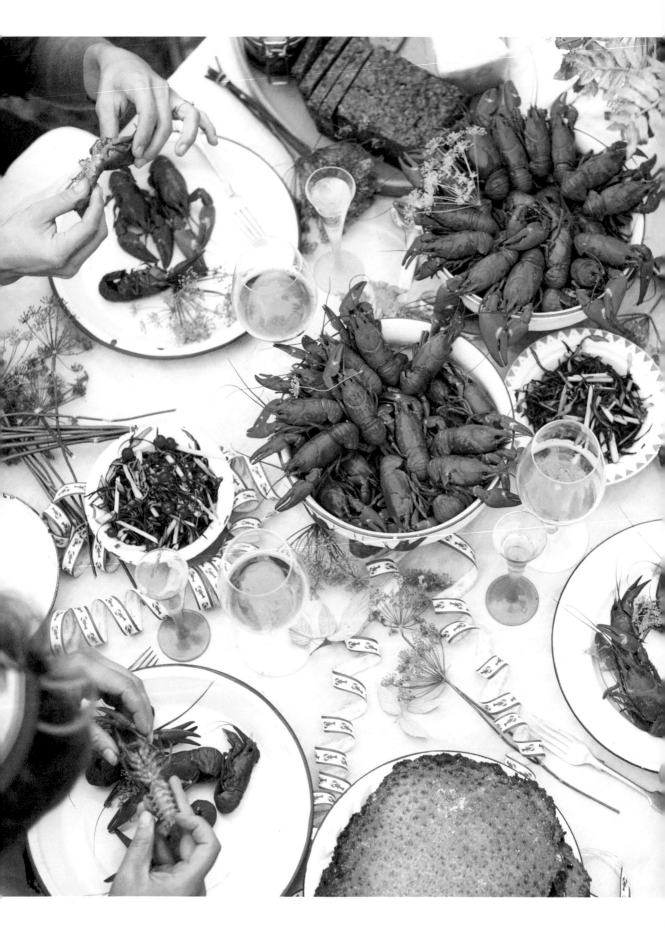

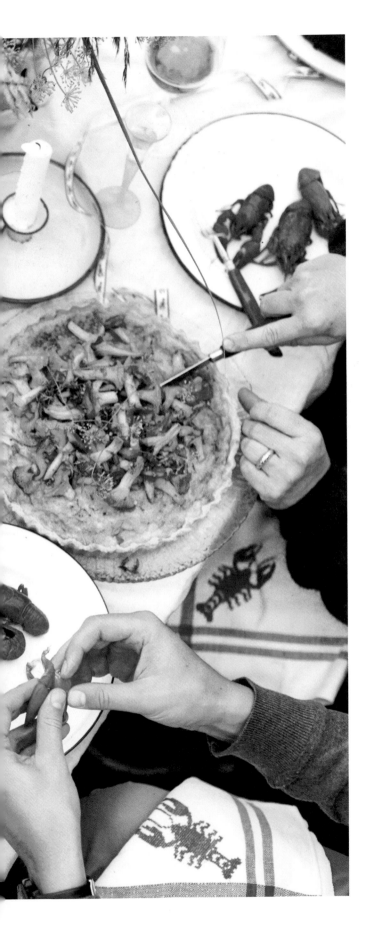

Crayfish party /

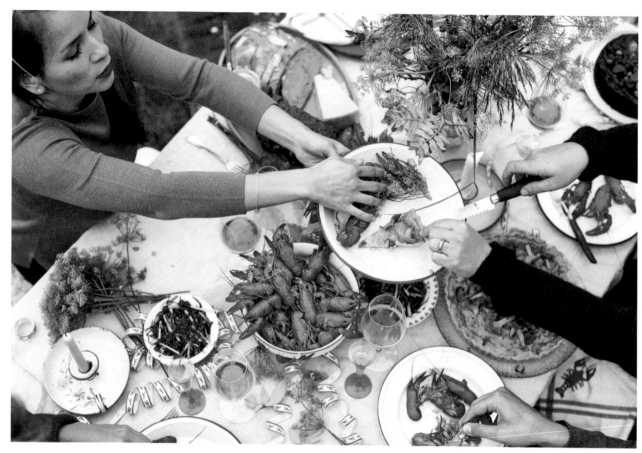

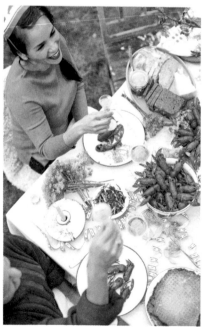

Crayfish

Kräftor

A crayfish party simply wouldn't be complete without mountains of brined crayfish decorated with dill. A salty, sweet brine, heavily laced with the aniseed flavour of dill, is essential. If you ever happen to be invited to a crayfish party hosted by Swedes, you'll notice a rather particular way of eating them, which involves sucking some of the brine from the shells before cracking them open.

Serves 4–6 / Dairy free /
Preparation time: 1 hour 30 minutes /
Resting time: overnight /
Cooking time: 30 minutes /

3kg live crayfish

500ml stout

300g sea salt

20 stalks of crown dill or regular dill, plus a few sprigs to garnish

3 tbsp caster sugar

Leave the live crayfish to sit in a large pot of fresh water for an hour. Rinse and drain the crayfish and place in the freezer for 20 minutes.

Place all the ingredients apart from the crayfish in a large stockpot with 5 litres of water and bring to the boil. Remove the crayfish from the freezer and add to the boiling stock. Cover with the lid, reduce the heat and leave to simmer for 5 minutes.

Place the stockpot in a sink half-filled with ice cubes and water and leave to cool for 2 hours, replacing the ice cubes every 30 minutes, then chill overnight in the fridge. Before serving, drain the broth. Serve the crayfish piled up, garnished with sprigs of dill.

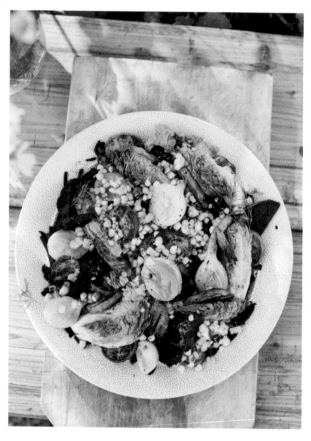

Midsummer salad

Midsommarsallad

Serves 6 / Vegetarian / Gluten free /
Preparation time: 30 minutes /
Cooking time: 20–30 minutes /

I always feel that vegetables get a little overlooked when it comes to barbecues. There's usually a thrown-together salad or maybe some roasted vegetables, but rarely anything to write home about. However, the barbecue is in fact an excellent tool to add another flavour to vegetables: the smokiness

really gives them some oomph. The key is to cook the veggies on a very low heat, using the glowing coals to infuse them with the smoky flavour. I've also been known to adapt this recipe using other vegetables I have in the fridge: butternut squash, aubergines, tomatoes ... the options are endless.

1kg cooked beetroot, skin kept on
 (pick larger ones)

2 corn cobs in their husks (ideally soaked
 for 30 minutes)

4 little gem lettuces, washed and halved

4 spring onions

200g new potatoes, washed and cut into
 1cm-thick slices

2 tbsp extra mild rapeseed oil or light olive oil,
 plus a little extra

sea salt and black pepper

4 tbsp thick Greek yoghurt

a small handful of fresh dill, chopped

When the barbecue coals are glowing, lay the cooked beetroot and corn cobs directly on the coals. Toss the little gems, spring onions and new potatoes in the oil. Place the grill back on top and put the potatoes, little gems and spring onions on the grill.

Every 2–3 minutes, turn all the vegetables around so they cook evenly. When the little gems and spring onions have grilled nicely, remove them. Remove the corn cobs and beetroot when they are black all over.

Leave the beetroot to cool slightly before peeling off the black skin. Grate one of the beetroots and season with salt and pepper. Mix in the yoghurt. Cut the rest of the beetroot into wedges.

Remove the husks from the corn, then slice the kernels from the cobs using a sharp knife. Toss the corn, little gems, spring onions and potatoes in a little more oil, and season to taste.

Spread the yoghurt beetroot on a serving plate. Layer the rest of the vegetables on top, then sprinkle over the dill.

Top tips / Using larger beetroots will help you get a good smoky exterior without burning them all the way through.

I like to soak the corn on the cob in their husks so that they don't burn too quickly in the coals. The husks act as a protective coat.

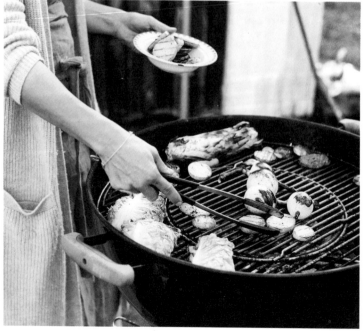

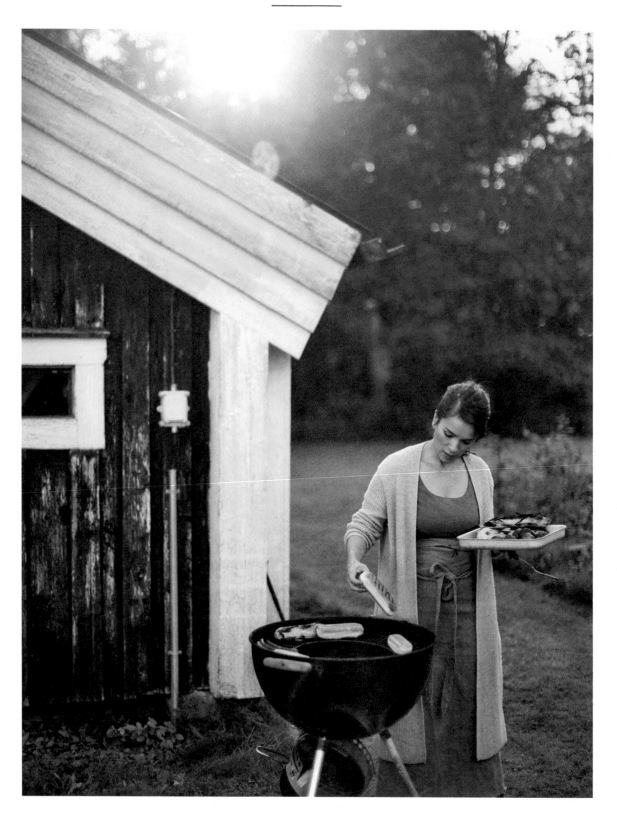

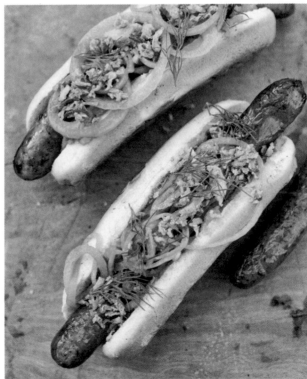

Peas, potatoes and chicken in a pot

Ärtor, potatis och kyckling i en gryta

I don't think it matters where you live in the world: there is something universally comforting about chicken cooked slowly in broth. This is a dish that I'll make on a cold day, of which there are many in Sweden, whether in winter or in summer. The slightly spicy green sauce is a riff on the Argentinian chimichurri sauce, which I fell in love with when I did a pop-up restaurant in Buenos Aires. Instead of chillies I'm using horseradish, which can certainly match a spicy chilli in terms of heat (I've been known to cry a fair amount while grating the fresh stuff).

1 whole chicken (about 1.25kg)

sea salt

2 corn cobs

3–4 tbsp rapeseed oil

2 onions, washed not peeled, halved

1 bay leaf

500g new potatoes, scrubbed

200g frozen peas

200g sugar snap peas

For the sauce:

2 tbsp finely chopped fresh parsley

1 spring onion, finely chopped

2 tbsp finely grated horseradish

2 tbsp finely chopped fresh chives

4 tbsp white wine vinegar

150ml extra mild rapeseed oil or light olive oil

Serves 4–6 /

Dairy free / Gluten free /

Preparation time: 30 minutes /

Cooking time: 2 hours /

Cut the chicken into 8 pieces by laying the chicken on the board breast side up. Pull a leg away from the body to see where it attaches, then slice through the skin between the thigh and the breast. Pop the thigh out of the socket, then use a knife to cut all the way through. Cut between the drumstick and the thigh. Repeat on the other side.

Pull the wings away from the body and make a small cut on either side through the skin. Pop the wing out and cut all the way through on both sides. Now flip the chicken over and use scissors to cut around the sides of the backbone to remove it. Finally, cut right through the breastbone to separate the two breast pieces.

Season the chicken pieces with plenty of salt. If the corn cobs are still in their husks, remove them, then cut each cob into 4 chunks.

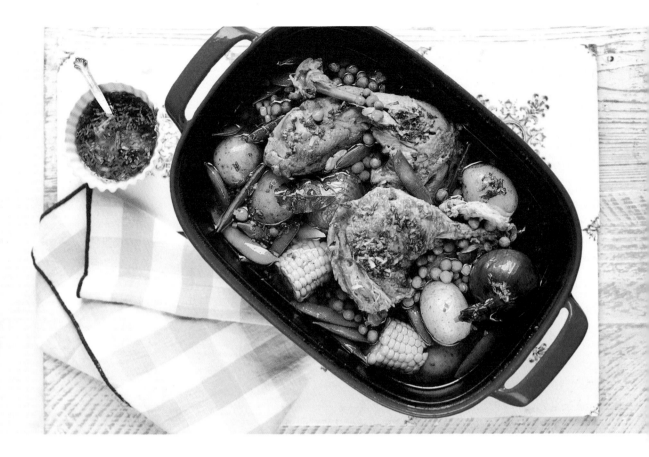

Put 2–3 tablespoons of oil into a large pan and fry the chicken pieces on all sides until golden. You will need to do this in batches so as not to overcrowd the pan, adding more oil if necessary. Once the chicken is nicely golden, return all the pieces to the pan, along with the corn cobs, onions, bay leaf and just enough water to cover it all. Bring to a gentle simmer and cover.

Simmer for 30 minutes, then add the potatoes and cook for another 10–15 minutes until the potatoes are tender. Taste for salt. Just before serving, add the peas and sugar snaps.

To make the sauce, mix everything together and taste for salt, adjust accordingly and serve alongside the stew.

Top tips / If there are leftovers, I pick off any meat from the bones and put it back in the pot, then throw in some pasta to make a thick soup.

The sauce is also excellent with other meats, poured over grilled halloumi or even as a salad dressing.

Get ahead / This is great made a day in advance, as the chicken has more time to develop in flavour. Just don't add the peas and sugar snaps until you reheat it.

Västerbotten pie

Västerbottenpaj

The Brits have Cheddar, the French have Comté and the Swedes have Västerbotten: a good, hardy, flavoursome cheese that can be cooked with or eaten as is. Västerbotten is an area in the north of Sweden; the cheese is renowned throughout the country and almost everyone has a piece of it in their fridge. This pie, which I've eaten my fair share of, nearly always crops up at midsummer and crayfish parties and at Christmas. Pie like this shouldn't be eaten just on celebratory occasions though: a slice in your packed lunch with a green salad on the side will make a perfectly satisfying meal.

Serves 8 / Vegetarian /
Preparation time: 1 hour /
Baking/cooking time: 1 hour 5 minutes /
Equipment: 21cm quiche tin, 4cm deep /

For the pastry:

130g plain flour

¼ tsp fine sea salt

1 tbsp wholegrain mustard

80g cold butter, cubed

1 tbsp vodka

For the filling:

3 medium eggs

300ml single cream

½ tsp fine sea salt

1 tsp black pepper

300g Västerbotten or mature Cheddar, grated

1 small onion, peeled and thinly sliced

For the mushroom topping:

75g butter

250g chanterelle mushrooms, brushed clean

a small handful of fresh parsley leaves, finely chopped

To make the pastry, mix together the flour and salt. Add the mustard and cold butter, then use your fingertips to rub it all together until you have a sandy texture. Add the vodka to bring it into a dough. Place between two sheets of baking paper and roll into a circle that is larger than your quiche tin. Leave to chill in the fridge for 30 minutes. Preheat the oven to 180°C/fan 160°C/gas 4.

Remove the pastry from the fridge and use it to line the pie tin. If the pastry is too hard, leave to soften for 5–10 minutes before lining the tin. Prick the pastry in the tin with a fork. Line with baking paper and pour in baking weights. Bake for 20 minutes, then remove the baking weights and paper and bake for a further 10 minutes, or until the base is dry and firm.

To make the filling, beat the eggs with the cream, salt and pepper until you have a smooth mixture. Stir in the cheese. Pour into the pie case, put the

onions on top and bake for another 25–30 minutes, or until the mixture is set but still a little wobbly.

When the pie has cooled, heat the butter for the mushrooms in a large frying pan. Once the butter is foaming, add the chanterelles and cook for 4–5 minutes, or until lightly golden and cooked through. Leave to cool slightly. Scatter the pie with parsley and top with the mushrooms to serve.

Get ahead / This is also great cold. You can cook the pie up to 2 days ahead and keep in the fridge, but only cook the mushrooms just before serving.

Poached chicken with quick pickled strawberry salad

Pocherad kyckling med picklad jordgubbssallad

My first midsummer party in Sweden was one of many firsts: my first time drinking schnapps and singing songs, as well as making flower crowns and dancing around a maypole. It was also my first taste of strawberries in a savoury salad, and it totally made sense, especially if your strawberries have more of an acidic tart note than one of pure sweetness. Oregano is not a particularly Swedish herb, but it's taken to my garden like a native.

Serves 4 as a main, 6–8 as a starter /
Gluten free / Preparation time: 30 minutes /
Cooking time: 25 minutes /

350ml milk

1 tsp sea salt

350ml vegetable stock

2–3 chicken breasts (about 600g)

2 tbsp white wine vinegar

3 tbsp rapeseed or olive oil, plus a little extra

½ tsp sugar

sea salt

250g strawberries, cut in half

250g small tomatoes, cut in half

400g asparagus, trimmed

200g baby spinach, washed

a couple of sprigs of fresh oregano or thyme

Bring the milk, salt and vegetable stock to a simmer in a large saucepan. Lower in the chicken breasts and leave to simmer very gently for 20 minutes.

Meanwhile, whisk together the vinegar, the oil, sugar and ½ a teaspoon of salt. Toss gently with the strawberries and tomatoes. Bring a pot of salted water to the boil, add the asparagus, then remove after 2 minutes. Plunge the asparagus into a bowl of iced water to stop the cooking and retain the colour.

Once the chicken is done, leave to rest for 10 minutes. Prepare the asparagus and spinach by tossing them in a little rapeseed oil with a pinch of salt. Place on a large serving plate, then slice up the chicken, toss with the strawberries and tomatoes, and add to the salad. Sprinkle over the oregano or thyme leaves and serve immediately.

Top tip / Grilled halloumi cheese makes a delicious vegetarian version (make sure the halloumi is vegetarian). Cold roast chicken also works well if you have any left over in the fridge. The salad is equally nice without chicken as a side for a barbecue.

Get ahead / The chicken can be poached in advance, sliced, and kept for a couple of days in an airtight container in the fridge.

Smoked sausage stroganoff

Korv Stroganoff

This is another Swedish comfort-food classic, but one you're unlikely to see served outside of work canteens or someone's home. It's usually served with rice, but I like to serve mine with pasta and add a few (elderberry) capers to the sauce for a bit of a kick.

Serves 4 /
Preparation time: 15 minutes /
Cooking time: 30 minutes /

a knob of butter

1 large onion, peeled and finely chopped

350g falukorv or smoked sausage, very finely diced

1 tbsp tomato purée

1 tbsp Dijon mustard

1 tsp paprika

130ml single cream

sea salt and black pepper

400g tagliatelle or pappardelle

2 tbsp eldercapers (see page 287) or regular capers

a handful of finely chopped fresh chives

Bring a large pan of salted water to the boil for the tagliatelle or pappardelle.

Put the butter, onion and sausage into a large pan. Fry, stirring occasionally, until the sausage and onion are golden. Add the tomato puree, mustard, paprika and cream, continuing to stir so the flavours mingle, and simmer gently for 5 minutes. Taste for seasoning and adjust to taste.

Add the pasta to the pan of boiling water. Cook for 7 minutes (or according to packet instructions). Drain the pasta, reserving a small mugful (around 80ml) of pasta water.

Add the mug of pasta water to the sausage sauce. Stir in with the capers and take off the heat. Toss the pasta in the sauce until well coated, and sprinkle over the chives. Serve immediately.

Get ahead / The sauce can be made the day before (just don't add the chives at this stage) and then warmed up gently when you need it. You can also freeze the sauce in an airtight container for up to a month. Simply add the pasta water as stated above just before serving, and cook the pasta fresh.

Oat cookies

Havreflarn

I went to my local stationery shop the other day and it had a vacuum flask of coffee and oat biscuits out for customers. Never one to say no to a free biscuit, I had to try one; crunchy, crumbly, sweet and simple but totally satisfying, it was something I immediately wanted to recreate at home. The classic recipe uses sugar, flour and butter, but mine don't need much apart from some very ripe bananas (the riper they are, the better), as the sweetness relies on the bananas themselves. I'm partial to spreading them with a thin layer of chocolate and a sprinkle of sea salt – the biscuits started with good intentions ...

Makes 24 /

Vegetarian / Dairy free /

Preparation time: 30 minutes /

Baking time: 20–25 minutes /

Equipment: 6cm cookie cutter (optional) /

2 ripe bananas (200g peeled)

sea salt

1 tsp ground cinnamon or vanilla bean powder

150g oats

100g milk or dark chocolate, for the glaze (optional)

Preheat the oven to 220°C/fan 200°C/gas 7.

Blitz the bananas with a stick blender, along with a pinch of salt and the cinnamon or vanilla powder, until you have a smooth puree. Mix in the oats until well combined.

Line two baking trays with baking paper. Place the cookie cutter (if using) on the tray and spread a tablespoon of the oat mix evenly into the cookie cutter. Repeat until you have used up all of the mix. If you don't have a cookie cutter, you can freestyle the rounds. The trick is to get an even layer that is a couple of millimetres thick.

Bake for 10–15 minutes, or until the edges turn a deep golden brown, then flip the biscuits over and bake for another 10 minutes.

Remove and eat. Alternatively, break the chocolate up and place in a heatproof bowl over a pot of simmering water to melt. Once melted, spread a little chocolate on the flat side of the cookies and sprinkle with a little sea salt, if desired.

Get ahead / These biscuits will keep in an airtight container for several days.

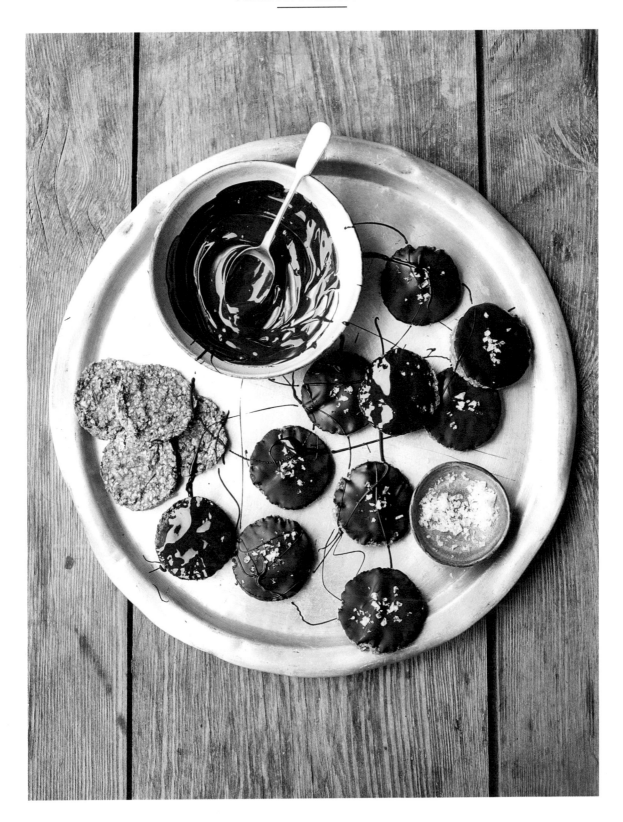

The chocolate cake the dog ate

Kladdkaka

Know the story of the boy whose dog ate his homework? Well, a similar thing happened to my chocolate cake, which was no ordinary cake. I was invited to a midsummer party one year and was asked to make a *kladdkaka*, or Swedish chocolate cake. It's a dense, muddy affair that is almost like a chocolate pudding or very gooey chocolate brownie; a good one should most definitely require a spoon in order to eat it, or if eaten with fingers must leave the telltale signs. Not a problem, I said, before I found out that this cake had to be vegan (no dairy, no eggs), gluten-free (bye-bye, flour) and nut-free (so forget the ground almonds instead of flour). This left me scratching my head and wondering how on earth I would oblige.

And so I embarked on a mission of making this free from almost everything but flavour. After a huge amount of experimenting I did succeed, only for it to be eaten by a dog at the party. The dog was fine but the cake wasn't. So it was roasted rhubarb with vegan vanilla ice cream for dessert instead.

Serves 10–12 / Vegetarian / Dairy free / Gluten free / Nut free / Preparation time: 20 minutes / Baking time: 30 minutes / Cooling time: 30 minutes / Equipment: 21cm cake tin /

For the cake:

250g dates, pitted

90ml espresso or strong coffee

80g ground flaxseeds

180ml vegetable oil

1 x 400g tin of black beans, drained (reserve 120ml of the liquid for the batter)

80g good-quality cocoa powder

2 tbsp vanilla bean paste

2 tsp baking powder

1 tsp sea salt

For the icing:

2 very ripe avocados

4 tbsp cocoa powder

4 tbsp carob or maple syrup, or to taste

a handful of mixed berries, for decorating

50g dark chocolate

Preheat the oven to 200°C/fan 180°C/gas 6. Line the cake tin with baking paper.

Roughly chop the dates, place in a small heatproof bowl, then pour over the hot coffee. Put into a food processor and blend the dates to a sticky paste. Add the rest of the ingredients for the cake, and blend until the mixture is perfectly smooth.

Dollop the mixture into the prepared cake tin and use a palette knife or spoon to smooth the top. Bake for 30 minutes in the centre of the oven. When you insert a skewer, it should still come out slightly wet. Leave to cool for 10 minutes in its tin before transferring to a wire rack to cool.

To make the icing, scoop the avocados out of their skins and blend in a food processor with the cocoa and carob or maple syrup. Taste and add more syrup to your liking.

When ready to serve, transfer to a serving plate. Use a palette knife to spread the icing over the top of the cake. Decorate with the berries and grate the chocolate over the top to finish.

Top tips / This batter can be baked in muffin cases for individual cakes. Bake for 10 minutes.

Using coconut butter will give the cake a slightly coconutty flavour, whereas a neutral vegetable oil will keep the chocolate flavour pure.

It's important to use really ripe avocados to achieve a perfectly smooth frosting.

Get ahead / The un-iced cake keeps for a couple of days when well wrapped, or can be frozen in an airtight container for up to a month.

Midsummer meringue crowns

Marängkrans

Long before Coachella and other music festivals made it hip to wear flower crowns, the Swedes were making their *midsommarkrans*. Going out on the morning of midsummer celebrations to collect local wild flowers and weaving them together into a crown is a tradition that stems from wanting to harness nature's magic, in the hope that wearing a beautiful flower crown will bring good health for the rest of the year. My experience of making crowns isn't exactly Martha Stewart worthy, so I'm not going to demonstrate how to make one in these pages. However, when it comes to making the edible kind, that's a completely different story.

Makes 4 crowns / Vegetarian / Gluten free /
Preparation time: 45 minutes /
Baking time: 1 hour 30 minutes /
Equipment: 2 piping bags, with a petal nozzle and a 1cm nozzle (nozzles optional) /

120g caster sugar

2 medium egg whites (60g), at room temperature

2–3 drops of lemon juice

150g whipping cream

2 tbsp icing sugar, sifted

1 tsp lemon zest

a few strawberries (small ones are best), blueberries, lingonberries or other berries

elderflowers, rose petals, pansies or other edible flowers

fresh mint sprigs or strawberry leaves

Preheat the oven to 200°C/fan 180°C/gas 6.

Sprinkle the sugar on to a tray lined with baking paper. Put into the oven for about 10 minutes, until the sugar just begins to melt around the edges.

In the meantime, whisk the egg whites until soft and frothy with an electric or free-standing mixer. Squeeze in the lemon juice. When the sugar is ready, turn the speed on the mixer up to high and tip in the sugar slowly, a few tablespoons at a time. Continue to whisk until the meringue is thick,

glossy, has cooled down and the sugar is fully incorporated. Spoon into a piping bag with a petal nozzle, or cut a diagonal 1.5cm opening in a corner of your piping bag (keeping the slit facing upwards).

Turn the oven down to its lowest setting, about 70°C/fan 50°C/gas ½. (You don't want the meringue to colour at all.)

Draw four 10cm circles on to a sheet of baking paper, leaving as much space as possible between them. Cut the sheet into 4 pieces, so you are left with 4 rectangles with a circle on each one. Pipe along the edge of the circle, using small circular movements, to create waves (see Top tips). Turn the piece of paper while you're piping. Place the meringues on a baking tray and bake for 1½ hours, or until crisp on the outside and the meringue peels off without sticking to the paper.

Whip the cream with the icing sugar and lemon zest until it forms soft to firm peaks. Decant into a piping bag fitted with a 1cm nozzle or snip a 1cm opening in your bag. Pipe small dollops on top of the cooled meringue and decorate with the berries, flowers and leaves.

Top tips / If you find the piping technique too complicated, simply pipe a thick ring of meringue. Make sure the flowers you use have not been sprayed and are safe for human consumption.

Get ahead / The meringues can be kept in an airtight container for a couple of days. Assemble just before serving or the cream will soften the meringue.

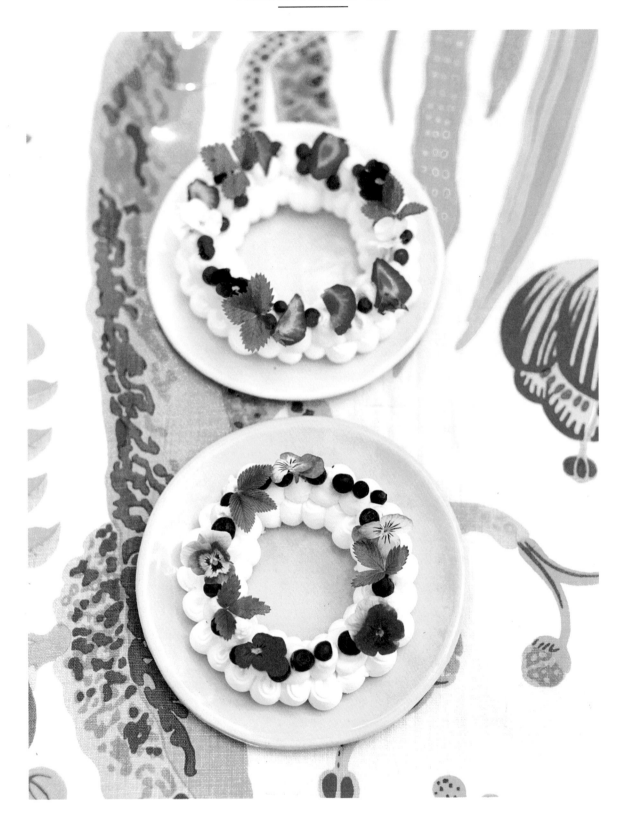

DIY wedding cake

Gör-det-själv bröllopstårta

Baking your own wedding cake is a daunting task, even when you're known for your baking, but leaving it to someone else was not an option for me. Of course, there's no way I could actually have baked it on the day or even the day before, with family and friends arriving. So in the run-up to my wedding I worked on creating a recipe that would keep well. A simple yoghurt cake, which stays moist and keeps its shape, was in order. I wanted everyone to be able to get up and dance and not fall into a food coma after the meal, so a combination of a zesty fresh lemon curd (my husband's favourite) and whipped cream cheese frosting (rather than a fondant – too sweet; or buttercream – too rich) finished the cake off.

On the day, the cake was assembled by the lovely April Carter (who is a bit of a cake expert). It was filled and iced half naked (so you could see some of the cake itself) and topped off with the same flowers (peonies) that were in my wedding bouquet.

This is by no means a cake just for grand occasions; it's simply a tasty cake that would go just as nicely with a cup of tea as a glass of Champagne.

Serves 8 or more / Vegetarian /
Preparation time: 30 minutes /
Resting time: 20 minutes /
Baking time: 50–60 minutes /
Equipment 2 x 19cm cake tins /

For the cake:

baking spray or oil, for greasing the tins

240g soft butter

250g caster sugar

4 medium eggs, beaten

175g full-fat natural yoghurt

a pinch of fine sea salt

zest of 1 lemon

320g plain flour

1 tbsp baking powder

For the lemon curd (makes roughly 450g):

125ml lemon juice, plus the zest (equivalent of 3–4 lemons)

200g caster sugar

3 medium eggs

a pinch of fine sea salt

1 tsp cornflour

100g butter

For the cream cheese icing:

300g soft butter

250g icing sugar, sifted

500g cream cheese

fresh, unsprayed flowers to decorate

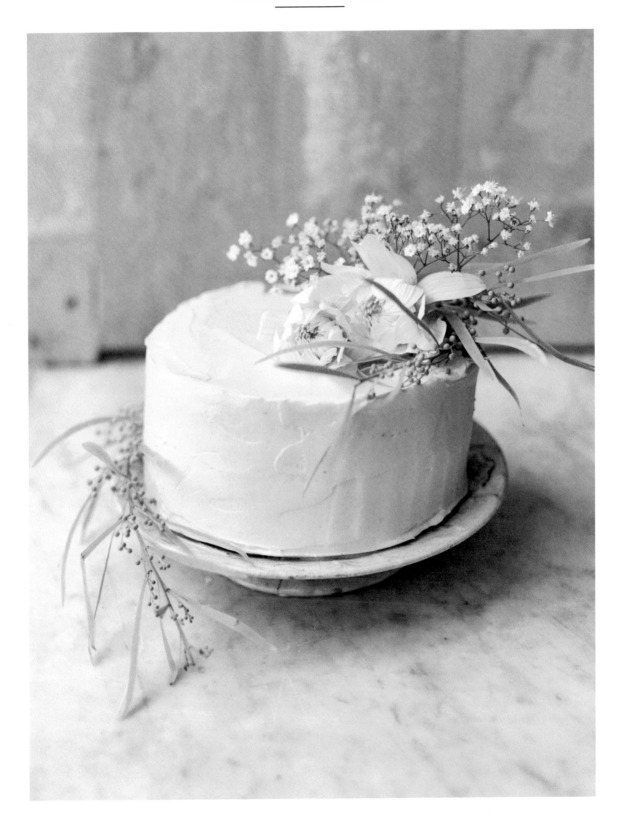

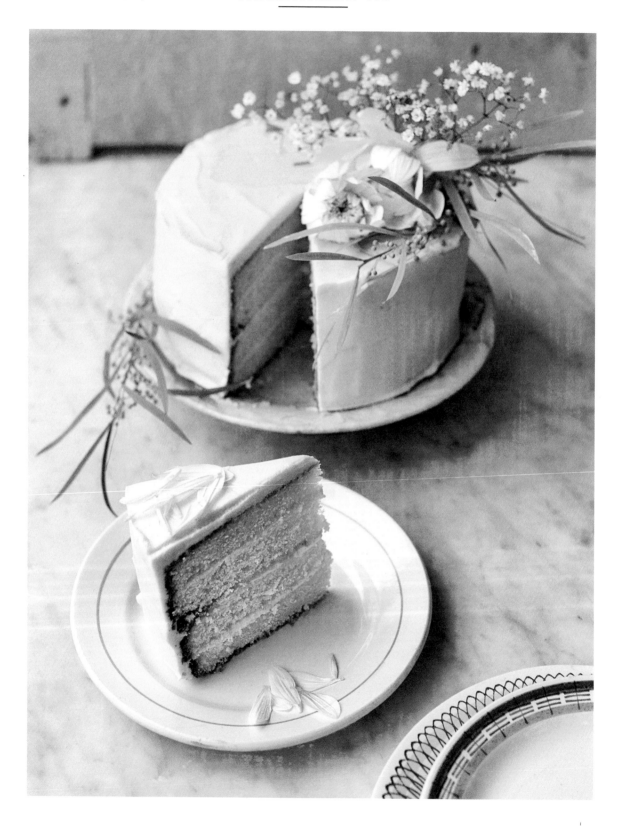

Place all the ingredients for the lemon curd, apart from the butter, in a saucepan. Whisk on a medium heat until the sugar has dissolved. Continue to whisk until one or two bubbles are released, but don't let it boil. Take off the heat and whisk in the butter. Pour through a sieve if desired (I leave the lemon zest in). Pour into a sterilized sealable jar and chill until needed. This makes more than you will need, but it keeps well for a few days.

Heat the oven to 180°C/fan 160°C/gas 4. Grease your cake tins lightly with baking spray or oil, and line the bottom with baking paper. Whisk the butter for the cake with the sugar until light and fluffy. Add the eggs, one at a time, whisking between each addition. Beat the yoghurt with the salt to remove any lumps, then pour into the egg mixture along with the lemon zest. In a separate bowl, mix together the flour and baking powder, then fold this into the egg mixture.

Divide the batter between the cake tins and bake for 30–35 minutes, or until a skewer inserted into the centre comes out clean. Transfer the cake tins to a cooling rack and leave to cool for 5 minutes before removing the cakes. Leave to cool before cutting both cakes in half horizontally with a serrated knife to make 4 layers.

Whip the butter for the icing until white and fluffy before beating in the sugar and cream cheese.

To assemble, place one layer of the cake on a serving plate. Add a generous dollop of the icing and spread out evenly. Add 2 heaped tablespoons of lemon curd and spread all the way to the sides. Add the next layer of the cake. Repeat once more. Repeat again, then add the remaining icing to the top and smooth around the sides. Decorate with the fresh unsprayed flowers.

Top tips / The cake is delicious on its own, warm out of the oven or served at room temperature.

When icing the cake, to get a neater finish I begin with a crumb layer – a coating of cream cheese icing spread over the top – and then place the cake in the fridge to firm up for 30 minutes. I then remove it from the fridge and do the final layer of icing over the top of the cold crumb layer.

Get ahead / The un-iced cake keeps very well for 2–3 days if well wrapped. You can also freeze it for a couple of months.

Lemon curd keeps for several days in the fridge.

Blueberry soup with caramelized nut clusters

*Blåbärsoppa med
karamelliserade nötter*

Long before energy drinks, there was *blåbärsoppa*, or blueberry soup: blueberry juice thickened with a little potato starch and maybe a touch of sugar. The bright yellow cartons of the shop-bought variety have gone out of fashion since the arrival of fancy smoothies, but it's still common to have a vacuum flask of this when you go for a long winter walk. I prefer to use a banana to thicken the soup rather than potato starch, and it also doubles up as a natural sweetener.

Serves 4 / Vegetarian / Gluten Free /
Preparation time: 15 minutes /
Cooking time: 20 minutes /

For the nut clusters:
100g walnuts
100g pecans
50g ground almonds
50g golden syrup
a pinch of sea salt

For the soup:
500g frozen blueberries
1 banana, sliced
a pinch of sea salt
sugar or honey, (optional)
4 heaped tbsp natural yoghurt, to serve

Preheat the oven to 200°C/fan 180°C/gas 6.

To make the nut clusters, roughly chop the nuts and toss with golden syrup and salt. Spread out across a baking sheet lined with baking paper. Bake for 20 minutes or until toasted and golden all over, stirring occasionally so they toast evenly.

In the meantime, get started on the soup. Put the blueberries and banana into a saucepan with 2 tablespoons of water and the salt. Cover with a lid and place on a medium heat for several minutes, stirring occasionally. Once the berries have melted and the mixture has started to bubble, cook for another 2 minutes. Blitz until smooth in a blender, adding a little more water until the consistency is to your liking. If your berries are quite sour, you may want to add a little sugar or honey for sweetness.

Serve either warm or chilled, poured into bowls or large mugs. Add a swirl of yoghurt and some nut clusters to the top.

Top tips / If you're planning on putting this into a vacuum flask to take out, you may want to add a little more liquid to make it easier to drink.

The soup can also be served as a hot berry sauce over vanilla ice cream.

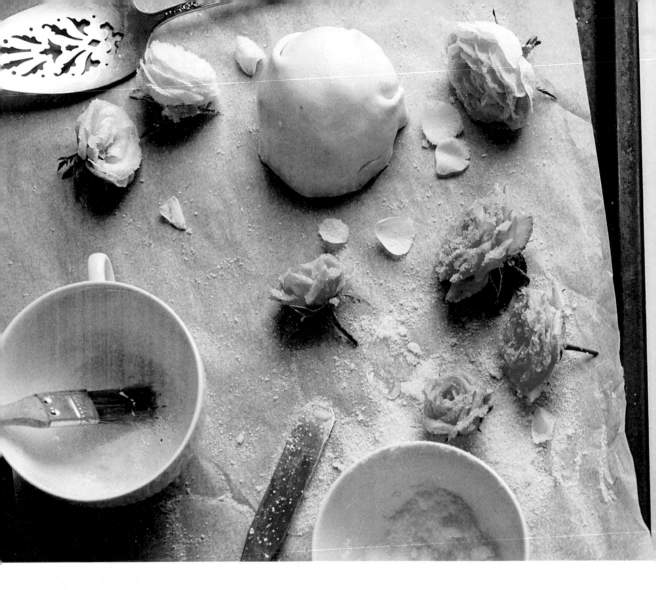

Mini princess cake with fresh roses

Mini prinsesstårta med rosor

Makes 9 / Vegetarian / Preparation time:
1 hour 30 minutes / Chilling time: 1 hour /
Cooking time: 30 minutes / Equipment: 30cm x
20cm Swiss roll tin, plus 7cm cookie cutter /

Fluorescent green topped off with a bright pink marzipan rose, the classic Swedish *prinsess-tårta* is more than a little bit kitsch. My version tones things down a touch, forgoing the food colouring in favour of pale marzipan and fresh roses. In Swedish bakeries these are often available as large cakes or slices, but here I've made cute individual cakes, ideal for a quiet teatime treat.

500ml whipping cream

80g icing sugar, sifted, plus 50g for dusting the surface

500g white marzipan

9 small rose heads or a handful of petals, unsprayed

For the custard:

3 medium egg yolks

50g caster sugar

20g cornflour

250ml whole milk

1 vanilla pod

For the génoise sponge:

50g butter, plus extra for greasing the tin

4 medium eggs

125g caster sugar

100g plain flour

For the strawberry compote:

200g strawberries, hulled

1 tbsp caster sugar

Preheat the oven to 180°C/fan 160°C/gas 4. Line a Swiss roll tin with baking paper and grease the sides with butter.

For the custard, whisk the egg yolks with the sugar until light and thick, then whisk in the cornflour. Pour the milk into a pan. Split a vanilla pod in half and scrape out the grains, using the back of a knife (save the other half for the whipped cream). Add the vanilla pod and grains to the milk, then bring to the boil and switch off the heat. Remove the vanilla pod and pour the milk on to the egg mixture in a slow stream, whisking vigorously all the time.

Return the mixture to a clean pan and continuously whisk over a medium heat. Make sure you scrape the sides and the bottom, otherwise it will burn. The custard will start to thicken. Once it releases a bubble or two, take it off the heat.

Pour on to a tray lined with cling film. Cover with cling film (pat the cling film so it sticks directly on to the custard) and refrigerate for at least 1 hour before using.

For the sponge, melt the butter, then set aside to cool. Set a large bowl over a pan of simmering water – the base of the bowl shouldn't touch the water. Crack in the eggs, add the sugar and start whisking as intensely as you can, ideally with an electric whisk. Whisk for a good 6–7 minutes, or until the mixture becomes pale and at least doubles in volume. Remove from the heat, leave to cool slightly, then fold in the flour very lightly. Stir in the butter right at the end, then carefully pour the batter into the prepared Swiss roll tin, trying not to lose too much air from the light batter. Bake on the middle shelf of the oven for 12–15 minutes, or until a skewer inserted comes out clean. Leave to cool slightly before turning out on to a wire rack to cool down fully.

In the meantime, quarter the strawberries for the compote and put into a small pan. Add the sugar and a splash of water, cover with a lid and cook over a low heat for 5 minutes. Remove the lid and cook for a few more minutes if there's still too much liquid – you want quite a thick compote. Decant into a bowl to chill.

Whip the cream to firm peaks with the icing sugar and the seeds from the remaining half of the vanilla pod.

To assemble, use a 7cm cookie cutter to cut out 9 rounds from the sponge. Use a small paring knife to cut out a small well in the centre of the rounds (this is for the strawberries to sit in). Have all the components at the ready: custard, cream, strawberries. Beat the custard to remove any lumps.

Use a spoon to dollop the strawberries into the base of each round. Spread a layer of custard over the strawberries. Add a large dollop of the cream (you want a good dome of cream, so be generous). Use a palette knife to gently form the cream into a dome. Repeat with the remaining 8 cakes, then set aside in the fridge.

Roll out the marzipan on a clean surface dusted with plenty of icing sugar to as thin as you can get it, about 1 mm. Cut out a circle about 15cm in diameter, and gently lay it directly over the top of the dome of cream. Press the sides down and trim the base. Repeat with the remaining cakes. Return to the fridge, or if eating straight away, garnish with fresh rose petals or small rose heads to serve.

Top tips / When adding the whipped cream to the top of the cake, dip a palette knife in hot water and wipe dry between spreading it. You'll get a neater finish.

You can use a favourite jam instead of the strawberry compote.

These also look pretty with crystallized rose petals. Whisk an egg white with a tiny splash of water and use a small paintbrush to brush all over unsprayed fresh rose petals. Scatter with caster sugar and leave to dry in a cool dark place for a few hours or until crisp.

Get ahead / These can be made up to 2 days in advance and stored in the fridge without the rose decoration.

Blueberry breakfast pie

Frukostpaj med blåbär

Blueberry pie has a rather American ring to it, but it's also very popular in Sweden over the summer months. During my first summer in Sweden I was so overwhelmed with the glut of blueberries I found in the forest that I ended up with the inevitable purple-stained fingers and mouth. If I ever have a piece of pie left over from the previous night, it often ends up being my breakfast, served with a dollop of thick yoghurt. This pie is a bit more wholesome than your regular pie, using wholegrain oats, which are gluten-free, (see Top tips) and bananas to sweeten the pastry. If you have a sweet tooth, you can always toss the blueberries in some caster sugar (and a tablespoon of cornflour to soak up the liquid the sugar entices from the berries).

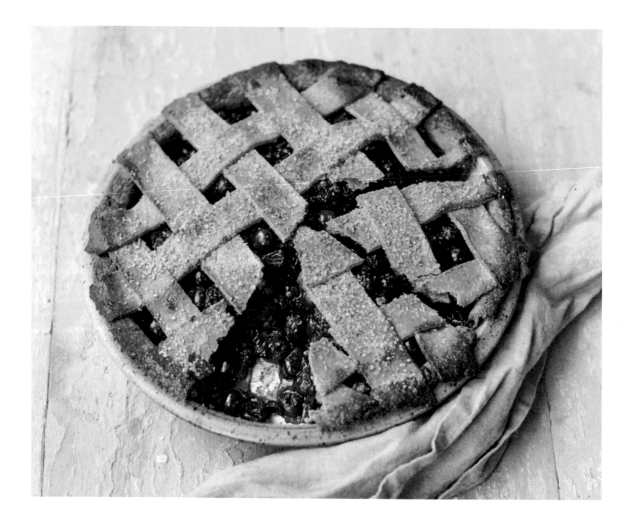

Serves 8 / Vegetarian /

Preparation time: 30 minutes /

Chilling time: 15 minutes /

Baking time: 35–40 minutes /

Equipment: 20cm pie tin or dish /

soft butter, for greasing the tin

160g soft ripe bananas, peeled

1 tbsp date or golden syrup

½ tsp ground cinnamon

a pinch of fine sea salt

250g toasted wholegrain oat flour (see Top tips)

100g cold butter, cubed

750g frozen blueberries, defrosted

1 egg, beaten, for egg wash

2–3 tbsp demerara sugar

thick yoghurt or quark, to serve

To make the pastry, mash the bananas with the syrup, cinnamon and salt. Stir in the flour and butter, then rub the mixture together with your fingertips. Once it starts coming together, press the mix into a ball. Place the pastry between two sheets of baking paper and roll out to 3mm thick. Chill for 5 minutes, then line your greased pie tin or dish with the pastry. Trim the excess pastry and roll into a ball. Roll out the excess pastry between two sheets of baking paper to a thickness of 2mm and place in the fridge. Put the pastry-lined pie tin into the freezer for 10 minutes.

Preheat the oven to 220°C/fan 200°C/gas 7. Line the pastry with baking paper and pour in baking weights. Bake for 10 minutes, then remove the baking weights and paper and bake for a further 15 minutes.

Remove the tin from the oven. Drain any excess liquid from the defrosted berries and fill the pie with them. Take the excess pastry out of the fridge and cut into strips. Lay the strips on top of the pie to create a lattice, then brush the edges and the strips with egg wash. Sprinkle with the sugar.

Bake for a further 10–15 minutes, or until the topping is golden. Serve each slice with a large dollop of thick yoghurt or quark.

Top tips / To make oat flour, simply toast wholegrain oats in a pan and leave to cool slightly before blitzing in a food processor until fine.

I use frozen berries for this pie as they're cheaper to buy in Sweden (they even have pick-and-mix frozen berry freezers at the supermarkets). You can substitute fresh berries if you prefer.

Oats are naturally gluten-free; however, during the farming process there may be some cross-contamination with equipment that is used to handle gluten grains. Therefore, if you're concerned, always check the packaging to see if the oats are processed in a gluten-free environment.

Plum Tosca cake

Toscakaka med plommon

There's a reason why the Tosca cake is such a firm Swedish favourite. Apparently named after Puccini's opera *Tosca*, this cake combines a soft tender crumb with a crispy, chewy top. Throw in some plums to add a tart note and you'll have a symphony of flavours and textures that will have your guests shouting, 'Encore, encore!'

For the cake:

150g caster sugar

100g soft butter

3 medium eggs

2 tsp baking powder

a pinch of fine sea salt

250g plain flour

1 tsp vanilla extract

9–10 plums, halved and stoned

For the topping:

50g butter

50g caster sugar

100g flaked almonds

1 tbsp rum (optional)

2 tbsp plain flour

3 tbsp double cream

a pinch of sea salt

Serves 8–10 / Vegetarian /

Preparation time: 20 minutes /

Baking time: 50–60 minutes /

Equipment: 21cm springform cake tin /

Preheat the oven to 180°C/fan 160°C/gas 4. Line your cake tin with baking paper.

Beat together the sugar and butter for the cake until pale and fluffy. Add one egg at a time, beating to incorporate. In another bowl, mix together the baking powder, salt and flour. Fold the dry ingredients into the egg mixture, along with the vanilla extract.

Pour into the prepared cake tin. Even out the mixture with a palette knife, then lay the plum halves skin side down on top of the cake. Bake for 30–35 minutes, or until the cake is still slightly wobbly in the middle.

In the meantime, make the cake topping by melting the butter. Once melted, take off the heat and mix with all the other ingredients until combined.

Take the cake out of the oven and turn the oven up to 200°C/fan 180°C/gas 6. Spread the topping over the cake and bake for 20–25 minutes, or until golden and crisp.

Top tip / The plums can be replaced with apricots, cherries and other soft fruits.

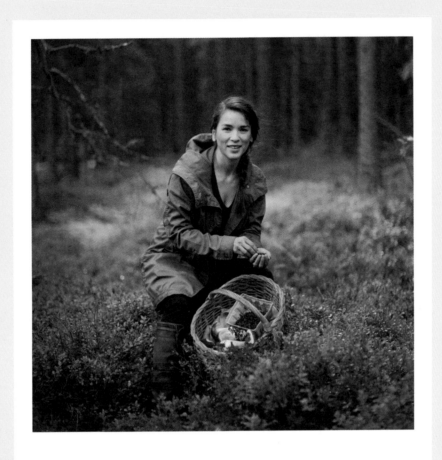

AUTUMN
höst

Autumn always creeps up quickly and startles me. Just as I'm beginning to warm up and enjoy the long days, I'll wake up one morning to a bright blue sky with a sharp chill in the air, usually towards the end of August. But with the cooler mornings comes a bounty of colours and usually mushrooms too. Suddenly the rich green hue that covers most of the Swedish countryside becomes a whole range of yellows, oranges and reds. Walk through the forest and you'll see colourful leaves falling like confetti, and if you're lucky some edible mushrooms. There's plenty of forest to discover in Sweden, since half of the country is covered in it, and the Swedes really love their forestland. They even have an expression, 'skogstokig' (literally 'forest crazy'), to mean raging mad. In the last year the term 'forest bathing' has appeared in Western media, derived from the Japanese practice of taking a short leisurely walk in a forest for health benefits. This is a term that could just as easily have come from Sweden, and to really understand the country you need to take several forest baths.

It was only when I took my first trip one autumn to the depths of the Swedish countryside, Småland, where the forests are thick and dense, that I really felt I was experiencing Sweden. After landing at Copenhagen airport, it was a two-hour train ride, over the famous bridge that has inspired a few Scandi thrillers, and then whizzing past fields, lakes and forests. I was picked up from a little countryside station and driven for what seemed like hours (but turned out to be just 45 minutes) through the thick, auburn and green forest. It was raining, which added a grey gloom to my surroundings but also gave it a mystical aura. It felt like the perfect setting for a psychological TV thriller; I was just waiting for the killer to turn up. While in the countryside, I spent the entire time hanging out with locals who grew up in the area, and gained a great insight into the country way of life.

Much like us Brits, everyone in Sweden hopes for a *Brittsommar* (an Indian summer), named after St Birgitta, or Brit for short, whose name day falls on 7 October. But otherwise it's all about embracing *höstmys*, or autumn cosiness. Get rid of the mothballs in your woolly jumpers, stock up on hot chocolate for the many *fika*-filled afternoons to come (*fika* is the Swedish coffee and cake break) and make sure you've got a big casserole pot to cook up plenty of bubbling stews (the sailor's stew on page 186 or the toasted pearl barley mushroom risotto on page 166 would be very fitting dishes). Another reason to welcome autumn is a relatively recent celebratory day that has been introduced on 4 October: *Kanelbullens Dag* – cinnamon bun day! Though frankly it's questionable whether Swedes really need a day to remind them to consume their favourite bun, considering the average Swede eats roughly 316 buns a year (see page 201 for my raspberry jam and chocolate spelt buns).

Fika – that time of day, usually mid morning or mid afternoon, when you sit down to have a coffee and a piece of cake or a bun – is truly engrained in the Swedish culture. It says it all when Pippi Longstocking, the main character in the series of classic kids' books by Swedish author Astrid Lindgren, is described consuming vast amounts of coffee and cake (though the character was created in the 1940s; I'm not sure you'd find Swedish kids drinking coffee now):

> 'First!' cried Pippi and was up by the table in two skips. She heaped as many cakes as she could
> on to a plate, threw five lumps of sugar into a coffee cup, emptied half the cream pitcher into her
> cup, and was back in her chair with her loot even before the ladies had reached the table.

All I can say is, embrace *fika* the way Pippi does!

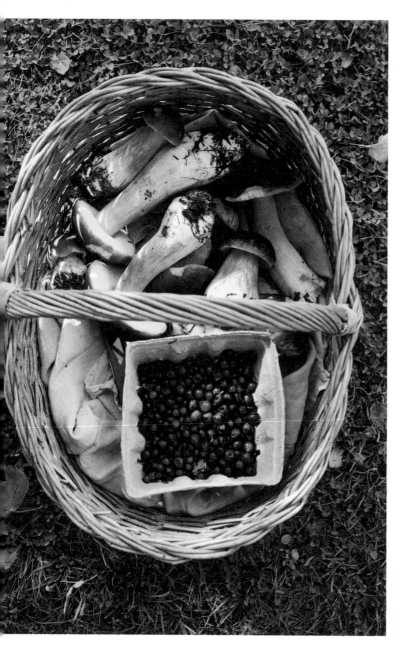

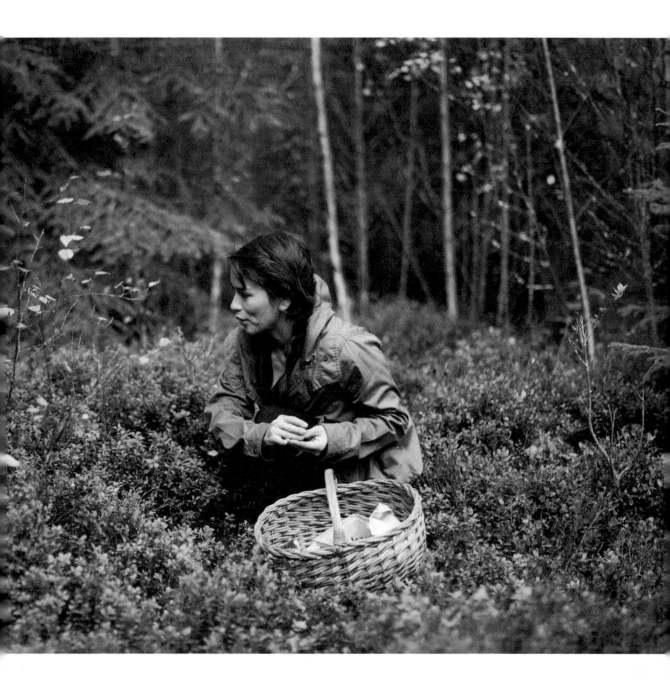

Roasted butternut squash waffles

Våfflor gjorda på rostad butternutpumpa

I had my first Swedish waffle when I visited Skansen, Stockholm's answer to a zoo and amusement park. There's plenty to see, with native animals such as moose, wild boar and lynx, and also old Swedish farm-houses where the guides (dressed in traditional costumes) demonstrate how to make typical Swedish food, from *knäckebröd* to home-smoked fish. The sweet smell of freshly made waffles enticed me past the wild-boar burger stand in pursuit of a waffle I had spotted earlier, served with a generous dollop of whipped cream and strawberry jam.

Butternut squash definitely doesn't feature in a regular Swedish waffle, but it does give it a natural sweetness, which means you can reduce the refined sugar normally added to the batter. It also gives you the option of turning this into a starter (or even a main when served with a crisp green salad) instead of serving it as a sweet.

For the waffles:

300g roasted butternut squash or pumpkin

100g cooled melted butter, plus extra for greasing the waffle iron

200g buttermilk

200ml whole milk

2 medium eggs

½ tsp ground cinnamon (optional)

1 tsp fine sea salt

200g plain flour

2 tsp baking powder

To serve as a sweet:

strawberry jam

whipped cream

To serve as a savoury option:

4–6 tbsp crème fraîche

1 red onion, peeled and finely chopped

2 tbsp finely chopped fresh chives

2–4 tbsp Kalix or other caviar

Makes 8 waffles /

Vegetarian (unless served with caviar) /

Preparation time: 15 minutes /

Resting time: 20 minutes /

Cooking time: 30 minutes /

Equipment: waffle iron /

Mash the roasted butternut squash or pumpkin and mix with the butter, buttermilk, whole milk and eggs. Sift together the remaining waffle ingredients into the bowl and fold to incorporate. Don't overmix or you'll get a heavy batter. Leave to rest at room temperature for 20 minutes.

Heat up your waffle iron, brushing with melted butter if required (no need with non-stick ones). Pour a ladle of batter into the middle. Gently close the lid and cook for a couple of minutes or until the outside is crisp (this will vary, depending on the heat of your waffle iron).

Leave to cool for a minute before topping with the garnish of your liking.

Top tip / If you don't have a waffle iron, you could make small drop pancakes instead. Heat up a non-stick frying pan on a medium heat, then pour in a small ladleful of batter. Fry for a couple of minutes on each side until golden.

Get ahead / The batter can be made the day before and chilled. Take out of the fridge 30 minutes before using, so it returns to room temperature. This ensures a lighter, fluffier batter.

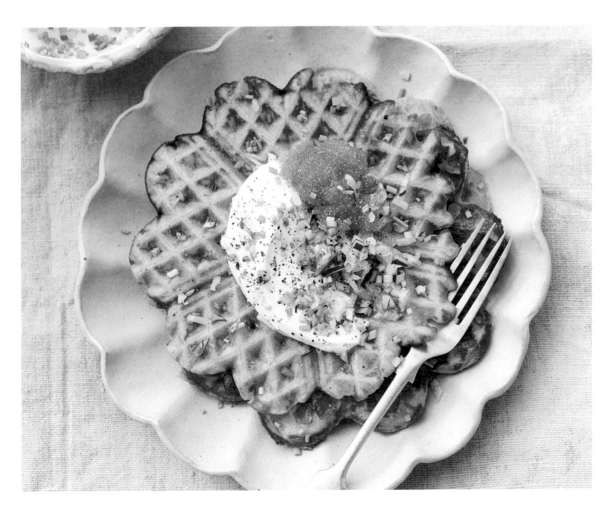

Bacon and prune stuffed apples

Äpplen fyllda med bacon och katrinplommon

Bacon fried with onions and apples is another typical Swedish comfort-food dish, one to whip up for a quick lunch with just a clutch of ingredients. It's a flavour combination you can't go wrong with. Adding the prunes gives a touch of sweetness and turns this into a lovely little appetizer.

Serves 4–6 /
Preparation time: 20 minutes /
Cooking time: 30 minutes /

1 slice of bread

4 rashers of smoked streaky bacon, finely chopped

2 knobs of butter

½ tsp ground allspice

1 red onion, peeled and very finely chopped

4 medium or 6 small apples

4 soft prunes, finely chopped

2 tbsp finely chopped parsley leaves

Preheat the oven to 170°C/fan 150°C/gas 3. When the oven is ready, put the slice of bread on a baking tray and place in the oven. Once the bread is dry and crisp, remove.

Put the bacon, a knob of butter, the allspice and the red onion into a frying pan over a medium heat. Fry until soft and golden, then remove and put into a bowl. Set aside the pan for later (don't wash it up quite yet).

Trim the top off one of the apples. Use a spoon to scoop out a couple of tablespoons of the core and the apple flesh, discarding the core and pips. Be careful not to scoop too close to the outside of the apples. You want to create a wall that is several millimetres thick. Repeat with the other apples.

Take some of the scooped-out apple flesh and finely chop, then add to the bacon bowl along with the prunes. Mix well, then stuff the mixture back into the apples before putting the lids back on. Put the apples into a baking dish then into the oven. Bake for 15–20 minutes or until the apples are soft but still holding their shape.

Meanwhile, grate the bread roughly and add to the frying pan with a knob of butter. Fry for 2–3 minutes or until just golden brown.

To serve, place an apple on a plate and sprinkle over some of the breadcrumbs and parsley.

Get ahead / The apples can be stuffed and baked a couple of hours ahead of time and kept in the fridge until needed. I reheat them before serving.

Porcini toast with bacon and thyme

Karljohansvamps-toast med bacon och timjan

When autumn arrives, I head to the forest. Småland, where my husband is from, is famous for its vast forests (and for being the birthplace of Ikea, among other things). When the porcini bounce up from the forest floor, I grab my basket and wellies and go on the hunt. If I can get to them before the other savvy locals, I like to eat them raw with little more than a drizzle of fat from the bacon pan and a sprinkling of thyme from the garden.

1 tbsp rapeseed oil

8 rashers of smoked streaky bacon

2 porcini mushrooms

2 large slices of sourdough bread

2 knobs of butter

4 sprigs of fresh thyme (flowering if available)

black pepper

Serves 2 /
Preparation time: 5 minutes /
Cooking time: 5–10 minutes /

Put the oil into a large non-stick frying pan over a medium heat. Lay the rashers of bacon out flat across the pan (do this in batches if you don't have space to lay them all out flat), and cook on both sides until crispy. While the bacon is cooking, slice the porcini finely using a mandolin or a sharp knife and toast the bread.

Butter the toast, then place on a plate. Add 2 slices of bacon to each slice of toast, then add the sliced porcini. Drizzle the pan juices over the porcini and top with the remaining bacon. Scatter with the thyme leaves (and flowers, if available). Season with black pepper and serve immediately.

Squash pancakes

Raggmunk

Lying somewhere in between a Swiss rösti and an English pancake, this Swedish recipe typically mixes grated potato (replaced here with butternut squash) with a pancake batter. It's usually served with a generous helping of lingonberries, grated carrot and crispy bacon, or, for a sweet version, you could top it with apple compote and a dusting of cinnamon, a dollop of crème fraîche or a scoop of vanilla ice cream.

Serves 4–6 /
Preparation time: 15 minutes /
Cooking time: 30 minutes /

400ml whole milk

2 medium eggs

½ tsp fine sea salt

200g plain flour

600g butternut squash (unpeeled weight)

2 carrots

2 knobs of butter

8 cooked rashers of smoked back bacon, to serve

lingonberry jam (see page 290), to serve

In a large bowl, whisk the milk, eggs and salt together. Sift in the flour and mix together until there are no lumps. Leave to rest while you peel and roughly grate the squash and carrots, keeping the carrots separate. Mix the squash with the batter and set aside the carrots for later.

Preheat the oven to 145°C/fan 125°C/gas 2. Add a knob of butter to a non-stick frying pan. Once it begins to sizzle, ladle in some batter. Spread the batter out a little so each pancake is roughly 9cm in diameter. Cook for 2–3 minutes or until golden brown, then flip and cook for another 2–3 minutes. Keep the made pancakes warm in the oven while you make the rest.

Serve with crispy bacon, the grated carrots and a dollop of lingonberry jam.

Top tips / Sweet potato, pumpkin and carrot can replace the butternut squash.

If you have odd bits of cheese in the fridge, grate and mix into the batter for an extra flavour punch.

Brown beans on toast

Toast med bruna bönor

I have lots of fond memories attached to baked beans on toast. It was my go-to food when I lived in Paris and craved a bit of British comfort, in the form of hot baked beans atop a crunchy fresh baguette slathered in plenty of butter. Since moving to Sweden I've discovered a Swedish version of baked beans. The Swedish brown bean sits in a sweet, tart sauce. Although the traditional way of serving this is as a side to thick slices of bacon (it's also a popular dish to serve on the *julbord* Christmas buffet), I prefer the beans on a thick slice of sourdough, which, of course, I top with a generous stroke of soft butter.

For the brown beans:

sea salt

200g dried Swedish brown beans or
 kidney beans (see Top tip)

1 cinnamon stick

1 tbsp potato flour or cornflour

1 tbsp cider vinegar

1–2 tbsp molasses

To serve:

sourdough bread

soft butter, for spreading

4 soft-boiled eggs

sprigs of fresh thyme

Serves 4 / Vegetarian /
Preparation time: 10 minutes /
Soaking time: 8 hours or overnight /
Cooking time: 1½ hours /

Stir 1 tablespoon of salt into 2 litres of water until it dissolves. Add the beans and leave to soak overnight or for at least 8 hours.

Drain the beans and put them into a medium pan with 1 litre of water. Add a pinch of salt and the cinnamon stick. Cover the pan and cook for an hour and a half or until the beans are tender but still have a bite (if you prefer the more traditional mushy consistency, cook for a little longer).

Mix the potato flour or cornflour with 2 tablespoons of water to make a paste, then stir this into the hot cooked beans. Quickly bring to the boil and take off the heat. Add the vinegar and 1 tablespoon of molasses. Taste for seasoning, adding more molasses and salt if desired.

To serve, ladle the beans over toasted and buttered bread and top each portion with a soft-boiled egg and a few sprigs of thyme.

Top tip / Dried Swedish brown beans can be ordered online. If you can't find them, use kidney beans and reduce cooking time to 45–60 minutes.

Get ahead / The beans can be made in advance and frozen in an airtight container for several months. Reheat with a little extra water.

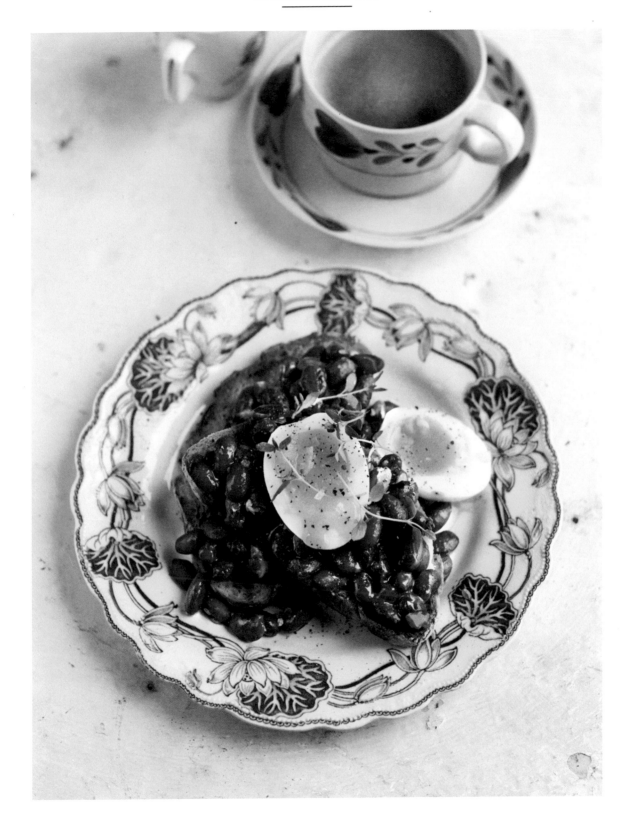

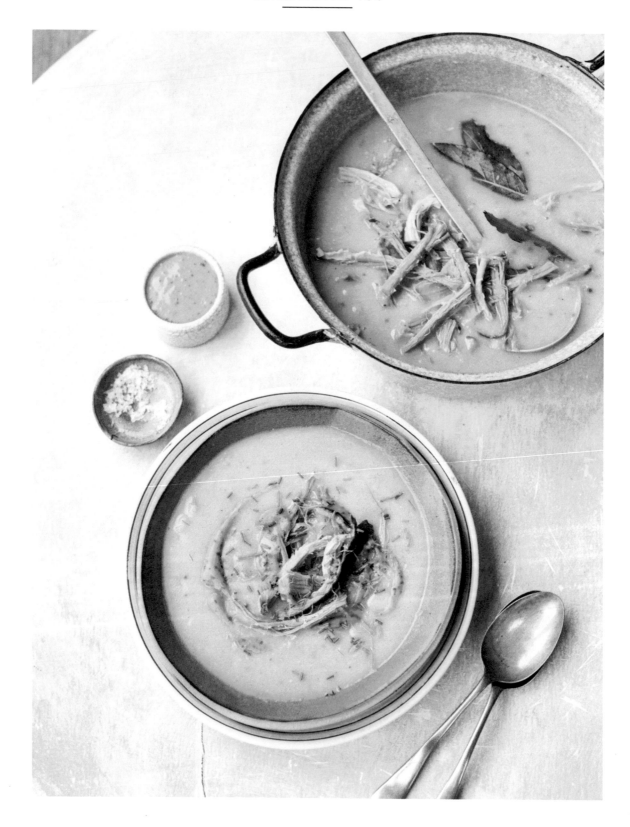

Yellow pea soup

Ärtsoppa

I first discovered this soup at the home of some friends in Skåne, the southern part of Sweden. We had spent the day outside, enjoying the beautiful nature around us despite the bitter cold. When we came back with rosy cheeks, runny noses and a large rumble in our stomachs, this soup was the perfect way to warm up from the inside out. A healthy squeeze of sweet Swedish mustard on top is a must.

Serves 6 / Gluten free /
Preparation time: 15 minutes /
Soaking time: 6 hours or overnight /
Cooking time: 1½–2 hours /

sea salt and black pepper

500g whole yellow peas

1 tbsp rapeseed oil

2 tbsp yellow mustard seeds

250g smoked bacon (in one piece)

4 bay leaves

1 tsp onion powder

sweet mustard (see page 15), to serve

Stir 3 tablespoons of salt into 3 litres of water until it dissolves. Add the yellow peas and leave to soak for at least 6 hours or overnight.

Drain the peas, reserving 2 litres of the soaking liquid. Put the rapeseed oil into a large stockpot over a medium heat and add the mustard seeds. Toast until the aroma is released.

Add the bacon, drained peas, bay leaves, onion powder and the reserved 2 litres of soaking liquid. Simmer for 1½–2 hours or until the peas are tender. Remove the bacon and bay leaves, then use a stick blender to blitz the soup. I like to leave it a bit chunky. Add more water if the soup is too thick.

Shred the bacon, discarding the fat and tough skin, and put the shredded meat back into the soup. Taste for seasoning, and add salt and black pepper if desired.

Serve with a squeeze of sweet mustard.

Top tip / Yellow peas, which require soaking, are more commonly found in Sweden than split yellow peas. You can purchase them online. If using yellow split peas, no soaking is required. Simply add 2 litres of water to the stockpot and simmer for 40–45 minutes or until tender.

Get ahead / I often make a double portion of this and freeze half of it. It will also keep for several days in the fridge.

Toasted pearl barley mushroom risotto

Svamppölsa

A northern Swedish dish, *pölsa* is made with pearl barley in almost the same way that Italians use Arborio rice to make risotto. The pearl barley is cooked with stock to make a thick porridge, then crispy fried mince and beetroot are added and it's all topped off with a fried egg – though I've omitted these and topped it with mushrooms instead. It's not exactly a dish that would be an Instagram viral hit, but with its nutty flavour the barley base is a delicious alternative to rice, and the ideal match for some autumnal chanterelles.

Serves 4–6 / Vegetarian /
Preparation time: 30 minutes /
Cooking time: 30 minutes /

280g pearl barley
3 knobs of butter
1 onion, peeled and finely chopped
sea salt
1 carrot, peeled and finely chopped
1 tsp ground allspice

1½ litres hot vegetable or chicken stock
200g chanterelle mushrooms, brushed clean
a handful of chopped fresh parsley leaves
5 tbsp sour cream
50g Västerbotten, mature Cheddar or Parmesan cheese, grated

Put the pearl barley into a large dry pan and toast for about 3 minutes until golden brown, tossing regularly. Remove from the pan and set aside. Put a knob of butter into the pan and add the onion and a pinch of salt. Sweat for 5 minutes over a low heat, then add the carrot and allspice. Continue to fry until the onion is soft. Add the stock and the toasted barley and cook for a further 20 minutes or until the barley is tender. Stir occasionally and top up with extra stock if it dries out.

Put 2 knobs of butter into another pan and when it starts to sizzle, throw in the mushrooms. Season with salt. Fry for a couple of minutes over a high heat until golden, then sprinkle with most of the parsley.

Just before serving, stir the cream through the risotto. Divide the risotto between bowls and scatter over the mushrooms. Grate a little cheese over the top and sprinkle with the remaining parsley.

Top tip / The risotto makes an excellent base for lots of different toppings or vegetables. Sometimes I throw a handful of frozen peas into the mix or top it with flaky smoked fish instead of mushrooms. This is a great one to cook when you have leftovers in the fridge.

Autumnal
Buddha bowl

Höstig Buddha bowl

Autumn always arrives too early for my liking. Just when I'm getting used to the longer, sunnier days, I'll wake up to a cold snap and the leaves on the trees shimmying their way down. With the change of temperature also comes a change of appetite: I want something a little heartier than the lighter summer fare. This is a bowl of goodness that celebrates the abundance of the autumnal forest fungi.

320g spelt or wild rice

1 tbsp extra virgin olive oil

sea salt and black pepper

1 tbsp cider vinegar

1 tsp caster sugar

1 small apple

1 large carrot, peeled into ribbons

200g mixed wild mushrooms
 (such as chanterelles, porcini, girolles)

2 tbsp rapeseed oil

a knob of butter

zest of ½ a lemon

4 eggs

pink pickled onions (see page 286)

3 tbsp sunflower seeds, toasted

Serves 4 / Vegetarian /
Preparation time: 20 minutes /
Cooking time: 15–20 minutes /

Bring a small pan of salted water to the boil. Add the spelt and cook for 15–20 minutes, or until tender but with a little bite. Drain and place in a bowl, then dress with the extra virgin olive oil and a generous pinch of salt.

Meanwhile, in another bowl, mix the cider vinegar with the sugar and a pinch of salt and stir to dissolve. Core and thinly slice the apple, then add to the bowl together with the carrot ribbons and toss in the vinegar to coat lightly.

Brush the mushrooms and chop into bite-sized pieces, leaving the smaller ones whole. Heat the oil and butter in a frying pan and, once hot, add the mushrooms (cooking in batches if the pan is too crowded). Cook until golden and sprinkle over the lemon zest.

Cook the eggs for 5½ minutes in a pan of boiling water. Drain and run under cold water.

To assemble, divide the spelt between four bowls. Add the ribbons of carrot and apple, some pickled onions and the wild mushrooms. Cut the eggs in half and place on top. Scatter with the toasted seeds and some black pepper, and serve.

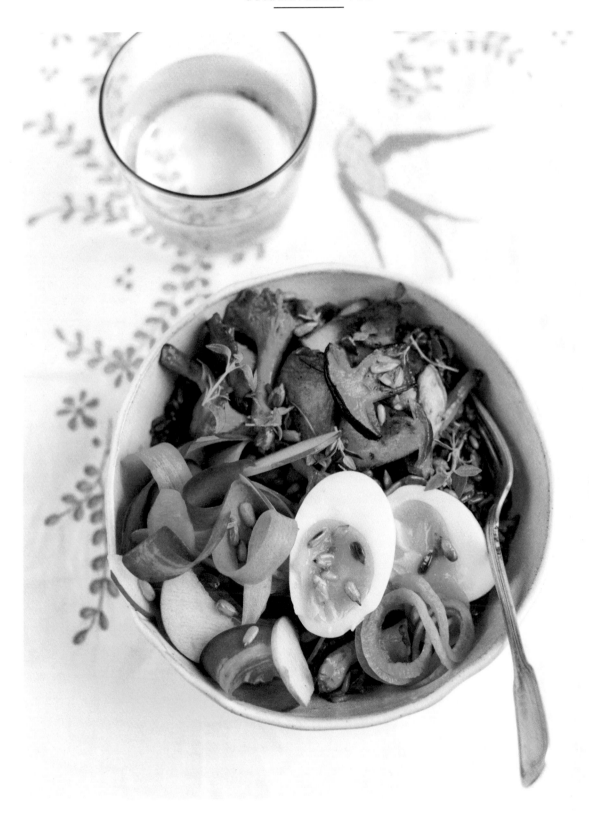

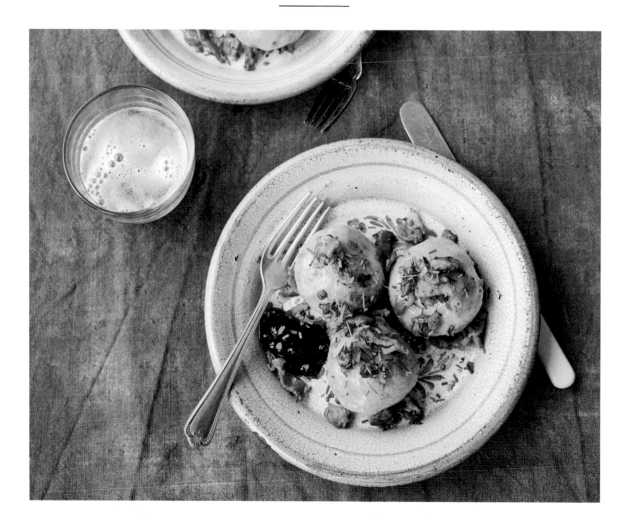

Potato and pea dumplings

Kroppkakor

These tennis-ball-sized potato dumplings are the Björn Borg of the dumpling world. They are old-school champions, and can be boiled or fried, filled or unfilled (and differ in other ways, depending on which regional variety you make: Smålandska dumplings sink when they are initially boiled and rise to the top when they are finished, whereas those from Öland, an island off the east coast of Sweden, do the opposite). Peas aren't usually added, but I like the way they give the otherwise grey-looking dumpling a lovely green pop. I've skipped the filling in this recipe, instead piling them high with a salty, sweet and spicy topping.

Serves 4–6 / Gluten free /

Preparation time: 1 hour /

Cooling time: 15 minutes /

Cooking time: 40 minutes /

For the dumplings:

300g potatoes

300g frozen peas

sea salt

2 medium eggs

½ tsp freshly grated nutmeg

300–350g potato flour

For the topping:

a knob of butter

1 tsp ground allspice

1 tsp white pepper

250g smoked streaky bacon, finely chopped

1 onion, peeled and finely chopped

a handful of chopped fresh chives

sugared lingonberries or lingonberry jam
 (see page 290)

Fill a large saucepan with cold salted water and peel the potatoes. Put the potatoes in the pan, bring to the boil and simmer for 15 minutes or until tender, then drain and leave to cool slightly.

Meanwhile, put the frozen peas into another pan with 1 tablespoon of water. Cover and cook for about 2 minutes, until just tender. Drain and blend to a smooth paste in a food processor. Finely grate the potatoes, then mix with a pinch of salt, the blitzed peas and eggs. Add the nutmeg and 300g of the flour and stir to combine, only adding more flour if you need it – the dough should be firm.

Bring a large pot of water to the boil with a generous pinch of salt. While it's coming to the boil, roll the dough into a long sausage and cut into 12 equal pieces, then roll each one into a ball.

Next, make the topping: put the butter into a large frying pan over a medium heat and add the spices, bacon and onion, cooking until the onion is crisp and golden. While the bacon and onion are frying, add the dumplings to the boiling water and cook for 5–10 minutes, or until they are firm but bounce back when touched. If you are unsure, cut one open: the dumpling should be cooked and hot all the way through.

Serve immediately with a generous heap of the topping, a sprinkle of chopped chives and some sugared lingonberries or lingonberry jam.

Get ahead / The dumplings can be frozen after they've been boiled. Plunge into boiling water to defrost and reheat.

Pan-fried duck breasts with elderberry sauce and buttered spinach

Stekt ankbröst med smörslungad spenat och flädersås

What grows together belongs together in the pan: this can certainly be said about mallard (wild duck) and elderberries, both in abundance in the autumn. Small game such as mallard can often be found on the Swedish dinner table. A lot leaner than its farm-raised cousin, mallard is best pan-fried with some butter. I've tried this recipe with both types of bird, and the tart elderberry sauce goes deliciously with either. Pictured overleaf is Gressingham duck (farm-raised), which gets a crispier skin due to its thick layer of fat.

Serves 2 as a main, 4 as a starter /
Gluten free / Preparation time: 30 minutes /
Cooking time: 1 hour /

340g duck breasts (2–3 depending on size), skin on

For the elderberry sauce:
1kg fresh elderberries, washed
250ml red wine vinegar
a knob of butter
5 cracked black peppercorns
3 juniper berries
1 tsp caster sugar
1 red onion, peeled and finely sliced
sea salt

For the buttered spinach:
500g frozen spinach
a knob of butter
½ tsp freshly grated nutmeg

Preheat the oven to 200°C/fan 180°C/gas 6. Take the duck breasts out of the fridge and set aside.

Place the elderberries and vinegar in a baking dish and bake for 30 minutes. Line a sieve with an old but clean tea towel (one you don't mind ruining) and press the berries through it to collect the juice.

Put a knob of butter, the cracked black peppercorns, juniper berries, sugar and red onion into a pan and fry until the onion is soft. Add the elderberry juice and simmer for 20 minutes, or until the sauce has thickened to the consistency of single cream or coats the back of a spoon and looks glossy.

In the meantime, score the skin of the duck breast with a sharp knife – don't slice all the way to the flesh when scoring – then season liberally with salt. Place a large frying pan over a high heat. When the pan is so hot that you can't hold your hand over it, place the duck breasts, skin side down, in the pan and turn the heat down to medium-high. Fry the breasts for 4–5 minutes on each side or until golden brown and cooked to

your liking. You may want to drain off some of the fat while cooking, but don't throw it away – duck fat is excellent for roasting potatoes. Once the duck is cooked to your liking, remove the breasts from the pan, wrap them in foil and leave to rest on a warm plate for 10 minutes.

Put the frozen spinach and a couple of tablespoons of water into a saucepan. Cover and cook for 5 minutes, then swirl in a knob of butter. Season with the nutmeg and some salt to taste.

Slice the duck breasts, place alongside a heap of buttered spinach and serve with the sauce.

Top tip / Mallard (wild duck) is a lot leaner than farmed duck and will require either some butter or oil to fry in.

Get ahead / The elderberry sauce can be made a couple of days in advance and kept in the fridge in an airtight container. You can warm up the sauce gently in the same pan you have used to fry the duck breasts.

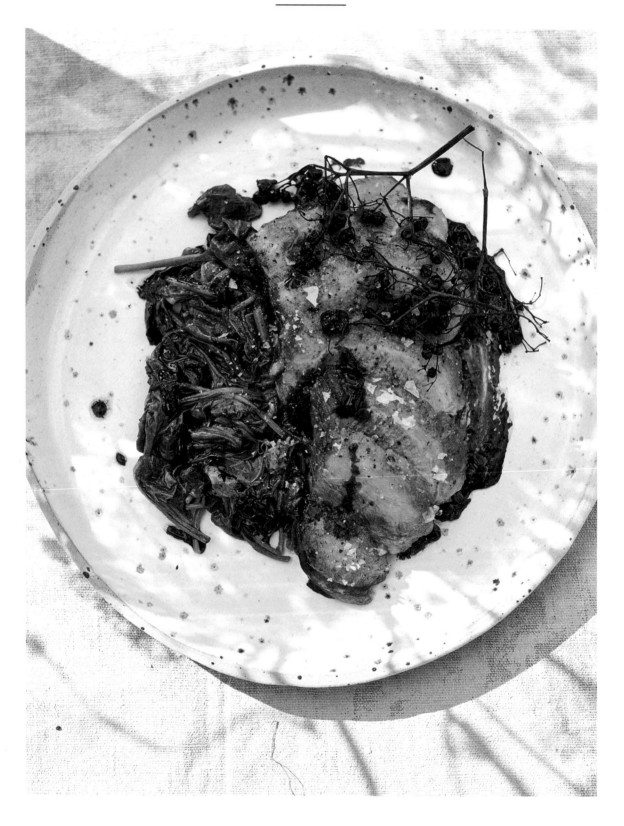

Venison 'saltimbocca'

Hjort 'saltimbocca'

Hunting is a huge part of the Swedish culture, so game meats are in turn an important part of Swedish cooking. I have some friends who grew up in remote areas where eating game was an everyday occurrence, while a roast chicken was for special occasions. It makes sense when you live in far-flung parts of the country (Sweden is over 1,500km long — its length if turned on its head would reach to Rome — and has only 10 million inhabitants) to turn to what is around you rather than drive 45 minutes to the closest supermarket.

Serves 2–4, with sides / Gluten free /
Preparation time: 5 minutes /
Cooking time: 15 minutes /

4 x 100g venison loin medallions
a knob of butter
3 red onions, peeled and thinly sliced
sea salt
12 fresh sage leaves
8 rashers of smoked streaky bacon
1 tbsp rapeseed oil
125ml white wine

Remove the venison from the fridge for 30 minutes before cooking to get it to room temperature.

Heat the butter in a frying pan. Add the onions and a pinch of salt and sweat over a low heat for 10–15 minutes until soft. Set aside.

In the meantime, line a chopping board with cling film. Place the venison over the top, then put another layer of cling film over the meat. Use a rolling pin to bash the venison pieces until 1cm thick. Press a few sage leaves on top of each venison medallion, then wrap 2 bacon rashers around each of the pieces and secure with a toothpick or wooden skewer.

Place a large frying pan over a medium heat. Once hot, add the oil and cook the venison for 3–4 minutes on each side. In the last 2 minutes of cooking, deglaze the pan with the wine. Simmer for 1 minute, then return the onions to the pan to warm through. Remove the meat to a plate and leave to rest for 2 minutes before slicing.

Pour any resting juices over the venison and serve with the onions and some sautéed potatoes.

Get ahead / You can prep the venison the day before you want to cook it and keep it well wrapped in the fridge.

Meatballs

Köttbullar

Yes, here they are, the famous Swedish meatballs, probably Sweden's biggest culinary export. Even my cousins in Singapore went all the way to Ikea to eat them, such is their culinary reputation, but they aren't just for people stocking up on tealight candles and flat-pack furniture. Swedish meatballs are truly part of everyday Swedish eating. When I was invited to dinner at a friend's with a bunch of kids under three to feed first, they were served a child-friendly version (no salt), with pasta tossed in butter and some steamed broccoli. It was fun to see the ten-month-old happily gnaw at a meatball with his four teeth. This dinner left me quite inspired, and also made me think that this cookbook needed a classic Swedish meatball recipe (although the bean balls are very tasty too – see page 182). Note that the quantity here makes a double batch of meatballs (see Get ahead).

For the meatballs:

1 tsp fine sea salt

1 tsp white pepper

2 tsp sweet mustard (see page15)

1 medium egg

2 tsp onion powder

1 tsp ground allspice

75ml single cream

50g breadcrumbs

250g beef mince

250g pork mince

2–3 knobs of butter

For the gravy:

3 tbsp butter

3 tbsp plain flour

500ml beef stock

100ml single cream

sea salt and black pepper

Serves 4 (makes 40–48 meatballs,
 enough for 8) /
Preparation time: 30 minutes /
Cooking time: 30 minutes /

In a large bowl, mix the salt, white pepper, mustard, egg, onion powder, allspice and cream. Add the breadcrumbs and let it sit for 10 minutes, so the breadcrumbs absorb the liquid. Mix the mince with the soaked breadcrumbs until well combined. Roll into small, bite-sized balls. You should get about 40–48 meatballs from this quantity.

Preheat the oven to 150°C/fan 130°C/gas 2. Place a large frying pan over a medium heat, add a knob of butter and fry the balls in batches for about 10 minutes, until golden all over. Once cooked, place in a baking dish, cover with foil and place in the oven to keep warm while you make the gravy.

Heat the 3 tablespoons of butter in a saucepan. Once melted and frothy, add the flour and beat over the heat for 1–2 minutes until it starts to colour and form a paste. Whisk in the stock and bring to a simmer, whisking continuously, until it thickens enough to coat the back of a spoon. Add the single cream and stir through. Cook for 2 minutes, then remove from the heat.

Serve the meatballs with a few spoonfuls of the gravy, alongside sliced pickled cucumbers (see page 288), lingonberries and creamy mash or boiled potatoes.

Get ahead / This quantity makes a double batch of meatballs, as they are super-handy when you need something quick for dinner. I've also added them to a rich tomato sauce for an Italian spin on the Swedish classic. To freeze them, first cook, then leave to cool before putting into the freezer in a container. To reheat from frozen, place in a baking dish covered with foil and cook in the oven at 200°C/fan 180°C/gas 6 for 30 minutes, or until a metal skewer inserted into a meatball comes out feeling hot.

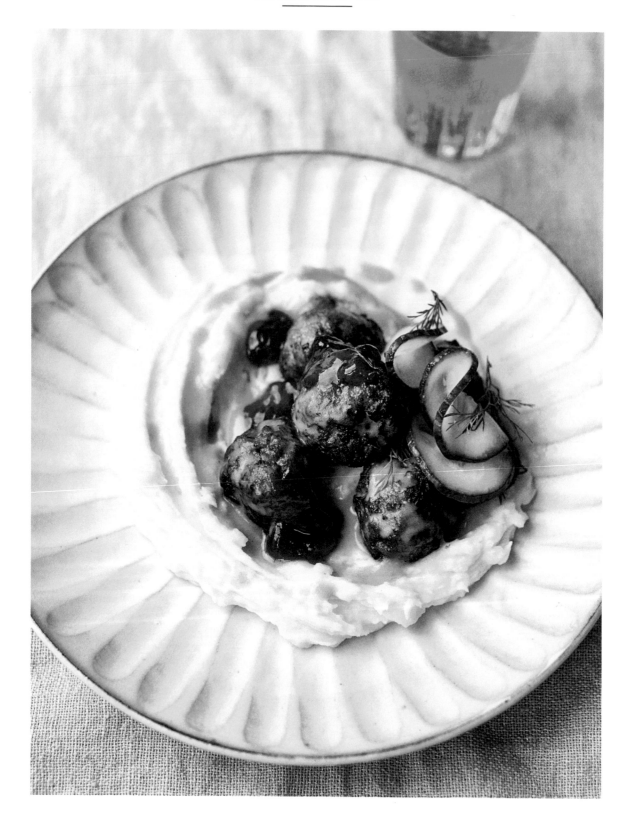

Swedish bean balls with butterbean mash

*Vegetariska köttbullar med mos
på vita bönor*

When I began writing this cookbook, this was the recipe I started with. I'm always trying to find ways to consume less meat, and this vegan version of the Swedish classic does a good job of fooling people when you serve it with the true traditional sides: mash, creamy gravy, lingonberry and pickled cucumber (in essence, these are what make the Swedish meatball truly Swedish). My Swedish friends insisted I include a classic recipe too, which you'll find on page 178.

Serves 4–6 / Vegetarian /
Preparation time: 1 hour /
Cooking time: 30 minutes /

For the bean balls:
20g dried porcini mushrooms
rapeseed oil
250g button mushrooms, finely chopped
1 small onion, peeled and finely chopped
1 tsp ground allspice
½ tsp black pepper
½ tsp sea salt
2 tbsp ground flax seeds
100ml water from one of the tins of beans
1 x 400g tin of black beans, drained
1 x 400g tin of kidney beans, drained
75g breadcrumbs

For the butterbean and cauliflower mash:
1 head of cauliflower, leaves removed
1 x 400g tin of butter beans, drained
50ml double cream or non-dairy alternative
sea salt and white pepper

For the gravy:
2 tbsp cornflour
1 tsp Marmite or yeast extract
black pepper
30ml double cream or non-dairy alternative
juice of ½ a lemon

To make the bean balls, soak the dried porcini in 500ml of hot water for 30 minutes. Meanwhile, place a large frying pan over a medium heat. Add 1 tablespoon of oil, the button mushrooms and the onion and fry for 10 minutes or until soft.

While this is cooking, whisk together the allspice, pepper, salt and ground flax seeds with the 100ml of water from one of the bean tins. Add the beans and use a potato masher to mash it all up.

Start preparing the mash by cutting the cauliflower into florets and placing in a steam basket. Steam for 10 minutes or until the florets are tender, then set aside, covered, until needed.

Drain the porcini (keep the water for later), finely chop the mushrooms and mix with the mashed-up beans, breadcrumbs and button mushroom mixture. Roll into small, bite-sized balls.

Preheat the oven to 120°C/fan 100°C/gas ½. Put 1 tablespoon of rapeseed oil into a pan over a medium heat. Fry the balls in the pan for several minutes or until crispy on all sides. Place into a baking dish, cover with foil and keep warm in the oven while you make the gravy.

You can make the gravy in the same frying pan that you used for the meatballs. Mix a couple of tablespoons of the porcini liquid with the cornflour and set aside. Pour the rest of the porcini liquid into the frying pan with the Marmite and a generous amount of black pepper. Whisk in the cornflour mixture, and bring to a boil while continuing to whisk.

Once the gravy has thickened, take off the heat. Whisk in the 30ml of cream and add a few drops of lemon juice. Taste and add more lemon juice and salt if required.

To finish off the mash, use a stick blender to blitz the cauliflower with the butter beans, the 50ml of cream and some salt and white pepper. Warm the mash in a saucepan over a low heat and adjust the seasoning to taste.

To serve, spoon a serving of mash into a bowl and add a few bean balls. Add a ladleful of the gravy and serve with lingonberry jam (see page 290) and pickled cucumbers (see page 288).

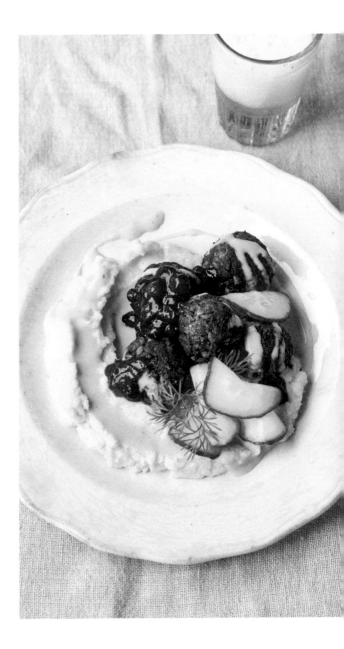

Get ahead / The uncooked bean balls can be frozen on a tray. Once frozen, transfer them to a bag. They can be cooked from frozen as above, but add a couple of minutes to the cooking time.

Boar burritos

Vildsvinsburritos

Over the past decade in Sweden there's been such a rise in the population of wild boar that they are now commonly found digging up people's gardens. Unlike places like Corsica, which has a long history of cooking with boar and is known for its delicious cured sausages, in Sweden boar has only recently started to appear on restaurant menus or at the super-markets. It's similar to pork but richer in flavour. I often make this recipe as it doesn't require much attention and is less daunting for any guests who are new to eating game.

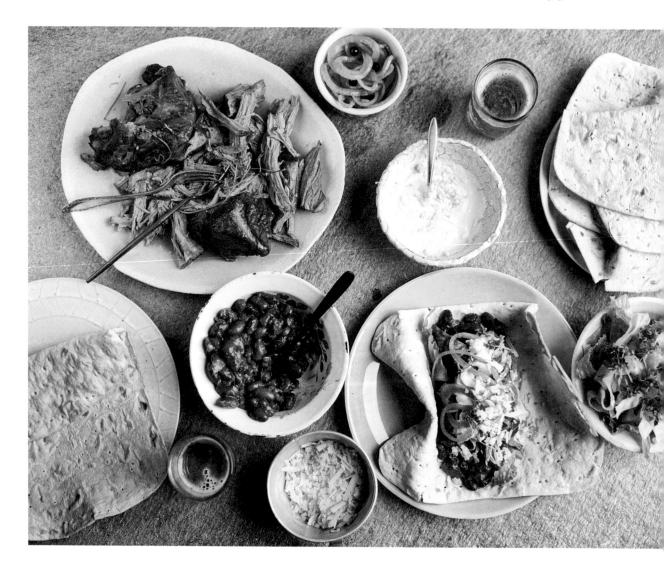

Serves 6–8 /

Preparation time: 30 minutes /

Cooking time: 2 hours /

fine sea salt

1 tsp white pepper

1 tsp ground allspice

1 tsp onion powder

1.2kg wild boar or pork shoulder, deboned

2 tbsp rapeseed oil

1 litre hot chicken stock

a few sprigs of fresh thyme

a thumb-sized piece of horseradish

250g sour cream

1 small head of romaine lettuce

a few snippings of cress

12–16 Swedish flatbreads (depending on their
 size) or flour tortillas

1 x brown beans recipe (see page 162) or
 1 x 400g tin of kidney beans

100g Västerbotten or mature Cheddar cheese,
 coarsely grated

pink pickled onions (see page 286)

Mix 1 tablespoon of fine sea salt with the pepper, allspice and onion powder and rub all over the meat. Place a large, heavy-based pan over a medium-hot heat and pour in the oil. Once hot, add the meat and cook for a few minutes on each side or until golden brown. Pour in the hot stock, then add the thyme. Turn down the heat to a very gentle simmer and cover with a lid. Leave to simmer for 1½ hours or until the meat is so tender it's almost falling apart. Remove from the stock and leave to cool slightly before using two forks to shred it. Pour over a little of the stock to keep it moist.

Meanwhile, peel and grate the horseradish. Mix with the sour cream and season with some salt. Place in the fridge until needed. Wash and dry the lettuce and shred into strips. Place in a serving bowl and top with the cress.

To serve, warm the flatbreads in a low oven and warm the beans in a pan. If you're using a tin of kidney beans, drain and rinse them before warming them and seasoning to your taste. Place the shredded meat, the beans, cheese and pickled onions on the table in separate serving bowls, along with the horseradish cream and flatbreads, and let everyone help themselves.

Get ahead / I often find that cooking the boar the day beforehand and letting it rest in the fridge makes for more flavoursome and tender meat. Reheat the shredded meat in the stock in a saucepan over a low heat until simmering, then remove with tongs and ladle a little of the stock over the top

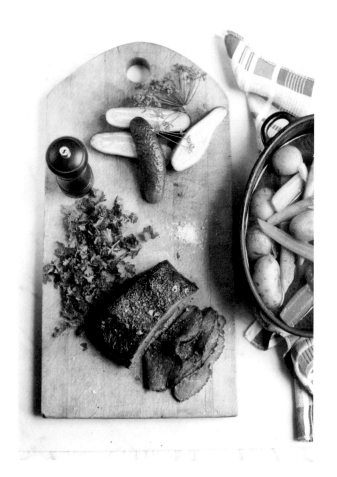

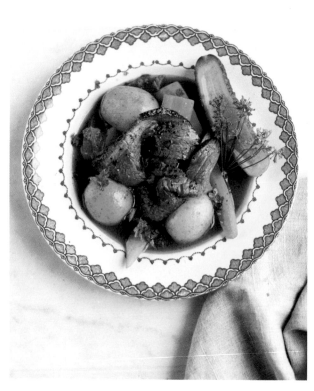

Speedy sailor's stew

Sjömansbiff

Out at sea for weeks, and the first leg on land you hotfoot it home for a steaming bowl of beef stew (fish is probably the last thing you want to see, after all) . . . well, that's how I like to imagine this dish got its name. It's simple to make, as in essence it relies on the magic formula of beef, vegetables and aromatics cooked with a glug of beer to create a comforting meal. Traditionally it's slow-cooked, but I've speeded up the process so you can get your hands around this gratifying bowl as quickly as possible.

Serves 4 /

Preparation time: 30 minutes /

Cooking time: 40 minutes /

600g beef rump

sea salt and black pepper

4 large spring onions

a knob of butter

a bunch of fresh flat-leaf parsley

4 bay leaves

10 peppercorns

10 whole allspice

600g new potatoes, washed

4 large carrots, peeled and cut in half lengthways

200ml ale

600ml hot beef stock

2 tbsp rapeseed oil

pickled cucumbers (see page 288), to serve

Season the beef rump with plenty of salt and pepper.

Remove the green parts of the spring onions (save these for the garnish) and cut the white bulbs into quarters. Place the white bulbs in a large, heavy-based pan with the butter over a medium heat and fry for a couple of minutes until slightly softened. Cut the stalks off the parsley and place with the bay leaves, peppercorns and allspice in a piece of muslin cloth tightly tied together with string. Add this to the pan, along with the potatoes, carrots and ale. Simmer for 5 minutes, then add the stock and simmer for a further 30 minutes or until the potatoes are tender. Meanwhile, preheat the oven to 200°C/fan 180°C/gas 6.

When the oven is ready, add the oil to an ovenproof pan. Once hot, add the piece of beef rump and fry until browned on all sides, then place in the oven for 5–6 minutes for medium rare or longer for well done. Remove from the oven and leave to rest for 8–10 minutes, covered with foil.

Finely chop the parsley leaves and reserved spring onions. Thinly slice the beef. Ladle the stew into bowls, top with the slices of beef, and sprinkle the chopped parsley leaves and spring onions on top. Serve with pickled cucumbers.

Top tip / To tell how well done your meat is, do the thumb test by pressing the meat and comparing it to the fleshy part of your thumb. Connect the tip of your thumb to the tip of your little finger on one hand and feel the fleshy part of your thumb with the index finger of your other hand: very well done. Thumb to ring finger: well done. Thumb to middle finger: medium. Thumb to index finger: medium rare. Thumb: rare.

Get ahead / The vegetables can be cooked a day in advance and gently reheated.

Crunchy cardamom hearts

Kardemummahjärtan

Before discovering the world of Swedish baking, I only used cardamom for making curries. The green pods were crushed and thrown in with a blend of chillies and other spices to make a fragrant heady paste. It never occurred to me to try and use it in a sweet way. Unlike the pared-back Swedish design, the Swedes are certainly not shy when it comes to using cinnamon or cardamom in their baking. More often than not, cardamom seeds (when you crush the green pods, the seeds pop out) are liberally sprinkled into buns. You end up with this amazing spicy crunch – definitely not for the faint-hearted. These biscuits will fill your home with the same amazing aroma. Hot out of the oven, the cardamom flavour hits you like an Avicii track blasting out of a sound system in a club, but give them a day (these biscuits keep well in a tin for a week) and the flavour mellows like the voices from First Aid Kit.

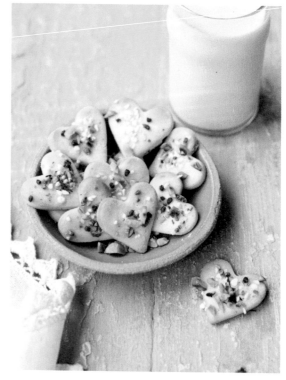

Makes 30–40 biscuits (depending on
 size of cookie cutter) / Vegetarian /
Preparation time: 30 minutes /
Chilling time: 30 minutes /
Baking time: 6–9 minutes /
Equipment: heart-shaped (or other)
 cookie cutter /

75g caster sugar

a pinch of fine sea salt

50g cream cheese

75g soft butter

1 medium egg

125g potato flour

150g plain flour

a pinch of vanilla bean powder

40g pearl or nibbed sugar

20g toasted hazelnuts, finely chopped

10g cardamom seeds

Beat the caster sugar, salt, cream cheese and butter until fluffy and creamy. Separate the egg and set aside the egg white for later. Add the egg yolk to the butter and beat until combined. In a separate bowl, mix together both flours and the vanilla bean powder. Combine with the butter mix until you can form a dough. Flatten the dough into a disc, roughly wrap in cling film and refrigerate for 30 minutes.

Preheat the oven to 220°C/ fan 200°C/gas 7 and line two baking trays with baking paper.

Roll the dough out between two sheets of baking paper until 3mm thick. Cut out hearts (or shape of your choosing) with your cookie cutter and place on the baking trays. Mix together the pearl sugar, hazelnuts and cardamom seeds. Brush the hearts with egg white and sprinkle the cardamom crunch mix over the top.

Bake in the oven for 6–9 minutes. Leave to cool before placing in an airtight container.

Top tips / If you can't get hold of cardamom pods, then ¼ teaspoon of ground cardamom will also work.

Pearl or nibbed sugar can be purchased online, but you can use demerara sugar instead if you prefer.

If cardamom is not your cup of tea, you can replace it with other spices or simply sprinkle sugar on top.

Get ahead / These biscuits will keep for a week in an airtight container. The longer you keep them, the more mellow the cardamom becomes.

Cheesecake

Ostkaka

This dessert is a local speciality from the region of Småland, where my husband is from, and is probably not like any cheesecake you've had before. It's creamy and rich with a slight tang, a delicious almond aroma and a slightly grainy, semolina kind of texture. It initially left me rather puzzled as to how so much could be going on in such a simple-looking dessert. I couldn't work out how they made it. It wasn't until I did some research that I discovered its secrets: rennet to make the curds, ground almonds for the texture, and grated bitter almonds to give it its fragrant flavour. It's very much a comfort dessert that ticks all the boxes. I like to make this without adding sugar to the curds, just using the fruit conserve as the sweetener.

Serves 6 /
Preparation time: 30 minutes /
Resting time: 1½ hours or overnight /
Baking time: 15–20 minutes /
Equipment: 6 ramekins /

40g plain flour

1½ litres whole milk

1 tbsp rennet

50g ground almonds

2 finely ground bitter almonds or ½ tsp almond essence

100ml single cream

1 tbsp caster sugar (optional)

a pinch of fine sea salt

1 medium egg

good-quality cloudberry or raspberry conserve, to serve

whipped cream, to serve (optional)

Put the flour into a saucepan and slowly whisk in the milk to avoid any lumps. Stir in the rennet and warm the milk up to 37°C, or warm enough that you can put your hand in without any discomfort. Once the milk hits this temperature, it should curdle. Don't stir at this point, just remove from the heat and leave to sit for 30 minutes.

Line a large bowl with a clean tea towel and pour the curdled milk on to it. Gather the corners and tie together to make a sack. Put a wooden spoon through the loop of the tea towel and tie it up so the remaining liquid can drip out into a bowl or the sink – I like to hang it over a tap. Leave for at least 1 hour to drain.

Preheat the oven to 190°C/ fan 170°C/gas 5.

Remove the curds from the tea towel, place in a bowl and beat them with a wooden spoon. Add the other ingredients and mix until well combined, then pour into 6 ramekins. Bake for 15–20 minutes or until lightly golden on the top. Serve with cloudberry compote or raspberry conserve and some whipped cream if you like.

Get ahead / The longer you leave the curds to dry, the firmer they become and they will develop a very subtle acidic note. You can bake these, then eat them cold the following day. The consistency is firmer but it is still creamy.

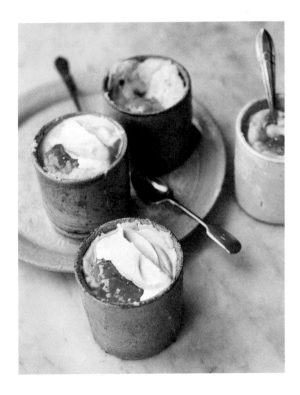

Prune and walnut soufflé

Soufflé med katrinplommon och valnötter

I encountered this soufflé for the first time not in France but on my friends' farm in the south of Sweden. I was told that it is a classic Swedish dish from the 1970s, and it's something I think is definitely worth reviving. Unlike a traditional soufflé, which requires a custard base, this is made by simply whipping up egg whites, which can easily be done while your guests enjoy the last glass of wine from the main course.

Serves 4 / Vegetarian / Gluten free /
Preparation time: 15 minutes /
Baking time: 12 minutes /
Equipment: 1 large ramekin or ovenproof
 dish, around 20cm in diameter /

50g shelled walnuts

3 tbsp caster sugar

a knob of soft butter

4 medium egg whites

4 soft prunes, finely chopped

a pinch of fine sea salt

Preheat the oven to 220°C/fan 200°C/gas 7.

Chop 2 tablespoons of the walnuts very finely, then mix with 1 tablespoon of the sugar. Brush your ramekin or ovenproof dish with the soft butter, making sure you brush in upward strokes from the base to the rim (this will help the soufflé to rise evenly). Pour the sugary walnut mix into the ramekin and roll the mixture around to coat it. Pour any excess out and discard. Roughly chop the remaining walnuts.

Start to whisk the egg whites. When they begin to froth, gradually add the remaining 2 tablespoons of sugar while continuing to whisk. Once the egg whites are thick and glossy, fold in the prunes and remaining chopped walnuts. Pour into the ramekin and smooth over the top, then place in the middle of the oven and turn the heat down to 190°C/fan 170°C/gas 5.

Bake for 12 minutes or until risen and golden on top. Serve immediately.

Top tip / If you're using small individual ramekins, bake for 8 minutes.

Get ahead / The ramekin can be buttered and coated and left in the fridge until needed.

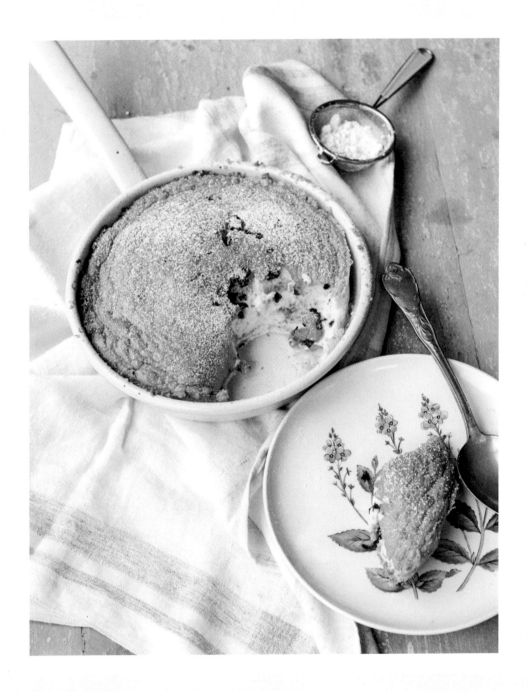

Fresh curds with salted caramel sauce

Färskost med saltad karamellsås

Messmör – a sweet, salty, golden-brown spread – is a dish which divides the Swedes: people either love it or hate it. It's made of whey (a by-product of the cheese-making process), which is reduced until the natural sugars caramelize. Imagine a very salty caramel with a slight tang. Unless you're a cheese producer (or you're making the cheesecake on page 190), it's unlikely you'll ever have whey to hand. The majority of Swedes wouldn't make *messmör* at home as it can be bought in blocks or tubes in Swedish supermarkets. This recipe uses a similar method to the one for that cheesecake, but the sugar makes the cooking process shorter, and the sauce adds sweetness rather than a tangy note. You could easily add some fresh fruit to the finished dessert if you like.

2 litres whole milk

50ml rennet

200g icing sugar

a generous pinch of fine sea salt

50g toasted hazelnuts, chopped

Serves 4–6 / Gluten free /
Preparation time: 5 minutes /
Resting time: 30 minutes /
Cooking time: 50–60 minutes /

Put the milk and rennet into a large pan (a larger pan will shorten the cooking time). Stir and heat to 37°C, or warm enough that you can put your hand in without discomfort. Once it hits this temperature, the milk should curdle. Don't stir at this point, just remove from the heat and let it sit for 30 minutes.

Line a sieve with a clean tea towel and place on top of a large bowl. Pour the whey and curd in. Bring the edges of the tea towel together and squeeze as much whey out as possible.

Put the whey into a very large clean pan and bring to the boil, then turn the heat down to a rapid simmer. Once it's reduced by half, whisk in the icing sugar and salt. Continue simmering for another 30 minutes, until thickened and golden-brown. If it's starting to brown in some areas more than others, use a heatproof spatula to scrape the base and distribute the heat. Try not to over-stir it though. Once it hits the golden-brown stage, take off the heat as it can quickly turn black and burn.

Slice the fresh curd. Divide between four or six plates, drizzle over the salted caramel sauce and scatter with the toasted hazelnuts.

Top tip / The fresh curd is delicious served as a savoury starter with *knäckebröd* (see page 28). Drizzle the curd with a peppery olive oil and scatter with freshly grated lemon zest and herbs.

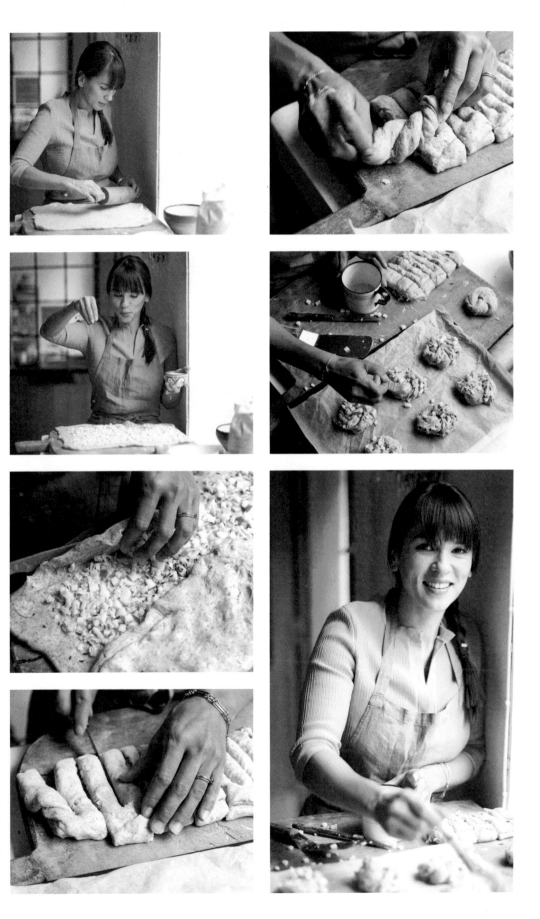

Apple and cheese spelt buns /

Apple and cheese spelt buns

Dinkelbulle med äpple och ost

One of the first words I learnt in Swedish was *bullar*, or buns. Not only am I a firm believer that the best way to learn a language is through food, but also because it's a word that crops up time and time again when talking about Swedish cuisine. Buns are very popular: you have the infamous; *kanelbullar* (cinnamon buns, which are celebrated in Sweden on 4 October every year); *kardemummabullar* (cardamom buns); *semlor* (cream buns, see page 57); *vaniljbullar* (vanilla custard buns); *lussekatter* (saffron buns, see page 254) ... I could have written a whole chapter on buns alone.

My aunt-in-law told me when I handed her yet another batch of freshly baked buns (she lives next door and is a very willing recipe taster) that Swedes just can't get enough of buns, and neither can I. I've gone for a rustic approach here, with a rye and spelt flour combination. Apple, cheese and caraway is one of my favourite flavour combinations, but you can easily replace the warm aniseed notes of caraway with some chopped walnuts instead.

Makes 12 / Vegetarian /
Preparation time: 30 minutes /
Proving time: 6 hours or overnight /
Baking time: 15–20 minutes /

For the leaven:

10g fresh yeast or 1 tsp instant dry yeast

280ml whole milk, at body temperature

140g spelt flour

For the bun dough:

200g spelt flour, plus extra for dusting

110g rye flour

1 tsp fine sea salt

50g butter, melted

30g honey

1 medium egg

For the filling:

1 egg, beaten, for egg wash

200g grated Västerbotten or mature Cheddar cheese

2 tbsp caraway seeds

1½ medium apples, cored, quartered and diced into 5mm pieces

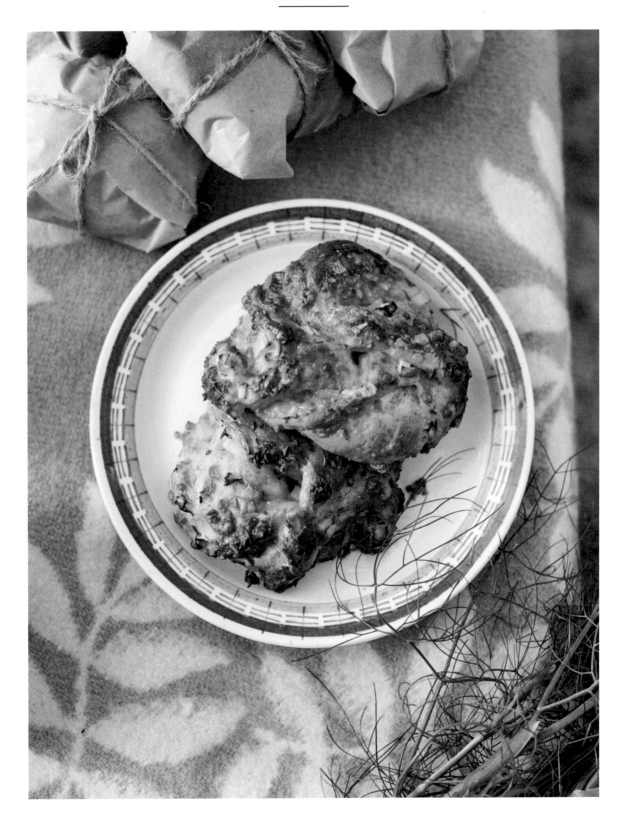

To make the leaven, dissolve the yeast in the milk. Sift in the 140g of spelt flour to make a paste, then whisk until the mix is smooth. Leave covered with a damp tea towel in a warm place for about 1 hour, until it has risen and dropped.

Next, mix together the 200g spelt flour, the rye flour and the salt. Make a well in the middle and add the remaining ingredients, plus the leaven. Mix together until you have a sticky dough, then turn out on to a lightly floured surface and knead until the dough is soft and smooth. Your fingerprint should bounce back when you poke it. Cover with a damp tea towel and leave to rise in a warm place for 4 hours, until doubled in size.

When the dough has risen, dust your work surface with flour. Roll the dough into a large rectangle until 0.5cm thick (about 45cm long x 35cm wide). Brush with egg wash, then sprinkle on the cheese and caraway seeds and scatter over the apple cubes.

Line two baking trays with baking paper.

Fold the dough into thirds, lengthwise, first lifting a third of the dough towards the middle, then folding the top third down so it aligns with the bottom edge of the dough.

Cut the dough into strips about 3cm wide. Cut each of the strips to split them down the middle but stop about 2cm from the top, just like you're making a pair of trousers. Twist one of the strips, then the other strip. Then twist them both together. Twist into a bun shape and place seam side down on one of the lined trays.

Repeat with the remaining dough, then brush with egg wash and leave to prove for about 1 hour.

Preheat the oven to 220°C/fan 200°C/gas 7. Brush the buns with egg wash once more, then put into the oven on the bottom shelf for 15–20 minutes, or until golden and cooked through. Remove from the oven and place on a wire rack to cool.

Best eaten slightly warm and fresh on the day.

Get ahead / The dough can be left overnight in the fridge after its 4–hour proving time.

You can also freeze the baked buns. Reheat at 170°C/fan 150°C/gas 3 for 15 minutes.

For a raspberry jam and chocolate variation

4 tbsp good-quality thick raspberry jam

100g dark chocolate with a pinch of sea salt, finely chopped

125g cold butter, in a block

Roll out the dough as on p.201–202, then spread with the jam and sprinkle with the dark chocolate. Use a mandolin or knife to cut the butter into 1mm slices. Lay it over the rolled-out dough, then follow the folding and baking instructions as before.

Dark chocolate buttercream biscuits with sea salt

Chokladbiskvier

When I was on maternity leave, these biscuits were my favourite afternoon treat. With sleep deprivation and the dark winter afternoons, these were a good motivation to wrap up my baby and head out to my local bakery. The combination of chewy macaroon, creamy chocolate buttercream and a thin crunch of chocolate on top is very hard to resist. Larger versions might seem appealing, but I find these smaller biscuits have a better chocolate/buttercream/macaroon ratio. A sprinkle of sea salt was the one tiny thing that was missing from the bakery-bought ones.

Makes 20–25 / Vegetarian / Gluten free /
Preparation time: 25 minutes /
Cooking time: 10–15 minutes /

For the dough:

2 medium egg whites

3 tbsp caster sugar

200g ground almonds

a pinch of fine sea salt

For the buttercream:

55g very dark chocolate (85% cocoa solids)

125g butter

200g icing sugar, sifted

For the coating:

200g very dark chocolate (85% cocoa solids)

sea salt flakes

Preheat the oven to 180°C/fan 160°C/gas 4.

Beat the egg whites with the caster sugar until the sugar dissolves. Stir through the ground almonds and salt until fully combined. Line one or two baking trays with baking paper. Gather about 1 tablespoon of the dough and form into a ball, then flatten it in the palm of your hand. You want it to be about 3cm in diameter. Place on the baking tray and repeat with the remaining dough.

Bake for around 10 minutes, or until the biscuits come away from the paper without sticking but still feel soft and chewy. Leave to cool on a wire rack while you make the buttercream.

Break up the 55g of chocolate and put into a heatproof bowl over a pan of simmering water, making sure the bottom of the bowl doesn't touch the water. Melt, then set aside to cool slightly. In the meantime, beat the butter until soft and fluffy, then add the icing sugar one spoonful at a time until it's fully incorporated and smooth. Keep beating until you have a light and soft buttercream. Add the cooled chocolate and beat again to fully combine.

Dollop a heaped spoonful of buttercream on to each biscuit, then use a palette knife to smooth it around and into a slight peak in the centre. Repeat with all the biscuits before transferring to the fridge to set until just firm.

Melt the 200g of chocolate for the coating in a heatproof bowl over a pan of simmering water, then remove from the heat. Take the biscuits out of the fridge and dip in the chocolate to coat the buttercream top. Sprinkle with some sea salt flakes, then transfer to the fridge to set the chocolate. They are best eaten at room temperature, so I remove them from the fridge 15–30 minutes before eating.

Top tip / To dip the biscuits, I transfer the melted chocolate to a smaller, narrower bowl. The depth of the chocolate makes it easier to get a good dip.

Get ahead / These can be made a day ahead of eating and stored in the fridge.

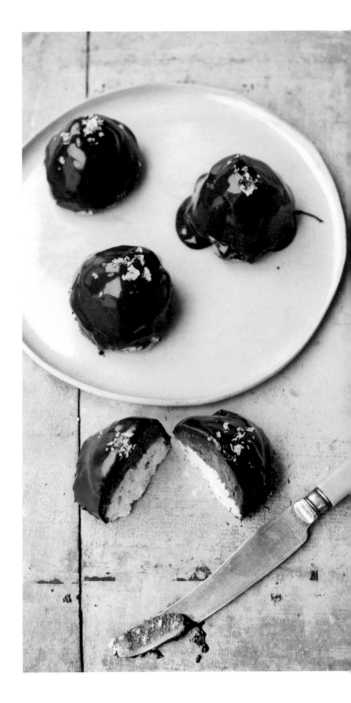

Raspberry and rye cookies

Hallongrottor

Hallongrottor ('raspberry caves') are another popular biscuit in Sweden, a country with a rich culture of cookie making. These thumb- or fingerprint cookies are child's play to make, although bigger thumbs and fingers are better for making a deeper indent, which allows for a more generous filling of jam or chocolate spread in the cookie 'cave'.

Makes 20 / Vegetarian /
Preparation time: 30 minutes /
Baking time: 10–15 minutes /

100g rye flour

80g plain flour

20g potato flour

30g light brown sugar

1 tsp ground cinnamon (optional)

¼ tsp baking powder

½ tsp fine sea salt

120g cold butter, cubed

100g raspberry jam

In a bowl, combine all the dry ingredients. Add the butter, toss together, then rub between your fingertips until you get a sandy texture. Press the mixture together until you have a smooth-ish ball. Roll into a sausage with a diameter of 3cm, then cut into 1.5cm rounds.

Roll each round into a ball and press your thumb or finger into the centre, leaving an indent for around ½ –1 teaspoon of jam. Put the jam into the cookie indent with a teaspoon, then place on a baking tray lined with baking paper.

Chill for 15 minutes in the fridge. Meanwhile, preheat the oven to 200°C/fan 180°C/gas 6.

Bake for 10–15 minutes, or until the cookies are firm to the touch. Leave to cool on a wire rack, then store in a container until ready to eat.

Top tips / Different jams, chocolate hazelnut spread or even a square of chocolate can be used to fill the thumb- or fingerprint.

If your dough gets too warm to work with at any stage, pop it back in the fridge to chill.

Get ahead / These cookies will keep in an airtight container for several days.

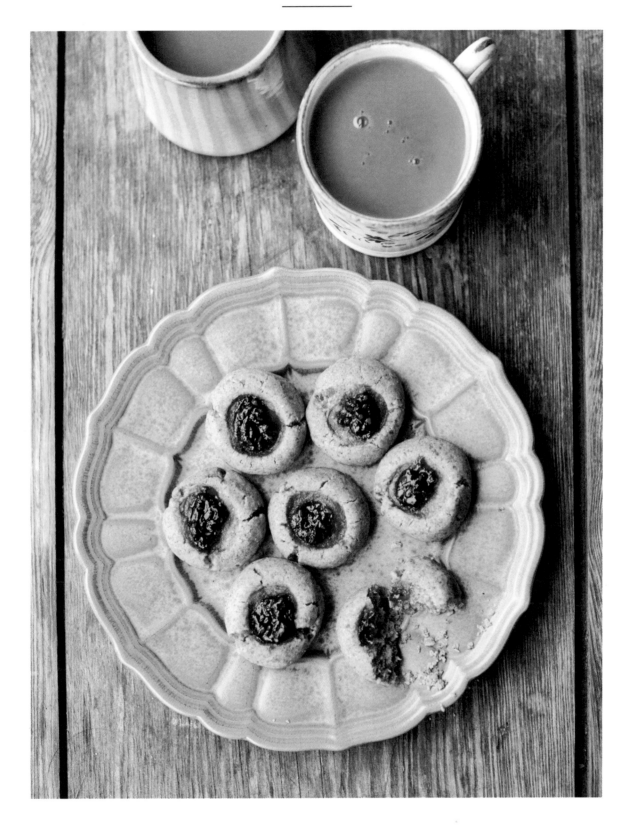

WINTER
vinter

Even back when I had my little Paris kitchen, I would make trips to Ikea. Half my kitchen was a mish-mash of kitchen island trolleys, chopping boards and flat-pack kitchen cabinets. Like every other Ikea shopper, I would inevitably arrive home with a big box of candles. And now I know why there are always sky-high piles of them by the checkout desks: the Swedes burn through candles like dry bamboo sticks on a barbecue. I've even got into the habit of lighting candles at breakfast time (and it's not because I'm trying to save on electricity): when the days are dark and long, a little candlelight goes a long way in brightening up your table.

Candles are a big part of the celebrations on St Lucia's Day, on 13 December, which was originally thought to be the shortest day of the year. On this day, long processions of girls in white gowns and crowns, carrying candles, kick off the festive celebrations, and golden saffron buns (see page 254) are traditionally eaten, though they are also popular throughout the festive season.

The highlight of the winter season though is, of course, Christmas, with its epic *julbord* ('Christmas buffet'), which requires minimal eating for at least 24 hours beforehand (and you won't want to eat for another 24 hours afterwards, for that matter). There is a bit of a strategy when it comes to eating your way through one of these buffets, and wearing loose-fitting clothing is a must. The first course consists of pickled herring, *toast skagen* (see page 226), gravlax and smoked salmon. The second course includes bread, ham, pâtés, beetroot salad (see page 220), a big hunk of blue cheese served with gingerbread (see my take on this with the recipe on page 272) and some other cheeses, especially Västerbotten. Then you move on to the hot course, which usually consists of meatballs, a stew of some sort, sausages, a Christmas ham and Jansson's temptation (see page 252), served with a large mound of ever-so-buttery mash, cabbage, sliced pickled cucumbers, a stack of *knäckebröd* and sugared lingonberries. There will also be a pot of Christmas mustard (which most of the time isn't much more than a jar of mustard in a fancy pot, I've figured out). A dessert table then makes an appearance, filled with more gingerbread and a range of sweet cakes and treats. Finally, coffee is served with

an assortment of biscuits. If you're a real pro, you'll be able to return for seconds of the hot and cold courses (or even thirds!) before moving on to the dessert table and falling into the inevitable food coma – much like other festive tables around the world.

It took me a while to get accustomed to the Swedish winters, and I'm not sure I will ever entirely get used to them. When I first moved to Stockholm I had few of my own friends (working from home and frequent travelling made it hard to meet people initially), so the daily trip to a little grocery shop on the corner of my street became a highlight. The shopkeeper was always happy to indulge me with small talk. After I'd made several attempts at conversation in my awful Swedish, I discovered that the shopkeeper was an ex-marine, originally from Florida, who moonlighted as a stand-up comedian at night but worked in the grocery shop during the day. He always seemed so happy, even on the greyest days, and I was keen to find out how he kept his spirits up in the colder months. He said it was down to a positive outlook, but also handed me a packet of vitamin D tablets (the government issues free vitamin D drops for children under the age of one to protect against deficiencies). I started popping those supplements like a kid in a candy store, hoping it would help. Though I didn't notice much of a difference, what did help was making sure I made it out of the house for a brief walk before the sun went down every day, and to eat foods that made me feel good. That could be anything from a hearty beef stew (see page 246) to something fresh and vibrant like a gravlax poke bowl (see page 234) or a toasted and generously buttered saffron bun. Whatever it takes to get you through the darkness, I say!

It's not all doom and gloom, though. When the snow arrives and the sun comes out, the dazzling brightness beats any Stockholm white-washed interior. It's mesmerizing to watch people skate along the Stockholm archipelago or strap on their cross-country skis and hit the snow tracks. Those kind of days need to be seized with gusto, and nothing makes the most of it better than heading out into nature with a rucksack full of goodies to feast on.

Crispy kale and lingonberry salad

Krispig grönkål och lingonsallad

Salad is not what immediately springs to mind when you think of winter. But having now spent several winters in Sweden, I've found that after a while my body craves dishes that are light and fresh, to cut through the heaviness of typical Swedish comfort food. A crushed lingonberry dressing provides the necessary zing here. If I have a few slices of bacon hanging around in the fridge, they will make their way on to this salad in the form of crisped crunchy crumbs. But some crumbly hard goat's cheese or blue cheese is just as satisfying. Oh, and pickled pink onions, though I must stop putting them on everything, as I seem to have an addiction to them.

360g kale

sea salt

200g pearl barley

100g lingonberries or redcurrants

a pinch of caster sugar

1 tsp white wine vinegar

2 tbsp light rapeseed oil or olive oil

2 tbsp pumpkin seeds

100g hard goat's cheese or blue cheese

pink pickled onions (see page 286), optional

Serves 4 / Vegetarian /

Preparation time: 30 minutes /

Resting time: 1 hour /

Cooking time: 20 minutes /

Wash and dry the kale, then remove any tough stalks. In a large bowl, season the kale leaves generously with salt and massage it in vigorously for 5 minutes. Spread the kale out on a large baking tray lined with baking paper. Leave to rest for at least 1 hour.

Bring a saucepan of salted water to the boil and add the barley. Cook according to packet instructions until al dente. Drain and set aside until needed.

Crush three quarters of the berries with a pinch of salt, the sugar and the vinegar. Set aside.

Preheat the grill to high. Dab off any excess water from the kale with a clean tea towel. Drizzle with the oil and toss in the cooked barley and the pumpkin seeds. Place under the grill until crisp, turning the leaves so they crisp on both sides. Keep a close eye as the leaves can char more in some parts than in others.

To serve, pour over the crushed lingonberries and toss together. Crumble over the cheese, and scatter with the remaining berries and some pickled onions, if you like.

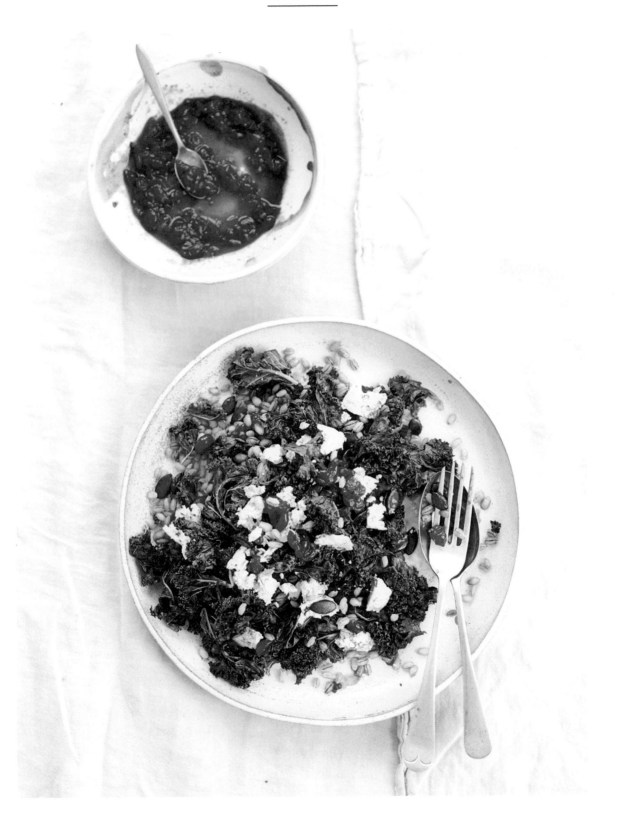

Rachel's caviar

Rachels kaviar

On one of my first visits to Stockholm, I headed to a coffee shop to grab a coffee and some breakfast. I ordered a boiled egg with buttered toast, and the lady behind the counter asked whether I wanted caviar with that. Being the gourmand that I am, I thought, 'Caviar for breakfast – well yes, of course.' Little did I know this would be Kalles Kaviar ('Carl's Caviar'), which comes in a blue tube and appears on almost every Swedish breakfast table. It's a salty pink paste made from cod roe that gets squeezed on to *knäckebröd*, boiled potatoes or eggs. The adverts for it show a Swede going around the world and getting people to taste it, to a very mixed reaction. It's a lot like the British spread Marmite: you either love it or hate it. I must say I belong to the latter group. However, I am rather partial to my own version, which I make using shavings of salted cured cod roe (bottarga) and a homemade mayonnaise.

Makes 250g / Dairy free /
Preparation time: 15 minutes /

3 medium egg yolks, at room temperature

200–250ml mild rapeseed oil, sunflower oil or
 mild olive oil

1 tsp lemon juice, or to taste

a pinch of caster sugar, or to taste

1 tsp tomato puree

30g bottarga, finely grated

To serve:

knäckebröd (see page 28) or boiled new potatoes

a little extra bottarga, to garnish

Place the egg yolks in a large glass or stainless-steel bowl set on a damp tea towel (this will stop the bowl from slipping). Start by whisking the egg yolks a little, then add the oil drop by drop – the eggs will begin to thicken and become pale in colour. Continue drizzling the oil into the mix until you have achieved the consistency you like. Add the lemon juice and sugar, then stir in the tomato puree and bottarga. Give it a taste and adjust the lemon and sugar to your liking.

To serve, spread on *knäckebröd* or boiled new potatoes, sprinkle with chives and shave a little extra bottarga on top.

Get ahead / The caviar can be refrigerated for up to 3 days.

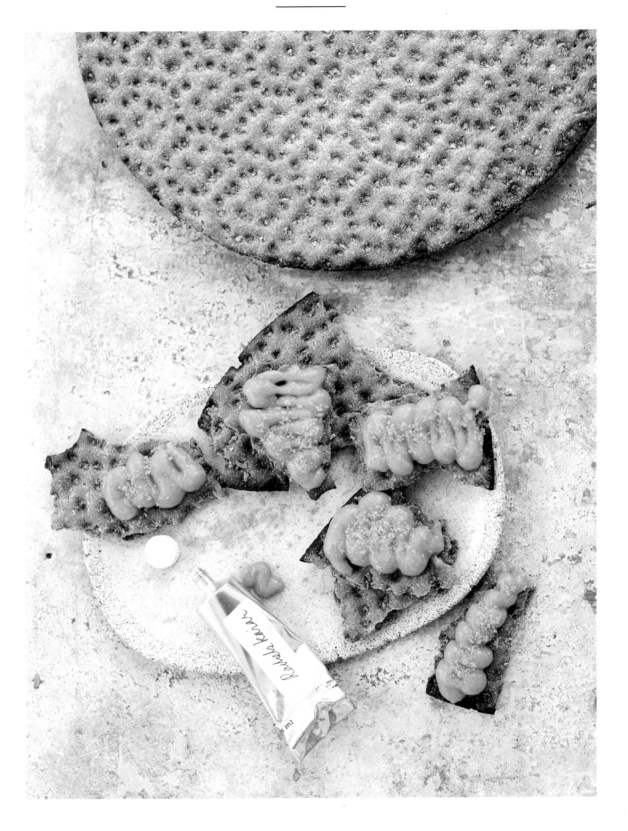

Christmas Buffet /

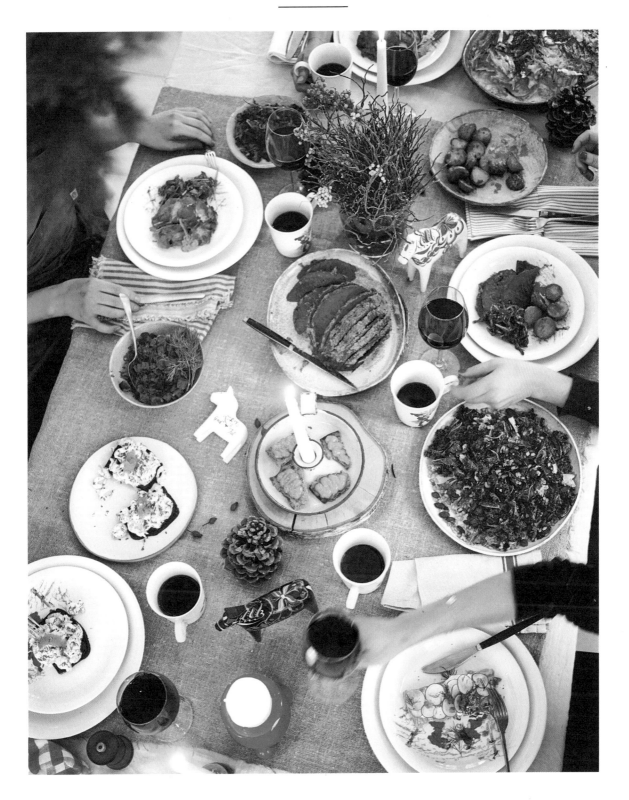

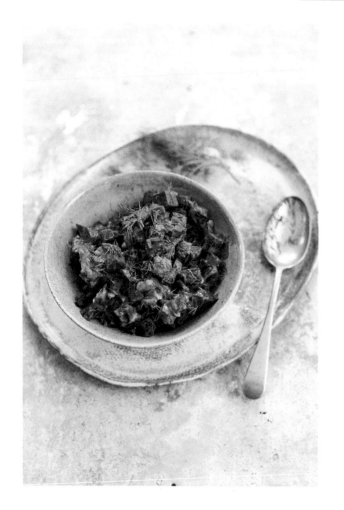

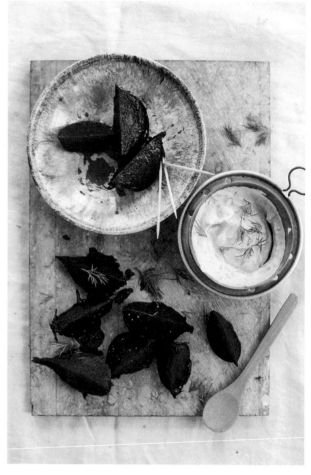

Salt-baked beetroot – two ways

Saltbakad rödbeta – två sätt

Serves 4 /
Vegetarian / Gluten free /
Preparation time: 30 minutes /
Cooking time: 1 hour /

If you have ever happened upon a Swedish supermarket you might have come across one of their ubiquitous salad buffets, which often look more like salad graveyards than perky displays of vibrant greens. Sitting in prime position between the tired lettuce and the cabbage salad, you'll usually find the *rödbetssallad*, a neon-pink beetroot salad, a must on any Swedish *julbord* (Christmas buffet). I don't care much for the stuff you find

at the supermarket, but if you make it at home it's quite the treat. Traditionally you just boil the beets, but baking them in a salt crust makes for an even sweeter root, locking in all the flavours and steaming the beetroot in its own juices. A wedge dipped into the crème fraîche dressing makes an excellent appetizer, but alternatively you can go down the classic root (excuse the pun!) and dress the beet chopped up, for that psychedelic-looking pink salad.

4 medium eggs

700g beetroot, skin on, scrubbed

950g table salt

125g crème fraîche

1 tsp Dijon or other strong sharp mustard

1 tbsp chopped fresh dill, plus a few
 sprigs to garnish

sea salt

1 tbsp cider vinegar

1 tbsp rapeseed oil

Separate the eggs, placing the whites in one bowl and the yolks in another, making sure to keep the egg yolks whole. Bring a small saucepan of salted water to the boil. Carefully slide in the egg yolks and cook for 5 minutes. Drain and set aside.

Preheat the oven to 210°C/fan 190°C/gas 7. Mix the table salt with the egg whites. Line a deep baking tray with baking paper. Place half the salt mix on the tray as a bed, then add the beetroot. Cover with the rest of the salt mix and use your hands to sculpt the salt around the individual beetroot so they are snug in the salt. Bake for 1 hour. Remove from the oven and leave to cool before cracking open the crust.

While the beetroot are cooking, crush the egg yolks into a paste with the crème fraîche, mustard and dill. Taste, and add sea salt to your liking, then keep in the fridge until the beetroot are ready.

To serve as an appetizer, peel and cut the beetroot into wedges and toss them in the vinegar and oil. Serve with the crème fraîche dressing and some cocktail sticks.

To serve as a salad, peel and cut the beetroot into small chunks and toss in the vinegar and oil. Then either toss in the crème fraîche dressing for the traditional Swedish beet salad or alternatively spoon a generous dollop of crème fraîche dressing on to each plate and top with the beetroot and an extra sprinkling of dill.

Top tip / Don't dress your salad with the crème fraîche dressing too far in advance as it starts looking unattractive if it sits for too long.

Get ahead / Once the beetroot are baked and tossed in the vinegar and oil, they'll sit happily in the fridge in an airtight container for a couple of days.

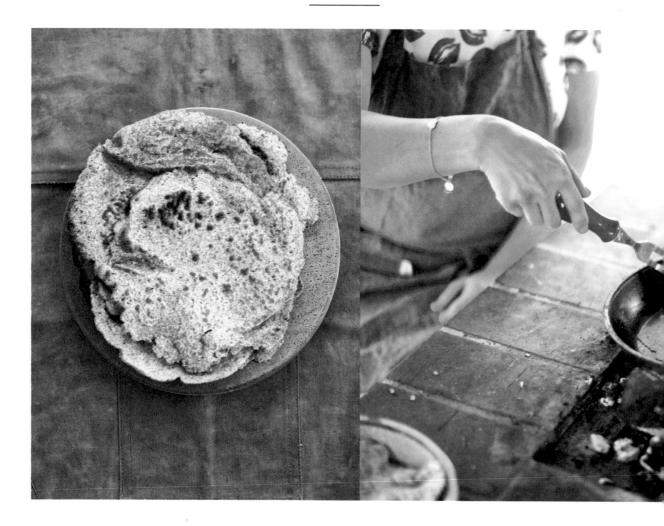

Rye spelt flatbread

Tunnbröd

Makes 10 /
Vegetarian /
Preparation time: 6 minutes /
Resting time: 30 minutes /
Cooking time: 4 minutes per flatbread /

There are numerous kinds of flatbread in Sweden, using a variety of flours, from plain wheat to hardier rye and barley. I once made a traditional northern Swedish *segkakor* (literally translated as 'tough cake'), which uses barley flour, but found the flavour too reminiscent of a pint of beer. Rye and spelt have a rustic, hardy flavour, without being too intense. A sprinkling of fennel or dill seeds adds a lovely warm aniseed flavour, which I can't get enough of.

Mix all the dry ingredients together, including the seeds (if using). Add the buttermilk, oil and 1 tablespoon of warm water and combine. Knead until you have a smooth dough — it should be slightly sticky. Cover with a damp tea towel and leave to rise for 30 minutes in a warm, dry place.

Divide the dough into 10 equal balls. Take a ball and roll out to roughly 20cm in diameter between two sheets of baking paper.

Heat a large non-stick pan with a tight-fitting lid until piping hot. Fork the dough and place in the pan, covering with the lid. Fry for 2 minutes or until it's browned and the dough on the underside looks cooked. Flip over and repeat. Place the cooked bread in another pan with a tight-fitting lid to keep warm and soft while you repeat the process with the rest of the dough.

Top tip / The bread sometimes goes more cracker-like after being cooked. If this happens, sprinkle with some water and warm in the oven at 170°C/ fan 150°C/gas 3 for 5–10 minutes.

Get ahead / Place sheets of baking paper between the flatbreads once baked and cooled, and freeze well wrapped.

150g spelt flour

100g rye flour

4g (1 tsp) instant dry yeast

1 tsp caster sugar

1 tsp fine sea salt

1 tbsp cracked fennel or dill seeds (optional)

150ml buttermilk, at room temperature

2 tbsp rapeseed oil

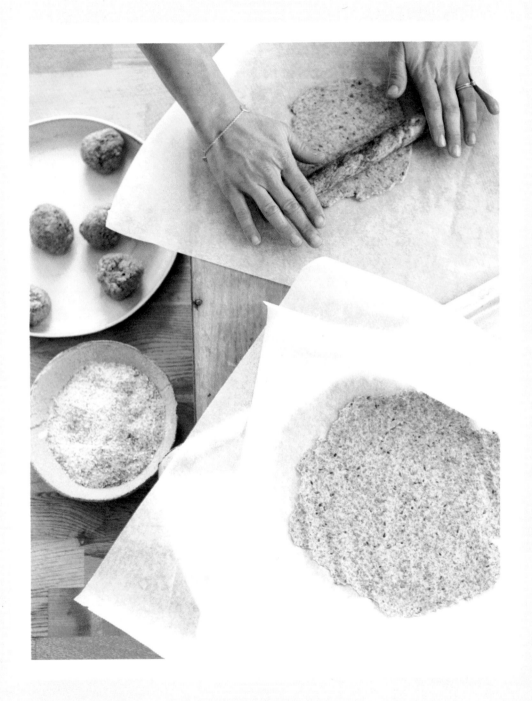

Prawns on pumpernickel toast

Pumpernickel toast skagen

Toast skagen is named after the most northern part of Denmark. What's ironic is that this iconic dish is almost unheard of in Denmark, while in Sweden it's probably one of the most popular appetizers there is. Usually this dish is served with white bread fried in butter, which I must admit is delicious. However, the crunchy, nutty flavour of pumpernickel bread (slathered in butter, of course) goes very well too. Adding crème fraîche to the mix is a recent addition of my own, but I like it. If you're not a crème fraîche fan, you can easily substitute it for more mayonnaise.

Serves 2–4 as a starter, 4–6 as a nibble /
Preparation time: 15 minutes /
Cooking time: 10 minutes /

6 slices of pumpernickel bread

soft butter, to spread

150g small cooked prawns

1 heaped tbsp good-quality mayonnaise

1 heaped tbsp crème fraîche

¼ tsp Dijon mustard

a pinch of white pepper

1 tsp finely chopped fresh dill

80g Kalix caviar

2 tbsp finely chopped fresh chives

Toast the pumpernickel bread and generously butter. If having as a nibble, cut each slice in half.

Mix together all the other ingredients apart from the caviar and a tablespoon of the chives. Leave to marinate for 10 minutes, then heap a tablespoon of the mix on to each slice and top with the caviar and remaining chives. Eat immediately.

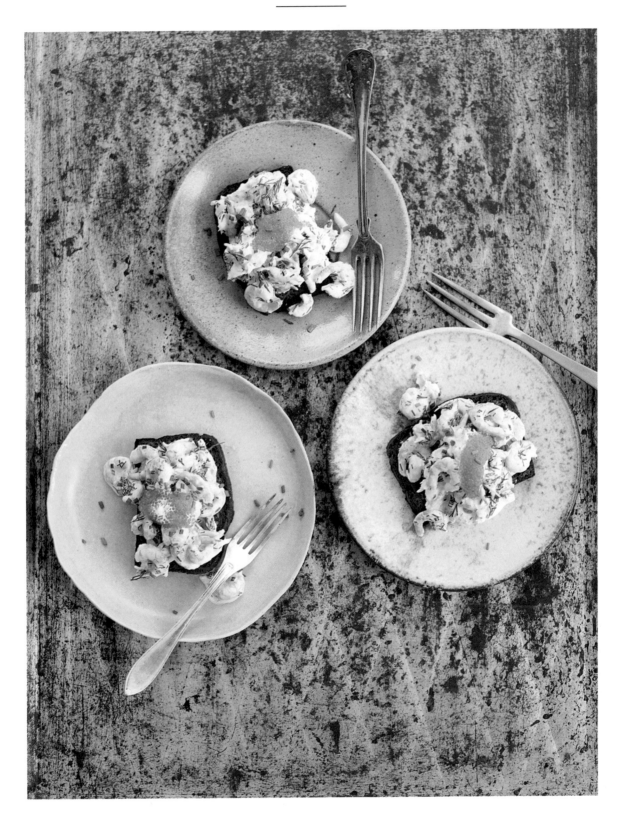

Black pudding buns with lingonberry

Blodpuddingbullar med lingon

I should get a T-shirt with the slogan emblazoned 'I heart black pudding'. My love of it started in Paris, where my local butcher would make the creamiest black pudding, dotted with chunks of sweet chestnuts. A slice of that with a fresh green salad and I'd have a satisfying lunch in minutes. Luckily the Swedes love the stuff too. It can be readily found in the supermarket, sold in large wedges. Often it's sweetened with apples and thickened not only with pig blood but also with rye flour, spiked with a heavy hit of cloves, allspice and ginger.

Traditionally you'd fry this with some bacon and serve it with lingonberry jam (starting to recognize a pattern here?). During my pregnancy my midwife told me that I needed to up my iron intake and recommended I eat a couple of slices a week, a prescription I gladly accepted. Making a bun version meant I could have a black pudding snack to go.

Makes 8 /
Preparation time: 30 minutes /
Resting time: 30 minutes /
Cooking time: 30 minutes /

For the filling:
½ a medium onion, finely chopped
½ tsp ground allspice
½ tsp white pepper
½ a small apple, cored and finely chopped

a knob of butter

100g black pudding, roughly chopped

2 tbsp frozen lingonberries or redcurrants

a handful of fresh parsley leaves, chopped

For the dough:

7g fresh yeast or a scant ¾ tsp instant dry yeast

75ml milk, at body temperature

185g plain flour, plus extra for dusting

15g caster sugar

½ tsp fine sea salt

½ tsp baking powder

45g frozen lingonberries or redcurrants

1½ tbsp finely chopped fresh parsley leaves

1½ tsp vegetable oil, plus extra for
 brushing the buns

Make the filling by frying the onion, spices and apple in the butter in a large pan on a medium heat. When everything begins to soften, crumble the black pudding into the pan and toss together.

Turn up the heat and continue to fry so the black pudding caramelizes a little. Take off the heat, then add the lingonberries and parsley.

To make the dough, dissolve the yeast in the milk. Mix all the dry ingredients, together with the lingonberries and parsley, and make a well. Add the milk and vegetable oil, then combine and turn out on to a lightly floured surface. Knead for a good 10–15 minutes or until you have a smooth dough.

Roll into a sausage and cut into 8 equal pieces. Take one piece and use a rolling pin to flatten it into a round of about 6cm. Place a heaped tablespoon of the filling in the middle of the round. Care-fully gather the edges together and place seal side down on a small piece of baking paper or in a muffin case. Brush the bun lightly with some oil, then repeat with the rest of the dough and filling. Leave the buns to rest in a warm place for 30 minutes.

Put the buns into a steamer and steam for 12–15 minutes or until fluffy and risen. Don't let the water touch the buns, and try not to open the lid of your steamer too many times.

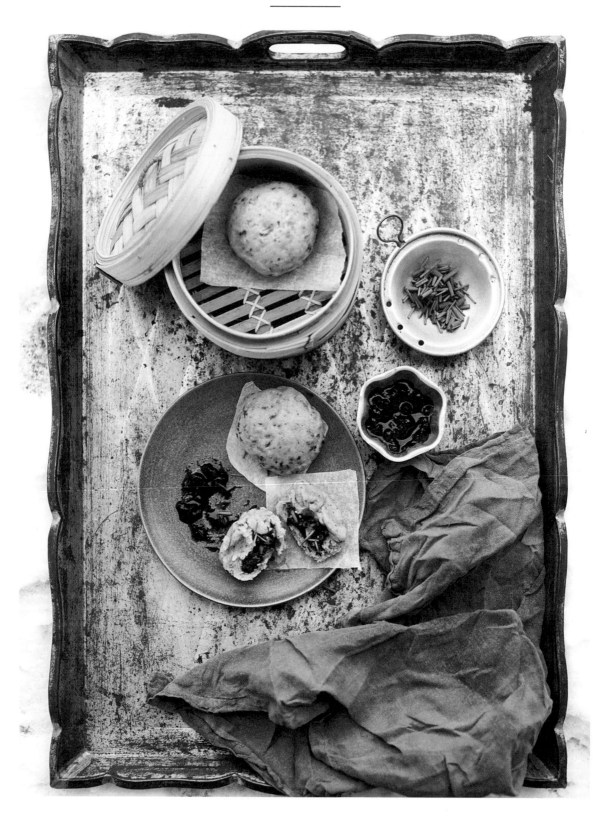

Stewed spinach eggs

Ägg med stuvad spenat

While writing this cookbook I quizzed a lot of my Swedish friends and family for their favourite Swedish foods, and this recipe was one I particularly loved for its simplicity, comfort and wholesomeness. I often have cravings for green leafy vegetables, especially when I've been travelling a huge amount. Eating out is fun, but nothing beats some home-cooked comfort food.

Serves 4 / Vegetarian / Gluten free without toast / Preparation time: 10 minutes / Cooking time: 20–25 minutes /

500g frozen spinach

1 onion, peeled and finely chopped

a knob of butter

150ml single cream

150ml milk

whole nutmeg

½ tsp white pepper

sea salt

4 eggs

For the herb garnish:

1 small fresh red chilli, deseeded and thinly sliced

1 small red onion, peeled and finely chopped

1 tbsp white wine vinegar

a pinch of fine sea salt

a pinch of sugar

a handful of fresh dill, roughly chopped

a handful of fresh chives, finely chopped

First make the herb garnish. Put the chilli and red onion into a glass or ceramic bowl with the vinegar, 2 tablespoons of water, the salt and the sugar.

Next put the spinach, onion and butter into a large frying pan. Place on a very gentle heat and cook, covered, for 5 minutes. Uncover, stir and continue to fry for another 5–10 minutes, until the water from the spinach has evaporated. Add the cream, milk, a generous grating of nutmeg and the white pepper. Cook for a further 5 minutes, stirring at intervals. Taste for seasoning and adjust to your liking.

Make four wells for the eggs. Crack in the eggs and continue to cook for 5 minutes or until the egg whites have set – covering with a lid will help this along.

Just before serving, toss the dill and chives with the chilli and red onion. Sprinkle over the spinach and eggs and serve immediately.

Top tip / Traditional recipes call for plain flour to thicken the mix. I often find cooking for longer and evaporating as much water as possible means you don't need it. If you find, however, that your spinach is very wet, you can whisk a couple of tablespoons of flour into the milk before adding it to the spinach.

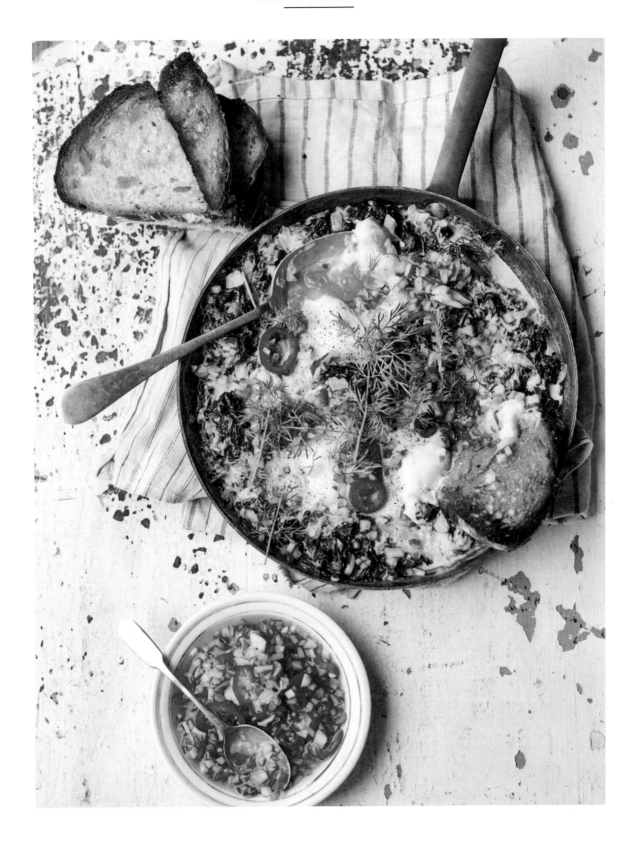

Gravlax poke bowl

Poke bowl med gravad lax

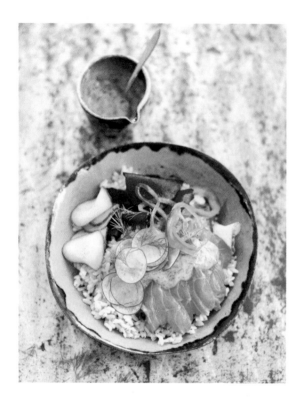

It's interesting how things suddenly make more sense when you begin to learn a language. Now I have a basic understanding of Swedish, the names of dishes have taken on a whole new meaning. *Gravad lax* (buried salmon) is one of those dishes. Buried under a salty and sweet dry brine with plenty of dill and lemon zest, the salmon cures lightly. It makes

a perfect addition to a 'poke bowl' of sorts (pronounced *POH-keh*, *poke* is Hawaiian for 'to slice or cut'), the type of vibrant bowl of food that's become popular in Stockholm, and all over the globe, I might add, over the last couple of years. The vegetables I use to top my bowl depend on what I have in the fridge, so don't feel you have to limit yourself to what I have suggested below. Anything that's fresh and has a good crunch will do.

1 x 250g salmon fillet (deboned and skinned)

zest of ½ a lemon

2 white peppercorns, crushed

50g fine sea salt

30g caster sugar

a bunch of dill, roughly chopped, plus
 several sprigs to serve

320g brown rice

800ml vegetable stock

2 cooked beetroot

4 radishes

100g pickled cucumbers (see page 288), sliced

pink pickled onions (see page 286)

4 tbsp freshly grated horseradish (optional)

For the sauce:

2 tsp Dijon mustard

2 tsp wholegrain mustard

1 tsp honey

50ml sunflower oil

juice of ½ a lemon

2 tbsp finely chopped dill

a pinch of fine sea salt

Serves 4 /

Gluten free / Dairy free

Preparation time: 30 minutes /

Resting time: 1 hour 20 minutes /

Cooking time: 40 minutes /

Dry the salmon fillet with a clean tea towel. In a food bag, mix together the lemon zest, white peppercorns, sea salt, the caster sugar and the bunch of roughly chopped dill. Put the salmon into the bag and gently massage the ingredients into the salmon. Leave at room temperature for 40 minutes, then turn over and leave for another 20 minutes before placing flat in the fridge for a further 20 minutes.

Cook the brown rice in the vegetable stock according to packet instructions. Meanwhile, thinly slice the beetroot and radishes using a mandoline or sharp knife.

Whisk all the sauce ingredients together. Taste for seasoning and adjust to your liking.

Take the salmon out of the bag and remove the brine by rinsing and patting dry. Cut into slices of about 7.5mm.

To serve, divide the rice between four bowls. Arrange the salmon, beetroot, radishes and pickled cucumbers on top. Scatter with a few pickled onions and some sprigs of dill, then drizzle over the mustard sauce. Sprinkle the grated horseradish over the top, if using.

Top tip / Try to get a piece of salmon that is an even thickness all over, as this helps the brine penetrate the fish evenly.

Get ahead / The gravlax is only a lightly cured fish, so I wouldn't recommend making it more than a day in advance. How well it will keep will depend on the quality of salmon you use.

Celeriac hasselback 'ham'

Rotselleri 'hasselback style'

This dish is an amalgamation of a couple of Swedish classics: the famous Swedish hasselback potatoes (potatoes that are halfway cut through into thin slices and breadcrumbed) and the typical Christmas ham (*julskinka*) you'll find on the Swedish Christmas table. I always think vegetarians get left out when it comes to celebratory feasts, so for me the ultimate goal when it comes to vegetarian dishes is to make something that will please both an omnivore and a vegetarian. I think this one fits the bill perfectly.

Serves 4 / Vegetarian /
Preparation time: 30 minutes /
Cooking time: 40 minutes /
Cooling time: 10 minutes /
Equipment: 2 chopsticks /

½ a celeriac (about 500g)

2 tbsp mustard seeds

5 peppercorns

3 juniper berries

750ml beetroot juice

200ml cider vinegar

40g honey

1 tsp smoked paprika

½ an onion, peeled and cut into quarters

1 bay leaf

60g sea salt

For the glaze:

1 tbsp sweet mustard (see page 15)

1 tsp English mustard

1 tsp maple syrup

30g butter (a large knob)

3 tbsp breadcrumbs

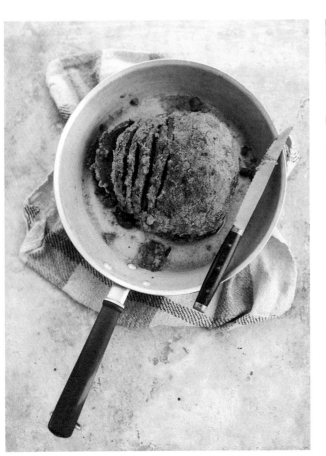

Wash and peel the celeriac. Place flat side down on a chopping board and put a chopstick on each side. Cut vertical slices, about 3mm apart, into the celeriac (the chopsticks will stop the knife slicing all the way through). Choose a pot that the celeriac half will sit in tightly. Put the mustard seeds, peppercorns and juniper berries into the pot over a medium heat. Toast until the seeds start to pop, then add all the other ingredients apart from the celeriac and those for the glaze. Bring to the boil while stirring, then turn down to a simmer and add the celeriac. Simmer gently, covered, for 30 minutes or until the celeriac is tender. Regularly turn the celeriac so every side sits in the cooking liquid and takes on a rich red colour. Leave to cool slightly in the liquid.

Preheat the grill to medium-high. Mix together both mustards and the maple syrup. Remove the celeriac from the cooking liquid and pat dry with some kitchen roll. Place an ovenproof frying pan on a medium heat and add the butter. When it begins to sizzle, put the celeriac flat side down into the pan to sear it. While it's searing, baste the top with the butter. Take off the heat when the base is golden brown. Spread the glaze on top and sprinkle with the breadcrumbs, then pour over any remaining butter from the pan. Place under the grill and cook until the topping is golden.

Serve with creamed spinach and roast potatoes.

Top tip / A slice of this cold is delicious with coleslaw and a salty mature cheese in a sandwich.

Get ahead / The celeriac can be simmered a day in advance and left to sit in the cooking liquid. Take out of the fridge 30 minutes before searing.

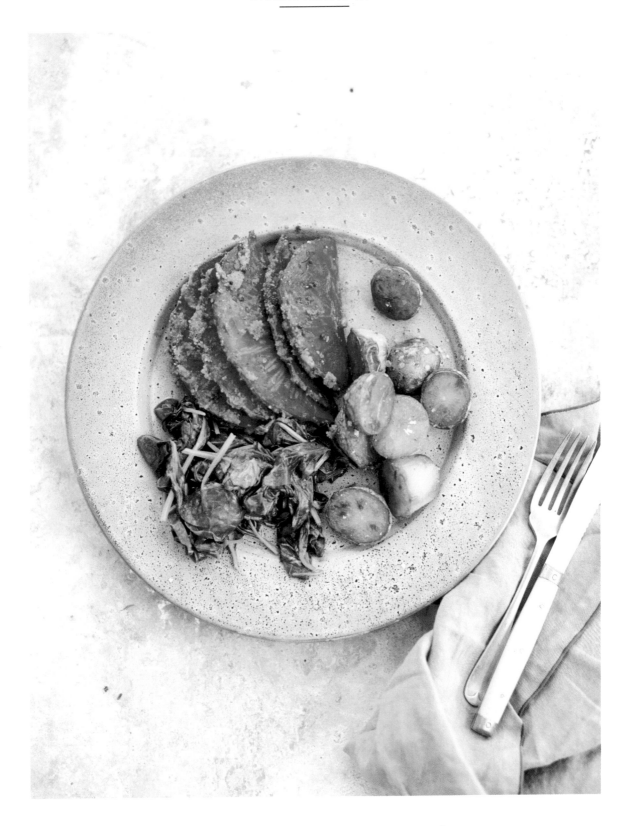

Quick turkey and lingonberry stew

Snabb gryta med kalkon och lingon

A quick stew that can be on the table in half an hour is always a good recipe to know. Lingonberries, like cranberries, go extremely well with turkey (a bird that doesn't have to be eaten only at Christmas or Thanksgiving). The turkey breast can be substituted with chicken if you like, or even wild boar (which is something I have in my freezer quite often). If you want to use leftover roast turkey or chicken, simply add the roast meat to the softened onion and continue cooking as in the method below.

1 large head of broccoli, cut into florets

a knob of butter

sea salt and black pepper

2 tbsp rapeseed oil

1 onion, peeled and finely sliced

3 sprigs of fresh thyme

450g turkey breast, cut into strips

200ml chicken stock

1 tbsp cornflour

250ml single cream

100g frozen lingonberries or cranberries, defrosted

1 tbsp finely chopped fresh chives

Serves 4 / Gluten free /
Preparation time: 10 minutes /
Cooking time: 20 minutes /

Put the broccoli into a steamer and steam until tender. Toss in the butter and a pinch of salt, then cover and set aside.

Meanwhile, put half the oil into a large frying pan and add the onion and thyme. Fry over a low heat for 10 minutes or until soft, then remove. Add the remaining oil and turn up the heat. When hot, add the strips of turkey breast and cook, stirring occasionally, until the turkey browns all over. Once golden brown, tip the onion and thyme back in and add the chicken stock.

Mix the cornflour with 2 tablespoons of water to make a thin paste, then stir into the stock and bring to the boil. Once the mixture has thickened, take off the heat, stir in the cream, season generously with black pepper and taste for salt. Add the lingonberries or cranberries and scatter over the chives.

Serve with the broccoli and some fresh bread to dip into the sauce.

Top tip / Don't stir the lingonberries through the sauce as they will make the cream split.

Get ahead / The stew without the lingonberries can be frozen and reheated. You may need to add a dash of stock if the sauce is too thick.

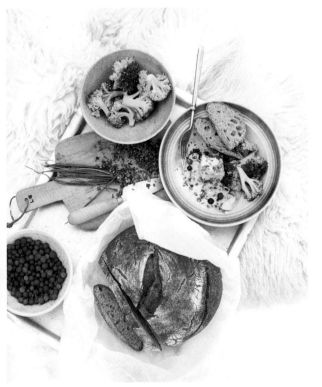

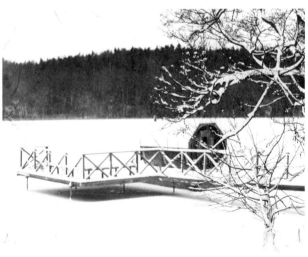

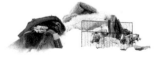

Wallenbergare burger

Wallenbergare

Serves 4 / Preparation time: 10 minutes /
Chilling time: 1 hour /
Cooking time: 15–20 minutes /

Thanks to the winning combo of veal mince, cream and eggs, this burger patty is worlds apart from the dry, rubbery kinds you might have eaten in your youth. This patty is rich and creamy, not a bad burger to have your name attached to (it's named after the forefather of one of Sweden's largest industrial families, the Wallenbergs, after all). Usually you'll find this served with a generous helping of buttery mash, peas and lingonberry jam, but I think a burger patty this good belongs in a pillowy-soft brioche bun.

400g minced veal or lean minced pork

100g single cream

4 medium egg yolks

sea salt

1 tsp white pepper

8 tbsp fresh breadcrumbs

2 knobs of butter

250g frozen peas

50ml hot chicken stock

4 iceberg lettuce leaves

4 brioche burger buns

4 tbsp lingonberry jam (see page 290)

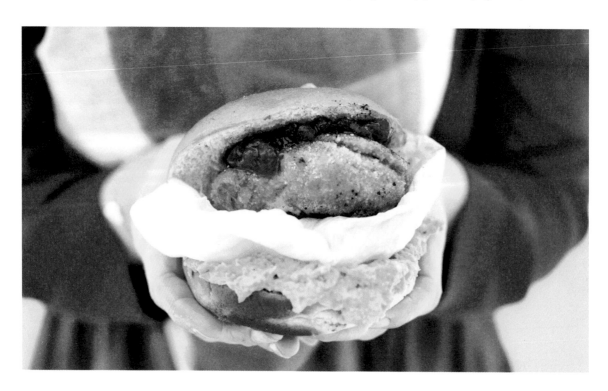

Put the mince, cream, egg yolks, 1 teaspoon of salt and the pepper into a food processor. Blitz until smooth, then place in the fridge and leave to chill for 1 hour – this makes it easier to form the mixture into patties. Pour the breadcrumbs into a bowl with a pinch of salt. Form the mixture into 4 patties and dip into the breadcrumbs, coating them all over.

Preheat the oven to 170°C/fan 150°C/gas 3.

Put a knob of butter into a frying pan over a medium heat. Once the butter begins to sizzle, add the patties and cook for 4–5 minutes on each side or until golden brown. Place on a baking tray and put into the oven for a further 5–10 minutes, or until cooked through and the juices run clear when you pierce the burgers with a knife.

In the meantime, bring a saucepan of salted water to the boil. Add the peas and cook for 5 minutes, then drain. Add the stock and a knob of butter and blitz until smooth. Taste for seasoning and add salt if necessary.

Spread a generous amount of the pea purée into each bun, then top with a lettuce leaf, a burger and a good smear of lingonberry jam.

Get ahead / The patties can be made in advance and frozen in an airtight container for a couple of months. Defrost them thoroughly before cooking as described on the left.

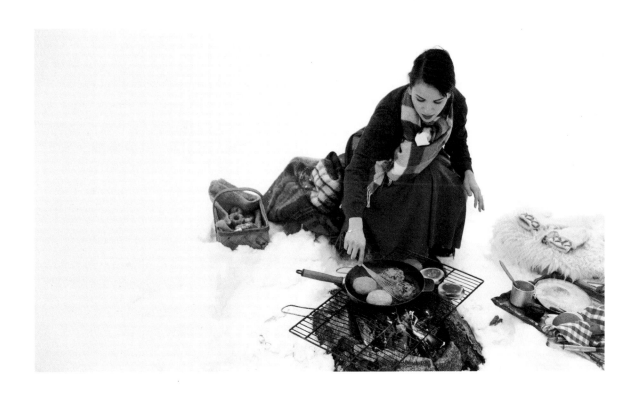

Seafood saffron stew

Skaldjursgryta med saffran

The first time I bought saffron at the super-market it felt like I was buying something illegal. I looked all over the supermarket: the baking aisle, the spice aisle, the exotic foods aisle. When I had exhausted all possibilities, I asked a supermarket assistant in my broken Swedish where these golden threads were. 'Behind the till,' he responded. While I queued at the checkout I craned my neck to see if I could spot the saffron but it was nowhere to be seen, not even in the designated *snus* (Swedish snuff tobacco) fridge. It came to my turn and I asked for the saffron, only to be questioned on how much I wanted, 'Half a gram or a gram?' Money transaction completed, she then slid me a packet of the prized spice. While a lot of effort might have gone into obtaining the saffron, not much goes into making this delicious dish.

Serves 4 / Gluten free without bread /
Preparation time: 10 minutes /
Cooking time: 20 minutes /

2 knobs of butter
2 onions, peeled and finely chopped
2 small fennel bulbs, thinly sliced
sea salt

½ a cauliflower, cut into 0.5cm slices and broken up
light rapeseed oil or olive oil
8 large raw prawns, shells on
600g cod, skinless, cut into chunks
125ml dry white wine
a pinch of saffron threads
250ml hot shellfish stock
2 tbsp crème fraîche
a handful of chopped fresh dill

Put the butter into a large, heavy-based saucepan over a medium heat. Add the onions and fennel, along with a generous pinch of salt. Cook for several minutes or until the onions begin to soften (you might have to do this in batches if your pan isn't big enough). Add the cauliflower and cook on a high heat until it begins to caramelize and colour. Remove to a bowl and cover with foil while you cook the rest.

Put 1 tablespoon of oil into the same pan, and when it begins to sizzle add the prawns. Cook for 3–4 minutes on each side, then remove from the pan and set aside. Put the cod fillets into the pan, adding more oil if required. Cook for a couple of minutes, then turn over and cook for a further 2 minutes or until the fish is just cooked and starting to flake apart. Set the cod aside.

Turn up the heat and add the white wine and saffron threads. Let the white wine almost evaporate before adding the stock, then stir and let it reduce by a third before whisking in the crème fraîche. Taste for salt.

Divide the cauliflower mix between the bowls and top with the prawns and the cod. Pour over the sauce and sprinkle on the dill. Serve immediately.

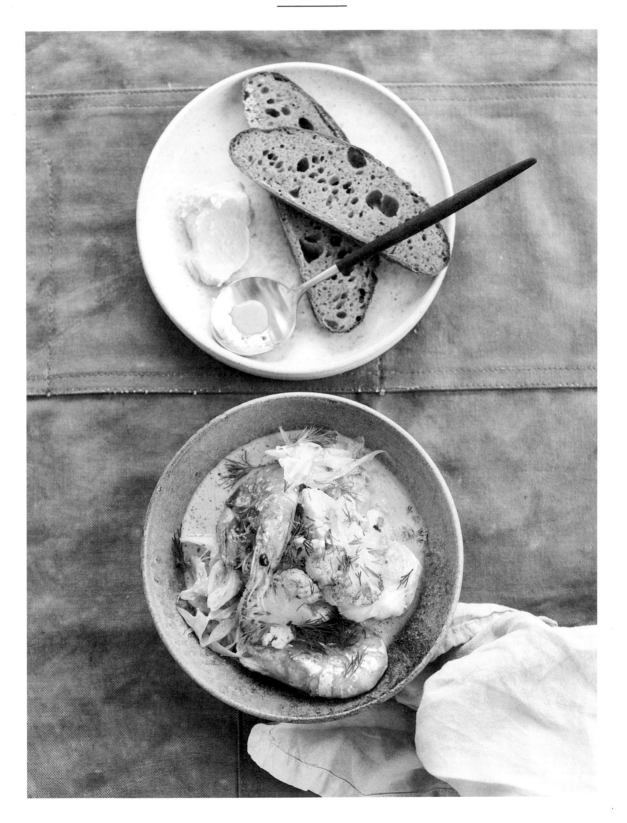

Swedish beef stew

Skånsk kalops

Serves 6–8 /
Preparation time: 30 minutes /
Cooking time: 1½–2 hours /

This stew is supposedly from the Swedish county of Skåne, which is known as the garden of Sweden as it produces most of the country's produce (partly due to the fact that it lies in the south). However, the stew is so popular that pretty much the whole of Sweden has a version of it, called simply *kalops*. Some people compare it to the French *boeuf bourguignon*, although it doesn't rely on the richness of red wine, rather on some fragrant allspice, which gives the stew a lovely warmth.

4–5 tbsp rapeseed oil

4 onions, peeled and sliced

6 Swedish anchovies (see Top tip)

2 tbsp plain flour

1 tsp ground allspice

sea salt and black pepper

1kg chuck steak or stewing beef, cut into bite-sized pieces

8 thin carrots, peeled

1 tbsp red wine vinegar

1 litre beef stock

1kg potatoes (Désirée work well)

a knob of butter

a small handful of fresh parsley leaves

pickled beetroot, to serve

pink pickled onions (see page 286), to serve

Heat 2 tablespoons of the rapeseed oil in a large saucepan over a medium heat and add the onions and anchovies. Fry, stirring occasionally, for about 10–15 minutes, until the onion begins to turn golden brown. Meanwhile, mix the flour with the allspice and 1 teaspoon each of black pepper and salt, then toss the cubed beef in it.

Once the onion is golden brown, remove from the pan and add another 2 tablespoons of oil. When hot, add the meat (you may have to fry it in two or three batches if your pan is too small) and brown all over. Once the meat is brown, put the onion back in, along with the carrots, vinegar and beef stock. Half cover with a lid and leave to simmer gently for 1–1½ hours or until the meat is tender.

Thirty minutes before the stew is ready, peel the potatoes, chop into large chunks and cook in boiling water until tender. Drain and toss in the butter and parsley.

Taste the stew and add more salt and pepper if desired. Serve with the boiled potatoes, the pickled beetroot and pickled onions.

Top tip / If you can't get Swedish anchovies, use regular ones plus 1 teaspoon ground allspice, ½ teaspoon ground cinnamon and a pinch of nutmeg.

Get ahead / As with most stews, this is often better the day after it's cooked.

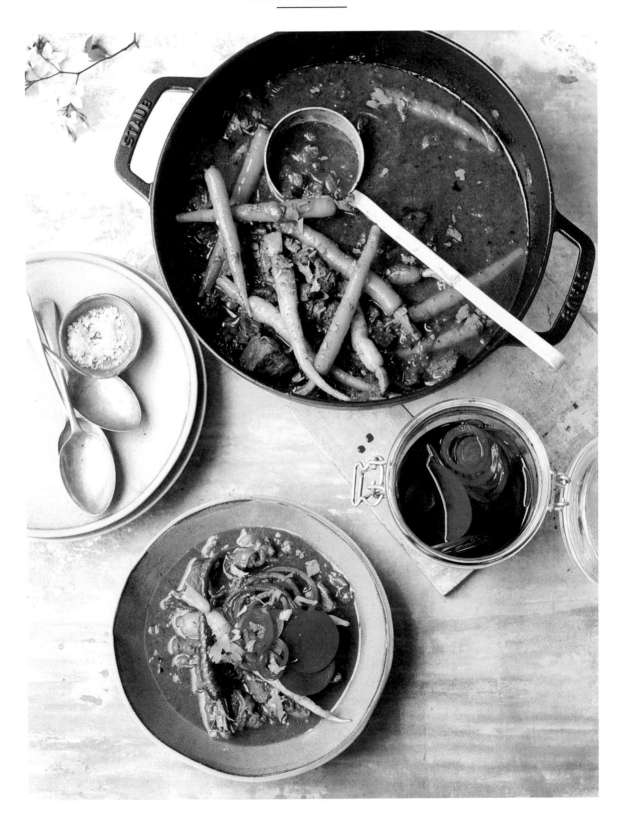

Yellow pea falafel with red cabbage and dill

Falafel på ärtor med rökål och dill

I'm a big fan of any dish that you can assemble with ingredients you might have lurking in the kitchen cupboard, fridge or freezer. It's the kind of food I make a lot when we're in the countryside or snowed in for the day in the city. I found out that there's a bit of a falafel scene in Malmö, the biggest southern city in Sweden, where falafel restaurants were more popular than a very famous American burger chain when they first arrived. It's hardly a surprise when you think about it, with Sweden's deep love for meatballs and the fact that falafel are far more tasty and wholesome than your average fast food burger. You could fry these like you would a traditional falafel, but I've taken the lazier route (nothing to do with it being the healthier option) by using a 12-hole muffin tin to cradle them in oil as they cook.

Serves 4 / Vegetarian /
Preparation time: 30 minutes /
Cooking time: 40–45 minutes /
Equipment: 12-hole muffin tin /

3 tbsp rapeseed oil

1 onion, peeled and finely grated or diced

200g frozen chopped spinach

sea salt and white pepper

a few gratings of nutmeg

1 x 400g tin of yellow peas, split peas or chickpeas, drained

40g potato flour

¼ of a red cabbage (about 450g)

a large bunch of dill, chopped

4 Swedish flatbreads (see page 222) or store-bought flatbreads of your choice

150g sour cream

pink pickled onions, to serve (see page 286)

Preheat the oven to 240°C/fan 220°C/gas 9. Grease a 12-hole muffin tin generously with 2 tablespoons of oil. Slide it carefully into the oven.

Fry the onion in a wide frying pan with 1 tablespoon of oil for 10 minutes or until soft. Add the frozen chopped spinach, some salt and pepper, the nutmeg and yellow peas. Cook for 10 minutes or until the majority of the water has evaporated, then take off the heat and mash. Stir in the flour and once cool enough to handle, roll into 12 equal balls (slightly smaller than a golf ball).

Take the muffin tin out of the oven and put the falafel in the holes – be careful as the oil might spit. Place back in the oven and turn the heat down to 220°C/ fan 200°C/gas 7. Cook for 20–25 minutes, turning the falafels around after 10 minutes, until browned all over.

Meanwhile, thinly slice the cabbage using a mandoline or sharp knife. Massage in a generous pinch of salt and toss with the chopped dill.

To assemble, take a flatbread, add some red cabbage and pop 3 falafel on top. Drizzle on some sour cream and add some pickled onions, then roll up and eat.

Get ahead / The falafels can be made up to 3 days in advance and reheated in a low oven before eating.

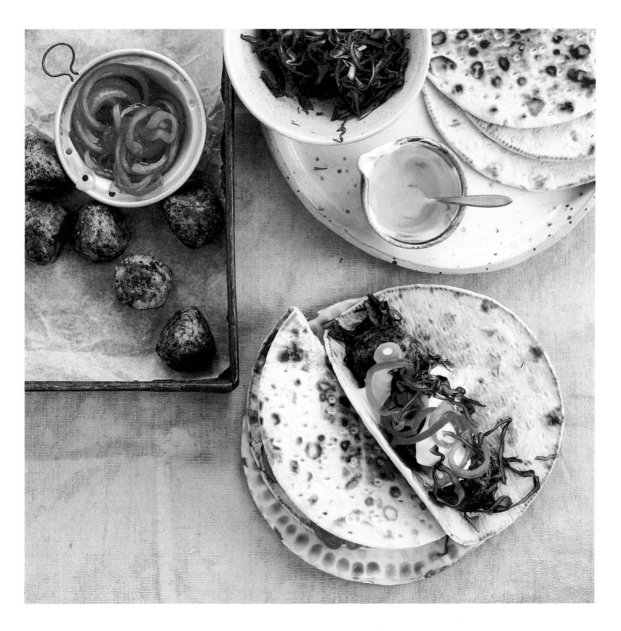

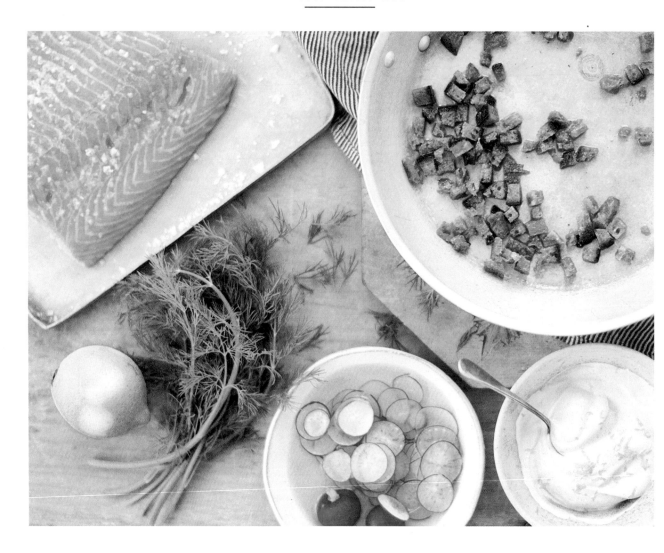

Slow-roasted salmon

Ungsbakad lax

When it comes to festive recipes, I generally use the tried and tested formula of rich and indulgent, but in recent years I've come to love food that is a little lighter on the palate during the Christmas period. Salmon makes a regular appearance on the Swedish Christmas table, whether it's smoked (hot or cold), cured (gravlax), made into a pâté, served raw like a carpaccio or cooked. This version relies on a slow, gentle roasting in the oven, which makes for the most tender and succulent flesh. It can easily be served warm or at room temperature.

Serves 4 / Preparation time: 30 minutes /
Resting time: 20 minutes /
Cooking time: 20 minutes /

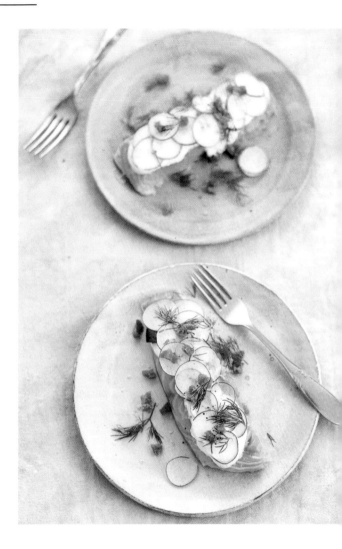

4 skinless fillets of salmon (about 150g each)

1 tbsp sea salt flakes

a knob of butter

1 slice of rye bread, cut into 0.5cm cubes

4 tbsp crème fraîche

zest of 1 lemon

4 radishes

2 sprigs of fresh dill

Season the salmon fillets on both sides with the sea salt. Leave to sit for 20 minutes at room temperature.

Preheat the oven to 120°C/fan 100°C/gas ½.

Put the butter into a large frying pan. Once it begins to sizzle, add the cubes of rye bread and toast until golden and crisp. Set aside until needed.

Use kitchen roll to pat the fish dry. Place in a baking dish and transfer to the oven to cook for 20 minutes, or until the fish is tender and flaky to the touch.

To serve, spread 1 tablespoon of crème fraîche on top of each fillet. Grate the lemon zest on top, then crumble over the rye cubes. Use a mandoline or a sharp knife to slice the radishes thinly, and place these on top too. Garnish with the dill and serve.

Get ahead / The salmon can be served either warm or at room temperature. You could bake this the day beforehand, take it out of the fridge 30 minutes before serving and garnish.

Jansson's temptation

Janssons frestelse

This dish is a must on every Christmas table in Sweden, although frankly I'm fond of it at any other time of the year too. Paired with a crisp green salad to balance out the creaminess, it makes a satisfying, rich and comforting meal. Encouraging plenty of the crispy charred bits on the top is a priority as far as I'm concerned, which is why I use a wide shallow dish for the extra surface area. If you want to keep it simple and classic, you can replace the beetroot and carrot with extra potato, but I love the pop of colour from this combination, which also lightens up this classic bake.

a knob of butter, for greasing the dish

3 potatoes (about 700g), peeled and thinly sliced

1 tsp sea salt

1 tsp black pepper

400ml double cream

100ml whole milk

2 carrots (about 200g)

1 medium beetroot (about 100g)

2 onions

1 x 125g tin of Swedish anchovies
 (see page 15), drained

2 tbsp breadcrumbs

Serves 6 / Preparation time: 30 minutes / Cooking time: 1 hour / Equipment: 25cm x 18cm baking dish, about 6cm deep /

Preheat the oven to 220°C /fan 200°C/gas 7. Grease the baking dish with the knob of butter.

Put the potato slices into a large saucepan with the salt, pepper, cream and milk. Bring to a simmer and cook for 10 minutes or until the potatoes are tender. Meanwhile, peel and slice your carrots and beetroot into thin strips or matchsticks. Peel and thinly slice the onions.

Remove the potato slices from the milk, keeping the milk to one side. Spread a layer of potato slices in the baking dish, followed by some of the onions, beetroot and then carrots. Add another layer of potatoes, then half the tin of anchovies, followed by some more onions, beetroot and carrots. Add a third layer of potatoes and the remaining carrots, beetroot and onions. Add the rest of the anchovies, then pour the milk from the potatoes over the vegetables.

Cover with foil and bake for 30 minutes. Uncover, sprinkle over the breadcrumbs and bake for a further 30 minutes (cover again if the topping browns too quickly).

Get ahead / You can bake this and freeze it. Reheat at 170°C /fan 150°C/gas 3, covered, for 50 minutes, then uncover and cook for a further 10 minutes.

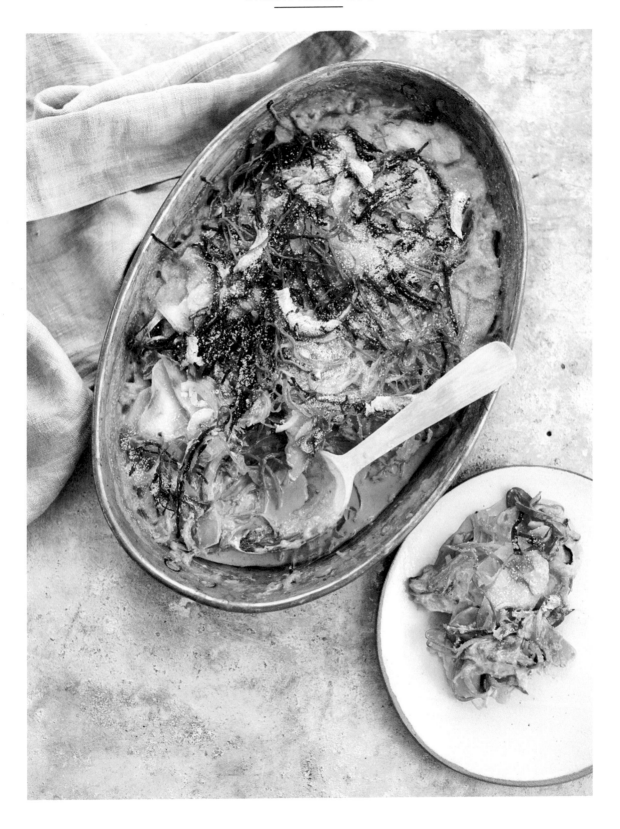

St Lucia saffron buns

Lussekatter

These buns are part and parcel of the winter season. Just like Easter eggs in the run-up to Easter, these buns start springing up in bakeries, supermarkets and even petrol stations as St Lucia's day approaches. On 13 December, when the darkness of winter is reaching its peak, you can find processions of children lighting up the night in long white gowns, holding candles and singing. The warm golden glow of the soft, enriched St Lucia buns, which are dotted with a couple of raisins, is a perfect pairing to the celebrations.

Truth be told, I've eaten far too many dry versions of these buns, so I decided to take some inspiration from the Jewish *babka* and encase a thin layer of spiced raisin paste in the bun, adding a rich and sticky sweetness to this saffron-infused favourite.

Makes 10 / Vegetarian /
Preparation time: 1 hour /
Resting time: 2½–3½ hours, or overnight
Baking time: 20–25 minutes /

For the raisin paste:

150ml whole milk

250g raisins

1 tsp ground cinnamon

1 tsp bourbon vanilla sugar

3 tbsp white breadcrumbs

For the dough:

2g saffron threads

150ml whole milk

375g '00' (superfine) flour, plus extra for dusting

50g caster sugar

½ tsp fine sea salt

1 tsp bourbon vanilla sugar

16g fresh yeast

75g soft butter

1 medium egg

1 medium egg, beaten, for brushing

Heat the milk for the raisin paste until scalding point (not boiling), then add the raisins, cinnamon and vanilla sugar. Leave to soak for at least 1 hour and overnight if possible. Set about 20 raisins aside for the decoration. Add the breadcrumbs to the milk and raisin mixture and pulse to a rough paste. I prefer it not too smooth, with some raisins still whole.

To make the dough, soak the saffron threads in the milk for at least 30 minutes, then remove and discard the threads. Put the flour, caster sugar and salt into a large bowl. Place the milk and vanilla sugar in a small pan and bring to room temperature over a very low heat. Crumble the yeast into a small heatproof bowl and add 2 tablespoons of the milk to the yeast to dissolve. Make a well in the centre of the dry ingredients and add the yeast, remaining milk, the butter and egg. Mix, then knead in a free-standing mixer with the dough hook attached for about 5–7 minutes, or by hand on a lightly floured surface, until the mixture doesn't stick and bounces back when touched.

Put the dough into a bowl, cover with cling film and leave to rise for about 2 hours or until doubled in volume.

Divide the dough into 10 equal balls. Dust your surface lightly with flour. Roll one of the balls out into a thin rectangle, about 20cm x 15cm. Spread a thin layer of raisin paste down the middle, leaving an edge of about 2cm. Roll up into a sausage, pinching the end of the rectangle together so it can't unroll. Lay the roll in front of you with the neat side on top, then slice the middle open to about 8cm, exposing the layers. Twist the middle and roll both ends in towards the centre to make an S shape. The ends have to be rolled in quite tightly, otherwise they uncurl. Press in 1 soaked raisin at each end. Repeat with the rest of the dough balls.

Preheat the oven to 240°C/fan 220°C/gas 9. Leave the buns to prove for 30 minutes, covered with a clean tea towel.

Brush the buns with egg wash, then bake for 5 minutes. Turn the oven temperature down to 200°C/fan 180°C/gas 6 and bake for another 15–20 minutes, until golden. Place on a wire rack to cool.

Get ahead / Once baked and cooled, the buns can be put into a food bag and frozen. Reheat from frozen at 170°C/ fan 150°C/gas 3 for 20 minutes.

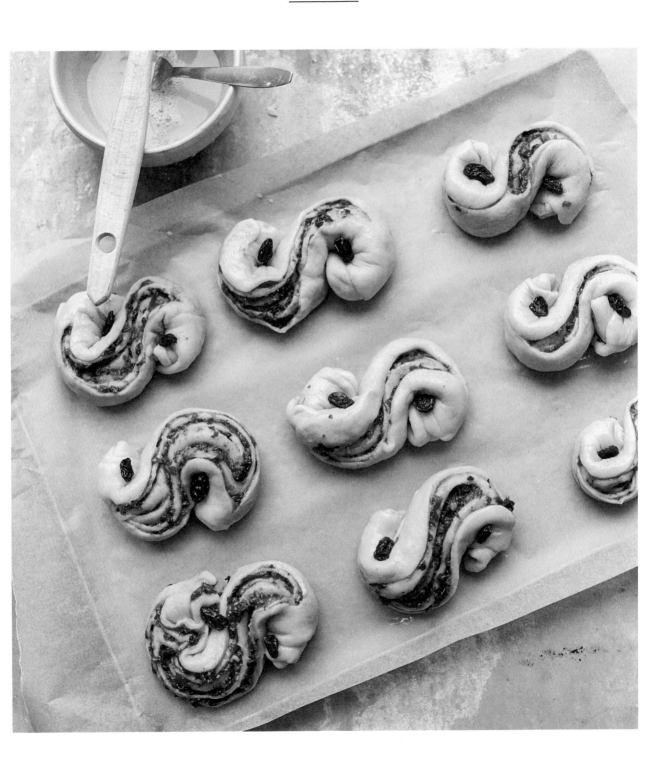

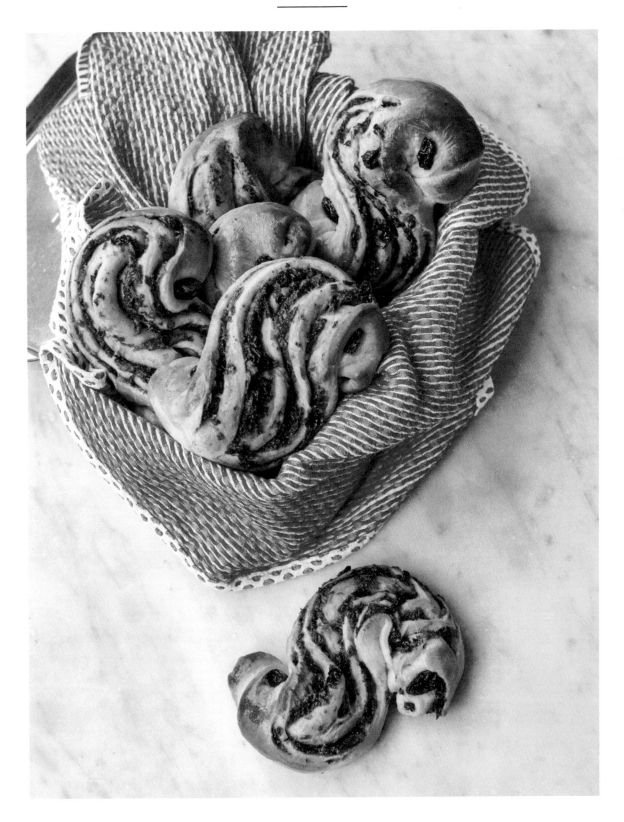

Rice pudding soufflé

Soufflé på risgrynsgröt

In the UK rice pudding comes in tins, in France I discovered it in plastic containers, but in Sweden it comes in a fat, sausage-shaped plastic tube, usually between tubes of yellow pea soup (see my recipe on page 165) and brown beans (see my recipe on page 162). Regardless of how it's packaged, a creamy, rich rice pudding is hard to resist. I was trying to make a summer version of rice pudding and seeing if I could freeze it to make a sort of ice cream. No matter how many versions I tried, freezing it resulted in a rock-hard block (the woes of a life without an ice cream machine), so instead I decided to bake the mixture. It turned into a delicious soufflé, the perfect comforting winter warmer, and much more sophisticated than anything from a tube.

Serves 6 / Gluten free / Preparation time: 30 minutes / Cooking time: 30 minutes / Equipment: 6 ramekins, about 9cm x 6cm /

150g pudding rice

700ml whole milk

2 cinnamon sticks

a pinch of fine sea salt

1 vanilla pod, split

1 tbsp caster sugar (optional), plus 50g

2 tbsp soft butter

4 tbsp demerara sugar

1 tsp ground cinnamon

2 medium egg whites

Put the rice, milk, cinnamon sticks, salt and vanilla pod into a large saucepan. Bring to a simmer and cook for 15 minutes or until the rice is tender, stirring occasionally with a wooden spoon to make sure the rice doesn't stick to the bottom of the pan and burn. Once done, take off the heat, stir in the tablespoon of caster sugar (if you prefer a sweeter pudding), and leave to cool slightly before blending in a food processor until smooth.

While the rice pudding is cooking, brush your ramekins with soft butter, making sure you brush in upward strokes from the base to the rim (this will help the soufflé to rise evenly). In a separate bowl, mix together the demerara sugar and ground cinnamon. Tip it all into one of the ramekins. Tilt the ramekin to the side while rolling it around in your hand – this should lightly coat the

base and sides. Once the ramekin inside is coated with cinnamon sugar, tip it into another ramekin and repeat. Place the ramekins in the fridge to chill until needed.

Preheat your oven to 220°C/fan 200°C/gas 7.

Whisk the egg whites until they start to get frothy, then gradually pour in the 50g of caster sugar and continue to whisk until the egg whites are glossy and thick. Lightly fold the blended rice pudding mixture into the egg whites until fully combined.

Divide the mixture between the ramekins, being careful not to spill any on the sides and keeping the edge clean (run your thumbnail around the edge of the ramekins). Place in the oven and turn the temperature down to 200°C/ fan 180°C/gas 6. Cook for 12–15 minutes or until the soufflés have risen considerably, then take them out of the oven and serve immediately.

Top tip / To chill the cooked rice speedily, I put a baking dish in the freezer, then decant the warm rice into the cold dish.

Get ahead / If you're short of time you can use 475g of shop-bought rice pudding. Usually commercially bought rice puddings are very sweet, so reduce the amount of caster sugar you add to the egg whites to 1 tablespoon.

Pear and gingerbread pie

Pepparkakspaj med päron

There's a long history of *pepparkakor* (ginger-snap or gingerbread) in Sweden. It made its way from Germany in the 15th century and stood the test of time partly because it keeps so well. Literally translated as 'pepper cake', *pepparkakor* used to contain only pepper to spice it up, which was thought to have medicinal properties (and it does, being a brilliant digestive aid, for instance). Traditionally honey was used to sweeten the cake, but I've replaced it with treacle, which adds a warming liquorice flavour. This gingerbread is more grown up with its robust rye and wholewheat spelt flour and generous helping of spices, but the sweetness of the ice cream and pears balances it out.

165g butter, plus extra for greasing the tin

80g demerara sugar, plus 1 tbsp for sprinkling

75ml treacle

225g wholewheat spelt flour

100g rye flour

1 tsp ground cinnamon

2 tsp ground ginger

1 tsp black pepper

1 tsp ground allspice

a pinch of fine sea salt

For the filling:

1 litre good-quality vanilla ice cream

8 small pears (about 600g)

Serves 6–8 / Vegetarian /
Preparation time: 20 minutes /
Baking time: 40 minutes /
Equipment: tree-shaped cookie cutter
 and a 23cm pie dish /

Preheat the oven to 180°C/fan 160°C/gas 4. Scoop 8 neat balls of ice cream. Place on a small baking tray and put back into the freezer.

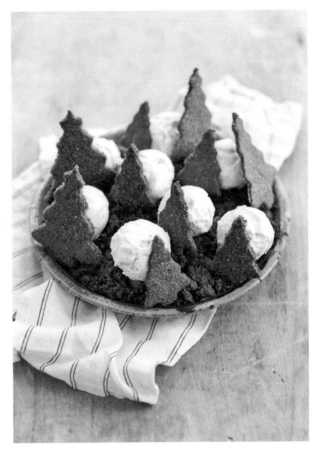

Cube the butter and put into a medium saucepan with the sugar and treacle. Stir until the butter is melted, then set aside to cool. In a bowl, mix the flours, spices and salt. Pour in the slightly cooled melted butter and bring together to a firm dough.

Roll out the dough between two sheets of baking paper to 3mm thick. Cut out 12 tree shapes with your cookie cutter and place on a baking tray lined with baking paper. Sprinkle 1 tablespoon of demerara sugar over the biscuits and bake in the oven for 10–12 minutes or until firm to the touch.

Grease your pie dish with soft butter. Peel the pears, core and thinly slice and place in the pie dish, then crumble the remainder of the biscuit

dough on top. Put into the oven and bake for 40 minutes. The pastry should have darkened and crisped up on top.

Place the frozen scoops of ice cream on top of the crumble. Poke the trees into the ice cream and serve immediately.

Top tip / You can omit making the pear crumble and simply roll out the dough to make biscuits.

Get ahead / The biscuits will keep in an airtight container for a couple of weeks. The crumble can be frozen if well wrapped. Reheat from frozen for 30 minutes at 170°C/fan 150°C/gas 3.

White chocolate and berry coconut mountains

Kokostoppar

Traditionally these coconut treats are densely packed just with coconut, but upon burning half my coconut while toasting it I ended up improvising with sesame seeds and ground almonds, only to discover how delicious these nutty additions are. The berries on top lend a bit of tartness, which balances the sweetness from the white chocolate and makes for a pretty little pink peak.

Makes 20 / Vegetarian / Gluten free /
Preparation time: 20 minutes /
Baking time: 30–35 minutes /

100g golden caster sugar

½ tsp fine sea salt

zest of 1 lemon

120g butter

200g desiccated coconut

150g sesame seeds

50g ground almonds

3 medium eggs

350g white chocolate

125g lingonberries or redcurrants

Preheat the oven to 200°C/fan 180°C/gas 6.

Put the sugar, salt, lemon zest and butter into a saucepan and melt over a medium heat. Set aside.

Pour the coconut on to a large tray lined with baking paper and place in the oven for 5 minutes or until fairly well toasted. Keep a close watch, and stir the coconut occasionally to toast it evenly. When the coconut is ready, take out of the oven and pour into a large bowl with the sesame seeds and ground almonds. Mix together, then pour in the melted butter and mix again. Add the eggs, then stir together until everything is well combined. Leave to cool slightly.

Line a baking tray with baking paper. Form the mixture into 20 small pyramids (about 4cm high and 5cm in diameter) and set on the lined tray. Place in the oven and bake for 20–25 minutes or until slightly golden on the peaks and firm to the touch. Remove from the oven and leave to cool on a wire rack while melting the chocolate.

Break up the chocolate and put into a small heatproof bowl over a saucepan of simmering water, ensuring the bottom of the bowl doesn't touch the water. Leave to melt, stirring occasionally. Once the chocolate has melted, dip the cakes into it and top each one with 3–4 berries of your choice.

Top tips / Dip in chocolate while the macaroons are still warm, as the chocolate will run down them better. White chocolate can be replaced with dark or totally omitted if you want to keep it simple.

Get ahead / These keep for several days in an airtight container.

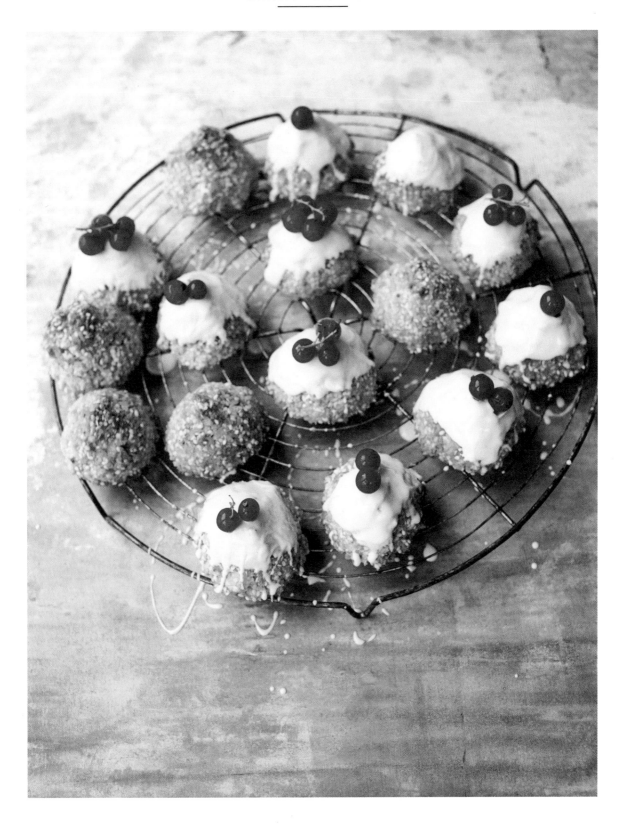

Lemon and dill parfait

Citron och dill parfait

This dessert is the perfect antidote to all the heavy and rich foods around at Christmas time. It combines two quintessentially Swedish flavours: dill with its slight aniseed note, and zesty lemon bringing freshness and acidity. While they usually appear mostly in savoury dishes, both make an equally delicious addition to a sweet one. If you have some lemon curd left, perhaps from making the wedding cake on page 134, I like to stir a few tablespoons through this parfait for extra zestiness.

Serves 6–8 / Vegetarian / Gluten free /
Preparation time: 30 minutes /
Freezing time: minimum 6 hours /
Equipment: 450g loaf tin /

2 medium eggs

zest of 1 lemon

1 tbsp finely chopped fresh dill,
 plus a few sprigs to serve

1 tbsp vodka

90g caster sugar

150ml whipping cream

300ml sour cream

3 tbsp lemon curd (optional)

Line the loaf tin with cling film. Separate the eggs, then put the egg yolks, lemon zest, dill, vodka and half the sugar in a heatproof bowl. Place over a simmering saucepan of water, making sure the bottom of the bowl doesn't touch the water, and whisk for about 5 minutes until thick and pale. Set the bowl aside.

In a separate bowl, whisk the whipping cream to soft peaks. In another bowl, whisk the egg whites to soft peaks, gradually adding the rest of the sugar. Add the sour cream to the slightly cooled egg-yolk mixture and fold together. Fold the whipping cream through, then incorporate the egg whites in two batches, folding it lightly together. Stir through the lemon curd if using, then pour into the lined loaf tin. Cover with cling film and freeze for a minimum of 6 hours.

Ten minutes before serving, remove from the freezer. Take the parfait out of the tin and peel away the cling film. Cut into thick slices.

Get ahead / The parfait will keep for a month in the freezer.

Peppermint and chocolate profiteroles

Polkagris och choklad profiteroles

Gränna, a small town in the south of Sweden, could have been the birth town of Willy Wonka had he been a Swede. Literally every other shop is a sweet shop, many of them making their own wares behind glass-fronted windows that look on to the street. You can watch confectioners pulling, stretching and twisting the unbearably hot sugar paste into candy canes. The most popular and traditional type is red and white and flavoured with peppermint, but you can find an assortment of other colours and flavours. A chocolate and mint flavour combo isn't just reserved for the famous after-dinner chocolates – there's also a Finnish hard mint sweet with a chocolate centre that is very popular in Sweden. If you're not keen on the mint addition to these profiteroles, you can replace the crunchy mint topping with chopped chocolate or toasted nuts.

Serves 6–8 / Vegetarian / Preparation time:
45 minutes / Cooking time: 60 minutes /
Equipment: 3 piping bags with a 1cm nozzle
and a water spray /

For the filling:

3 medium egg yolks

50g caster sugar

20g cornflour

250ml whole milk

25g cocoa powder

100ml whipping cream

For the choux pastry:

60ml milk

50g butter, cubed

½ tsp fine sea salt

½ tsp caster sugar

100g plain flour

2 medium eggs

For the *polkagris* meringue:

120g caster sugar

3 medium egg whites

50g *polkagris* or mint-striped candy cane,
crushed

Start by making the filling. Whisk the egg yolks with the sugar until light and thick, then whisk in the cornflour. Pour the milk into a saucepan and add the cocoa powder, whisking vigorously to combine. Bring the milk to the boil and switch off the heat. Pour the milk in a slow stream on to the egg mixture, whisking vigorously all the time. Return the mixture to a clean saucepan and continuously whisk over a medium heat. Make sure you scrape the sides and the bottom, otherwise it will burn. The filling will start to thicken, and once it releases a bubble or two, take it off the heat. Pour on to a baking tray lined with cling film. Cover with cling film (pat the cling film so it sticks directly on to the filling) and refrigerate for at least an hour before using.

Next, make the choux buns. Preheat the oven to 200°C/fan 180°C/gas 6. Pour 65ml of water into a pan and add the milk, butter, salt and sugar. Place the pan on a high heat and melt the butter. Turn the heat down to low and add all the flour. Beat hard with a wooden spoon. Continue beating until you have a smooth ball that pulls away from the sides of the pan without sticking and you can stand a wooden spoon upright in the dough. Take the pan off the heat and continue to beat until the dough is cold enough to touch. Mix in the eggs one at a time

– the batter will go lumpy when you add them, but beating continuously will smooth it out. Once all the eggs are incorporated and the mixture is smooth, put the dough into a piping bag fitted with a 1cm nozzle. Line two baking trays with baking paper, dotting a little dough in each corner to stick the paper down.

On the first tray, pipe 15 choux buns just bigger than a walnut. To do this, hold the nozzle at a 90-degree angle about 5mm from the tray. Keeping the nozzle upright, pipe a ball of dough, then quickly flick the nozzle sideways to stop the dough trailing. Repeat to make the other 14 choux buns, leaving a 3cm gap between each one. If they come out too pointy, dip your finger in some water and gently pat the points down, otherwise they will burn in the oven. On the second tray, pipe 15 choux buns just smaller than the walnut-sized choux buns. Spray the trays with a light mist of water before putting them in the oven (this will help with the rising). Bake for 20–30 minutes or until golden and crisp. The smaller ones will need roughly 20 minutes and the larger ones 25–30 minutes. Remove from the oven and use a chopstick or a skewer to pierce the undersides to release the steam. Leave to cool.

To make the meringue, spread the sugar on a baking tray lined with baking paper and put in the oven once the buns are out. Heat the sugar for about 10 minutes. In the meantime, whisk the egg whites until frothy with an electric or free-standing mixer. Pour the hot sugar in a steady slow stream on to the egg whites while the mixer is whisking on medium-high, scraping any sugar off the sides. Once incorporated, turn the speed up to high and beat for a further 5–10 minutes until cool and glossy.

Meanwhile, beat the chilled filling to remove any lumps and fold through the whipping cream. Place the mixture in a piping bag with a 1cm nozzle. Once the buns are cool, fill the buns with the mixture. Arrange the buns on a large plate in a wreath shape.

Put the meringue mix into a piping bag with a 1cm nozzle. Pipe the meringue on top of the profiteroles in small dollops, then sprinkle the crushed candy cane on top.

Get ahead / The buns can be made the day before and kept in an airtight container. The filling can also be made the day before. Assemble when ready to serve.

Gingerbread and blue cheese biscuits

Pepparkaka och blåmögelost kex

Glögg-fuelled get-togethers are always accompanied by plenty of delicious treats. One of my favourites is gingerbread biscuits served with blue cheese. Not your regular combination, but the spicy sweet biscuits stand up very well to a strong creamy blue cheese. These biscuits are more melt in the mouth than tooth-breakingly crunchy, thanks to a generous quantity of butter. For my *glögg* recipe, see page 280.

Makes about 30 double biscuits /

Vegetarian /

Preparation time: 15 minutes /

Resting time: 1 hour /

Baking time: 10–12 minutes /

Equipment: 4cm cookie cutter /

For the dough:

110g rye flour

110g plain flour, plus extra for dusting

1 tsp ground ginger

½ tsp ground cinnamon

¼ tsp ground cloves

seeds from 3 cardamom pods, crushed,
 or ¼ tsp ground cardamom

½ tsp bicarbonate of soda

¼ tsp fine sea salt

80g cold butter

50g dark (woodland) honey

3 tbsp strong coffee
 (made from 1 tsp coffee granules)

For the filling:

150g blue cheese

150g cream cheese

Mix the flours, spices, bicarbonate of soda and salt in a large bowl. Rub in the butter with your finger-tips, or pulse using a food processor, until it resemble fine breadcrumbs. Stir in the honey and add the coffee. Quickly draw together into a smooth ball, kneading as little as possible, then wrap in cling film and refrigerate for at least 1 hour.

Preheat your oven to 200°C/fan 180°C/gas 6. Line two baking trays with baking paper.

Divide the dough into 2 equal portions. On a flour-dusted surface, knead the first portion slightly into a ball and roll out to about 2mm thick. Cut out rounds with a 4cm cookie cutter and place on the baking tray. Roll out the leftover dough again and repeat. These will form the bottom parts of your biscuits.

Proceed in the same way with the second portion of dough, but this time cut out a 1cm circle (if you have a 1cm piping tip, this is the perfect tool) in the centre of each biscuit. These will form the top parts of your biscuits.

Bake the biscuits for 10–12 minutes, or until firm and crisp, then cool on a wire rack.

While the biscuits are cooling, combine equal amounts of blue cheese and cream cheese and beat. Carefully spoon about 1 heaped teaspoon on to the bottom part of the biscuits (or fill a piping bag and squeeze it on to the biscuit) and cover with the top part.

Get ahead / Filled biscuits should be eaten the same day, but biscuits without filling can be stored in a tin for up to 2 weeks.

Glögg poached pears with citrus Chantilly cream

Päron pocherade i Glögg med citrus chantilly grädde

I inevitably have leftover *glögg* in the winter months (when you host a *glögg* party, guests always bring an extra bottle along). Simmering pears in the ruby-red spiced liquid is the perfect way to use it up, resulting in a deliciously simple seasonal dessert. A dollop of zingy Chantilly cream or, if you're short on time, a scoop of vanilla ice cream, is all you need to accompany these pears. I've given instructions here on how to make *glögg* for the dish, but you can use 1 litre of ready-made *glögg* instead if you have some left over.

6 small firm pears

750ml fruity red wine

175g caster sugar

5 cloves

zest of 1 orange

1 cinnamon stick

For the cream:

250ml whipping cream

4 tbsp icing sugar, sifted

zest of 1 orange

Makes 6 /

Vegetarian / Gluten free /

Preparation time: 15 minutes / Cooking time: 20–25 minutes / Resting time: 6 hours /

Peel the pears, leaving the stem intact. Pour the red wine into a medium saucepan and add the sugar, cloves, zest of 1 orange and the cinnamon stick to the pan. Bring to a simmer over a low heat until the sugar has dissolved.

Lower the pears into the spiced red wine and bring to a very low simmer over a gentle heat. Poach for 20–25 minutes or until the point of a sharp knife glides through the flesh. If you find your pears are floating to the surface, scrunch up a piece of baking paper and submerge it in the liquid to weigh them down. Set aside to cool down in the syrup, then transfer to the fridge for at least 6 hours to deepen the pears' colour.

Bring the pears up to room temperature to serve, or serve chilled. When ready to serve, whip the cream to soft peaks, then add the icing sugar and whisk lightly to incorporate. Add the orange zest and stir through.

Serve the pears with a dollop of the cream, or a scoop of ice cream if you prefer.

Get ahead / The pears keep well submerged in the liquid for a day.

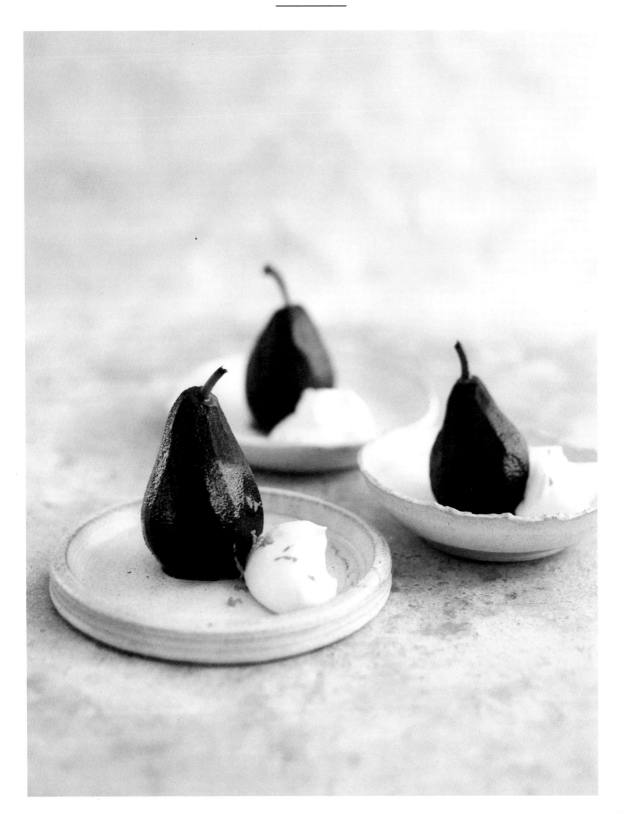

Praline and parsnip cake

Tårta med pralin och palsternacka

Serves 8–10 / Vegetarian /
Preparation time: 30 minutes / Resting time:
 30 minutes / Cooking time: 1 hour /
Equipment: 23cm springform cake tin, plus
 silicone-coated baking paper /

You are probably wondering what parsnips are doing in this cake. But this white, slightly sweet root, usually found in your Sunday roast, makes just as good a cake as its carroty rival. Like carrots, parsnips are sweet, which lets you use less refined sugar, but they also have a lovely nutty flavour, and putting vegetables in cakes helps to keep them moist. I made a version of this for my baby's christening.

For the cake:

150g wholewheat flour

50g ground hazelnuts

1 tbsp baking powder

½ tsp ground cinnamon

½ tsp fine sea salt

3 medium eggs

100g golden caster sugar

150ml sunflower oil

200g parsnips, peeled and grated

For the praline:

150g blanched hazelnuts

150g sugar

For the icing:

100g butter, softened

200g cream cheese

50g icing sugar

Preheat the oven to 200°C/fan 180°C/gas 6. Line the cake tin with baking paper.

Mix together the flour, ground hazelnuts, baking powder, cinnamon and salt. Beat the eggs and golden caster sugar until fluffy, then pour in the oil and add to the dry ingredients with the parsnips. Fold together, then pour into the prepared cake tin.

Bake for 30–35 minutes, or until a skewer comes out clean. Leave to cool for 5 minutes before removing from the tin on to a wire rack.

Next make the praline. Line a baking tray with silicone-coated baking paper. Toast the blanched hazelnuts in a dry pan until they are slightly golden. Leave to cool before roughly chopping.

Cover the base of a large pan with a thin layer of the sugar and place on a high heat. When the sugar starts melting at the edges, put some of the remaining sugar on top. Repeat until all the sugar is used up. Swirl the pan occasionally (don't stir). Once the sugar has reached a lovely toasty golden brown, take off the heat and quickly stir in the nuts. Pour on to your lined tray. Leave to cool before blitzing to a coarse powder in a food processor.

Make the icing by beating the butter until very soft, then beat in the cream cheese, sift in the icing sugar and beat again until smooth.

When the cake is fully cool, slice horizontally in two. Put the first layer on a serving plate, add a few dollops of the icing and smooth over the top. Add the second layer, and repeat with the rest of the icing. Scatter the sides with some of the praline, then sprinkle some on top.

Top tips / You can decorate this cake with some toy reindeer for a festive bake.

The cake is equally nice 'naked', without the praline and cream cheese filling.

This will make more praline than you need for this recipe, but it keeps well in an airtight jar and is great for jazzing up all sorts of desserts.

Get ahead / When well wrapped, the un-iced cake keeps for up to 4 days in the fridge, or it can be frozen for a couple of months.

Hazelnut and apple cakes

Nötkaka med äpple

The browned butter in this recipe is a nod to my French baking background: it's something I usually do when making madeleines, to introduce a nutty note. It's worth the extra pan to wash up, as it gives the cakes a lovely toasty flavour and brings out a new dimension in the hazelnuts. Apples and hazelnuts make a brilliant match, but pears also work a treat.

Makes 12 smaller cakes or 6 larger ones / Vegetarian / Preparation time: 30 minutes / Baking time: 12–20 minutes / Equipment: 1 muffin tin lined with 12 muffin cases, or a 6-hole mini bundt tin, well greased /

100g blanched hazelnuts

130g butter

20g honey

5 medium egg whites

100g icing sugar, sifted

a pinch of vanilla bean powder

100g plain flour

a pinch of baking powder

a pinch of fine sea salt

1 large apple, cored and cut into small cubes (about 0.5cm)

Preheat the oven to 200°C/fan 180°C/gas 6.

Put the hazelnuts into a dry pan and toast until golden. Leave to cool before blitzing into a fine powder in a food processor. Wipe out the pan and put in the butter, then heat it until it turns a dark golden-brown. Immediately take off the heat and leave to cool. Add the honey to the butter.

Whisk the egg whites until frothy, then gradually add the sugar, one spoonful at a time. Continue to whisk until thick and glossy and the sugar is fully incorporated.

Mix together the vanilla bean powder, flour, baking powder and salt. Add one third of the egg whites and beat to combine, then add the cooled butter. Lightly fold in the remaining egg white and half of the apple cubes. If using a bundt tin, scatter some of the apple cubes into the base of the moulds. Divide the batter between your muffin cases or the bundt moulds. If using muffin cases, put the remaining apple cubes on top of the batter.

Put into the oven and bake for 12–15 minutes if using a muffin tin, or 15–20 minutes if using a bundt tin, or until the cakes are lightly golden and a skewer comes out clean. Leave the cakes to cool for a few minutes in the tin, then turn out on to a wire rack.

Top tip / Hazelnuts can be replaced with almonds for a milder, nuttier flavour.

Get ahead / The muffins can be baked in advance and frozen. Leave to cool and place in a food bag before freezing.

Mulled wine

Glögg

Towards the end of the year when the darkness is almost at its peak, it's time to make the most of it, lighting the candles and getting a big vat of spicy mulled wine on the hob. If you're not invited to at least one *glögg* session while in Sweden in the run-up to Christmas, then you simply can't be in Sweden. More often than not there will be several to attend in one afternoon, hence the dainty little glasses used to serve the drink.

Glögg is similar to mulled wine or the *Glühwein* served in Germanic countries. The biggest difference, which took me some getting used to, is that people pop in a spoonful of *glögg* mix, a mixture of raisins and blanched almonds. By the time you've finished your drink, you've got some raisins and almonds plumped from the warm liquid. *Glögg* is particularly good with some *lussekatter* (see page 254).

Makes 1 litre / Vegetarian / Gluten free / Dairy free / Preparation time: 5 minutes / Resting time: ideally 1 week / Cooking time: 10 minutes /

1 cinnamon stick, broken

10 cloves

2–3 pieces of dried ginger or 1 tsp peeled, freshly grated ginger

5 crushed cardamom pods

zest of 1 orange

8 raisins

100ml vodka

750ml red wine

100g caster sugar

Optional serving suggestion:

10–20 blanched almonds

4 tbsp raisins

Place the cinnamon, cloves, ginger, cardamom, orange zest and raisins in a jar and top up with the vodka. Put the lid on the jar and leave to infuse for a week in a cool dark place. After a week, pour everything into a saucepan with the red wine and sugar. Heat until the sugar dissolves (don't let it boil). Leave to cool, then pour into a jug through a sieve to remove to remove the spices and pour into sterilized bottles.

When you want to serve the *glögg*, gently warm it up. Add several almonds and a couple of raisins to each glass if you like, and top up with the *glögg*.

Spelt pudding with cinnamon honeycomb

Dinkelgröt med kanel karamellbräck

In the UK, Father Christmas likes a little whisky and a mince pie. In Sweden it's a creamy rice pudding with a generous sprinkling of cinnamon. Traditionally, you make extra so that whatever *Tomten* (Father Christmas) doesn't gobble up on Christmas Eve can be eaten the following day for breakfast.

200g pearled spelt

2–2.5 litres whole milk

1 cinnamon stick

½ tsp fine sea salt

For the honeycomb:

100g caster sugar

50g golden syrup

1 tsp ground cinnamon, plus extra to serve

1 tsp bicarbonate of soda

Serves 4 / Vegetarian / Preparation time: 10 minutes / Soaking time: overnight / Cooking time: 55–65 minutes / Equipment: silicone-coated baking paper and a sugar thermometer /

Soak the spelt overnight in 2 litres of milk.

To make the honeycomb, line a baking tray with silicone-coated baking paper. Put the sugar and the golden syrup into a large heavy-based saucepan over a medium heat. Cook until the mixture reaches 150°C, by which point it will be golden and bubbly. Take off the heat and quickly whisk in the ground cinnamon and bicarbonate of soda (it will start to rise and foam up). Pour quickly into the baking tray and leave to cool slightly before placing in the fridge. Once cool and firm, bash up half the honeycomb quite roughly.

After the overnight soak, put the spelt and its milk into a large pan with the cinnamon stick and salt. Bring to a simmer and cook for 45–55 minutes or until the grains are tender and the mixture is thick and creamy. Remember to stir it every so often as the mixture can sink to the bottom and burn. Take off the heat, stirring in a little more milk if needed to loosen the mixture. Divide between your bowls and sprinkle over the honeycomb along with a little extra cinnamon, to serve.

Top tips / The quantity of honeycomb makes far more than is required, but you can store the rest in an airtight container for several days.
If you can't get hold of pearled spelt, pearl barley works well too.

Get ahead / The spelt pudding keeps happily in the fridge in an airtight container for a couple of days. Add a little more milk to loosen the pudding when reheating.

CONDIMENTS & SUNDRIES

Beetroot flatbreads

Tunnbröd gjort på rödbetor

In my last book, *Rachel Khoo's Kitchen Notebook*, I made a Swedish sandwich cake that required Swedish flatbreads. At the time I simply bought the bread (sometimes shortcuts are necessary). I ended up doing demos of that cake around the world, so my suitcase often contained soft, pillowy flatbreads. They aren't usually hot pink like these, but who says bread always has to be white or brown? These are great for filling (think packed lunches and picnics) or transformed into red *romtårta* (see page 100).

190g strong bread or pizza flour, plus extra for dusting / 60g rye flour / 3.5g (1 heaped tsp) instant dry yeast / 1 tsp fine sea salt / 1 tsp fennel seeds, plus extra for sprinkling (optional) / 110g beetroot juice / 40g sour cream / 1 tbsp runny honey / 2 tbsp melted butter, for greasing / 1 egg, beaten, for egg wash

Makes 6 / V /
Preparation time: 30 minutes /
Resting time: 2 hours /
Baking time: 15 minutes /

Combine the bread flour, rye flour, yeast, salt and fennel seeds in a large bowl. Put the beetroot juice, sour cream and honey in another bowl and mix until smooth. Add to the dry ingredients and use a wooden spoon and then your hands to bring together into a soft, slightly wet dough. Turn out on to a lightly floured surface and knead for 5 minutes, or until it is smooth, elastic and springs back when pushed with your finger.

Brush a medium bowl with the melted butter to grease it, then add the dough and turn to coat in the butter. Cover the bowl with cling film and place in a warm, draught-free place for 1–1½ hours or until doubled in size. Line a large baking tray with baking paper.

On a lightly floured surface, divide the dough into 6 equal pieces. Knead each slightly and roll into a ball. Use a lightly floured rolling pin (or a traditional Swedish flatbread roller) to roll out each ball into an 8mm-thick round. Sprinkle more fennel seeds on top if you like, rolling them into the dough. Place on the baking tray, cover with a clean, damp tea towel and set aside for 30 minutes. Preheat the oven to 190°C /fan 170°C/gas 5.

Prick each round all over with a fork, brush with egg wash and bake for 15 minutes until lightly coloured, but not browned. Remove from the oven and wrap in a clean tea towel to keep warm. Eat warm or at room temperature, or in my red *romtårta*.

Top tip / Keep the dough as sticky as it's possible to work with, for a moister bread. But if it's too wet, sprinkle in a little extra rye flour, a bit at a time.

Get ahead / These freeze well, if frozen on the day of baking. Bundle them up with baking paper between each one and wrap in cling film or a sandwich bag.

Pink pickled onions

Rosa inlagd lök

It's hard to escape these bright pink onions, since a jar of them is a must in every Scandi fridge. They appear in so many savoury dishes, and for good reason, instantly adding an uplifting zing to balance out the heavier flavours in Swedish culinary fare.

Makes a 1.5-litre jar / V / GF / DF / Preparation time: 10 minutes / Resting time: miminum 2 days / Equipment: 1.5-litre sterilized jar (see tips) /

100g caster sugar / 30g sea salt / 300ml cider vinegar / 20 juniper berries / 750g red onions, peeled

Put 400ml of water into a saucepan with the sugar, salt and vinegar. Bring to the boil, whisking so the sugar and salt dissolve. Add the juniper berries, then leave to cool. Cut the red onions into even 2mm slices, place them in your sterilized jar and pour the pickling liquid on top. Seal and place in the fridge. Leave for at least a couple of days before using.

Top tips / For a cucumber version, swap the red onions for thinly sliced cucumbers and replace the juniper berries with a few sprigs of fresh dill.

To sterilize your jars, put into the dishwasher on the hottest cycle, or submerge in boiling water for 10 minutes, then leave to dry completely.

Get ahead / These onions are quite happy for a month or so in the fridge.

Apple chutney

Äppelchutney

The apple trees in my garden have an ethos of 'every other year', and in the year when they do produce apples, they are laden with so many that I barely know what to do with them all. I once ended up making 20kg of chutney, in a cauldron-sized pot. Despite my friends benefiting from the bumper crop, I still have some jars in the basement, where it's maturing like a fine wine.

Makes 2 x 400ml jars / V / GF / DF / Preparation time: 30 minutes / Cooking time: 45–60 minutes / Equipment: 2 x 500ml sterilized jars (see tip above) /

1 tsp rapeseed oil / 120g finely chopped red onions (about 2 medium onions) / 150g brown sugar / 4 medium apples (about 550g in total) / 210ml cider vinegar / 60g raisins / 1 tsp sea salt / 1 tbsp ground ginger / 1 tbsp ground cinnamon / 1 star anise

Put the oil into a large pan over a medium heat, add the onions and cook for 15 minutes, stirring occasionally. Add the sugar and cook for a further 10–15 minutes, or until the onions are caramelized, stirring regularly.

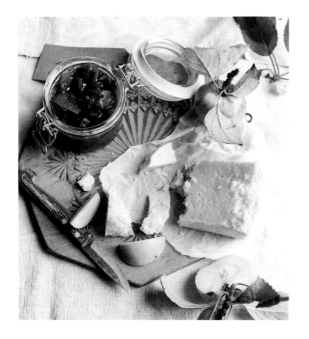

Peel, core and finely chop the apples, then add to the pan with the rest of the ingredients. Boil for 25–30 minutes or until you have a thick paste, stirring occasionally so nothing sticks to the pan. Seal tightly in sterilized jars.

Get ahead / If the jars are correctly sterilized and sealed, your chutney will keep in a cool, dry place for years. Once opened, it'll last in the fridge for several weeks.

Eldercapers

Fläderkapris

I've cooked with elderberries and elderflowers for as long as I can remember, transforming them into cordials, jams and fritters. However, I only discovered eldercapers here in Sweden, where they often crop up on restaurant menus. Green unripe elderberries can be turned into crunchy and very fragrant capers with the help of a little bath in salt, vinegar and sugar. De-stemming and resting eldercapers breaks down their poison, so be sure to follow the resting time

advised below. Use them in salads, sauces, steak tartare ... anywhere you would ordinarily add capers.

Makes a 400ml jar / V / GF / DF / Preparation time: 30 minutes / Resting time: 6–7 days / Equipment: 400ml sterilized jar (see top left for sterilization instructions) /

200g green unripe elderberries, de-stemmed / 80g sea salt flakes / 150ml cider vinegar / 25g caster sugar

Mix the de-stemmed elderberries with the salt and leave to sit, covered, in a cool, dry place. After 2–3 days, or when the elderberries turn from bright green to a khaki green, rinse and drain, then place in your sterilized jar. Bring the vinegar to the boil and add the sugar and 40ml of water. Stir until the sugar has dissolved, remove from the heat and pour into the jar. Seal and leave in a cool, dark place for at least 4 days before using.

Get ahead / The elderberries will keep for at least 1 year unopened if the jar is correctly sterilized. Once opened, store the jar in the fridge, where it will keep for 6 months (as long as you don't dip dirty spoons into it).

Pickled cucumbers

Inlagd västeråsgurka

Summer doesn't just bring longer days, berries and the opportunity for jumping into lakes, but also the illustrious *västeråsgurka*. Knobbly, tough-skinned, and looking slightly stunted in growth, these small cucumbers are full of flavour (similar to ridge cucumbers) and perfect for pickling or brining. Västerås, a city in central Sweden, has grown them for centuries and has long had a reputation for their particularly delicious cucumbers. If you're unable to get hold of them or gherkins, try to find a cucumber with a tougher skin like a ridge cucumber; thinner-skinned ones don't fare so well in the long pickling process.

Makes a 2-litre jar / V / GF / DF / Preparation time: 10 minutes / Cooking time: 10 minutes / Resting time: minimum 24 hours / Equipment: 2-litre sterilized jar

275ml cider vinegar / 80g sea salt / 1½ tbsp caster sugar / 1½ tbsp yellow mustard seeds / 45g horseradish, peeled and cut into 0.5cm cubes / 1kg small cucumbers, gherkins or ridge cucumbers / a handful of fresh crown dill or dill with stalks

Pour 750ml of water into a saucepan and add the vinegar, salt, sugar, mustard seeds and horseradish. Bring to the boil, whisking so the salt and sugar dissolves, then take off the heat and leave to cool. Cut small cucumbers in half lengthways and ridge cucumbers into quarters – you can leave gherkins whole, if small – and place in your sterilized jar with the dill. Pour over the cooled pickling liquid and shake the jar so everything mingles. Refrigerate for at least 1 day before using.

Get ahead / These will keep in the fridge for at least 1 week once opened, and for at least 1 month unopened.

Pickled mushrooms

Inlagd svamp

This is a great way to seize the mushroom moment that hits at the end of summer/beginning of autumn, letting you preserve some for later on in the year.

Makes a 400ml jar / V / GF / DF / Preparation time: 40 minutes / Cooking time: 5 minutes / Resting time: minimum 2 days / Equipment: 400ml sterilized jar (see page 286 for sterilization method) /

250g whole mushrooms (chestnut or chanterelles work well) / 10 black peppercorns / 10 juniper berries / 2 tsp sea salt flakes / 150ml cider vinegar / 2 tbsp caster sugar / 1 tsp dried thyme or a few fresh sprigs / approx. 200ml light olive oil or mild rapeseed oil

Wipe the mushrooms clean with a damp cloth or rinse quickly under water to clean off any dirt. Leave to dry.

To make the brine, crush the peppercorns, juniper berries and salt. Put into a large heatproof measuring jug with the vinegar, sugar and thyme. Top up with boiling water to 500ml and leave to infuse for at least 30 minutes while the mushrooms are drying.

Place the mushrooms and brine in a saucepan and simmer gently for 5 minutes, carefully stirring every minute or so. Remove the mushrooms from the pan with a slotted spoon and set aside on a clean tea towel for at least 30 minutes until completely dry. It's fine if some of the thyme and spices sticks to the mushrooms.

Pour some olive or rapeseed oil into your sterilized jar, add some mushrooms, then cover with more olive oil. Stir gently until all of the mushrooms are coated in the oil. Proceed until the jar is filled – the mushrooms should be completely covered in the oil. Cover with the lid. and leave to marinate for at least 2 days before eating.

Get ahead / The brine can be made days or even weeks in advance. Store in a cool, dark place in a sterilized jar.

Once opened, the jar of pickled mushrooms will keep in the fridge for at least a week.

Pickled mustard seeds

Inlagda senapsfrön

These are delicious with meat, in salad dressings or smeared on to a bubbling melted cheese sandwich. The longer they sit in the pickle, the more liquid they absorb, making these little beads pop in your mouth.

Makes about 60g / V / GF / DF / Cooking time: 50 minutes / Equipment: 250ml sterilized jar (see page 286 for tip) /

100ml cider vinegar / 2 tbsp caster sugar / a pinch of fine sea salt / 30g yellow mustard seeds

Put the vinegar and 250ml of water into a small pan with the sugar and salt. Cook gently for 5 minutes, then add the mustard seeds and simmer for a further 40 minutes to plump up the seeds and remove any bitterness. Add a little extra water if it dries out. Decant into a sterilized jar and set aside to cool.

Get ahead / These keep in the fridge for about 3 months.

Lingonberry jam

Lingonsylt

Lingonberry jam is for Swedes what ketchup is for Americans. It's the Swedish condiment that appears on or with countless dishes (and you will have seen it crop up countless times in this book). A lingonberry is not to be mistaken for its North American cousin, the cranberry. Cranberries are a lot larger (the size of large peas) and even though I'm a little biased, I think lingonberries tend to have a more complex flavour. Tart, sour and sometimes slightly bitter with a hint of sweetness, this small berry packs a punch, and when making jam a liberal handful of sugar is needed to round off the edges. I tend to use frozen lingonberries in this recipe for ease. (I like to throw fresh lingonberries into salads, mueslis, and so on.) If you're unable to get hold of lingonberries, then cranberries will make a good substitute.

Because lingonberries naturally contain large amounts of benzoic acid (a compound often used as a preservative), lingonberry jam can also be made by simply mixing lingonberries and sugar without cooking them. This variation, known as *rårörda lingon*, can be made using the same quantities as below. Stir the sugar through the berries and decant into a sterilized jar. Stir or shake, then leave to sit for 1–2 days until the juices escape and the berries break down.

Makes a 400g jar / V / GF / DF /
Preparation time: 2 minutes /
Cooking time: 25 minutes /
Equipment: 400ml sterilized jar (see page 286) /

500g lingonberries (frozen) / 350g sugar / a pinch of fine sea salt

Put all the ingredients into a saucepan on a medium heat and cover. Stir after 5 minutes and continue to simmer for 20 minutes uncovered. It will become thick and the berries will break down a little. A true *lingonsylt* will always be left chunky rather than made into a smooth puree. Leave to cool slightly before pouring into your sterilized jar (it will thicken once cool).

Get ahead / Store in the fridge, where it will keep for several months.

Lingonberry sauerkraut

Surkål med lingon

Sauerkraut has become increasingly popular over the last few years, with many exalting its health benefits thanks to all the good bacteria it contains. Long before it was fashionable I'd happily tuck into it even for breakfast, since its lively, fresh, sour taste is a surprisingly good wake-me-up. I used to buy it ready-prepared, until I discovered how simple it is to make yourself. I prefer to make smaller batches, as I don't like to ferment it for too long. Having a jar of this in the fridge makes putting a meal together super-easy – a generous helping of sauerkraut, a couple of slices of ham and a dollop of mustard, and that's lunch sorted in minutes.

Makes 1kg / V / GF / DF / Preparation time: 10 minutes) / Resting time: minimum 4 days / Equipment: 1-litre
 wide-mouthed sterilized jar, plus a smaller sterilized
 jar as a heavy weight (see page 286 for sterilization tip) /

1 cabbage (about 1kg) / 100g lingonberries / 6 juniper berries, crushed / 20g fine sea salt

Remove and discard the tatty outer leaves from the cabbage, then thinly slice the rest using a mandoline or a sharp knife, discarding the core. Put the sliced cabbage into a large bowl with the rest of the ingredients and mix together well to combine. Continue to mix until the cabbage becomes wet and completely covered by its own juices and that of the lingonberries.

Pack tightly into your sterilized jar. Press the cabbage down as much as you can, then weigh it down with something heavy, like a smaller sterilized jar with weights in it. It's important the cabbage is submerged in its own juices. Cover with a clean tea towel and keep at room temperature (around 20°C). After 30 minutes you may need to press the cabbage down again.

The mixture should start to bubble after 3–4 days. Remove any white scum, and change the tea towel if necessary. After 4 days, taste the cabbage every day, and when it has reached the sourness you like, seal the jar and refrigerate to slow the fermentation process.

Top tip / The warmer the room, the quicker the sauerkraut will ferment. If you have time, try doing a batch with a slower, cooler ferment – the flavours will be more complex. If you're like me and too impatient, then it's still tasty after 4 days in a warm room.

Lingonberry jam and seed crackers

Lingonsylt och fröknäcke

I discovered 'bake at home' seed-only cracker mixes at the Swedish supermarket and was instantly hooked. They are not hard to recreate at home. The secret lies in getting the right ratio of chia and other seeds to make it stick together. My mum added a sweet and tart twist with the lingonberry jam, which makes these crackers seriously moreish. Perfect as an on-the-go snack or with a slice of cheese.

Makes about 30 / V / GF / DF / Preparation time: 15 minutes / Resting time: 10 minutes / Cooking time: 30 minutes /

250g lingonberry jam (see page 290) or other tart jam / 100g sunflower seeds / 50g pumpkin seeds / 50g white sesame seeds / 25g linseeds / 25g chia seeds / 1 tbsp sunflower oil

Preheat the oven to 170°C/fan 150°C/gas 3. Heat up the jam in a small pan until all the lumps have dissolved and it's runny. Mix the seeds and oil into the hot jam and mix well. Leave to absorb for 10 minutes.

In the meantime, line a large baking tray with grease-proof paper. Spread the seed mixture on to the baking tray as thinly as possible using a palette knife. Take your time over this so that the mixture is evenly spread. If the thickness varies, it will cook at different rates.

Bake for 20–25 minutes until evenly browned. Leave to cool for 10 minutes until slightly hardened but still pliable. If it has browned but is still quite sticky, reduce the oven to 120°C/fan 100°C/gas ½ and leave the tray in there until the mix is no longer sticky to the touch. Use kitchen scissors or a pizza cutter to cut into strips or squares. Alternatively, leave to cool completely and break up roughly into bite-sized shards.

Top tip / You can use 225g pre-packed seed mix and add 25g chia seeds to help the mixture stick together.

Get ahead / These will keep in an airtight container for several weeks.

Roasted carrot ketchup

Ketchup på rostade morötter

Root vegetables are in abundance in Sweden almost all year round, whereas good local tomatoes make a very short appearance in the summer. Carrots are a great alternative for a ketchup-style condiment, with their natural sweetness and bright colour.

Makes roughly 500g / V / GF / DF / Preparation time:
 30 minutes / Cooking time: 30 minutes /

1 apple / 500g carrots, peeled and cut in half lengthways /
1 red onion, peeled and quartered / 2 cloves of garlic,
unpeeled / 1 tbsp vegetable oil / a generous pinch of salt /
½ tsp whole coriander seeds / 1 tsp celery salt / a pinch of
ground cinnamon / 50ml cider vinegar

Preheat the oven to 220°C/fan 200°C/gas 7. Peel, core and quarter the apple, then put into a bowl with the carrots, red onion and garlic and toss with the vegetable oil and salt. Roast for around 30 minutes or until tender.

In the meantime, toast the coriander seeds in a dry pan until the aromas are released. Grind with the celery salt and cinnamon using a pestle and mortar, then stir in the vinegar.

Squeeze the garlic out of its papery skins and whiz in a blender with the carrots, onion, spiced vinegar mix and 250ml of water. Pour into an airtight container or glass bottle.

Top tips / The ketchup will be slightly chunky unless you have a very powerful blender. You can pass it through a sieve if you prefer it smoother.

I like my ketchup quite tart. If you prefer something a little milder, start with half the amount of vinegar and add gradually, tasting as you go.

Get ahead / The carrot ketchup will keep in the fridge for a week in an airtight container. Alternatively you can freeze it for several months.

Index

Dietary Guide

Gluten Free

Lemony caraway cabbage salad with grilled prawns 22 / Burnt leek whipped butter 24 / Root vegetable crisps with caviar and red onion / Spring cabbage vinaigrette 30 / Old man's salad (without toast) 33 / Beet à la Lindström 40 / DIY kåldomar 50 / Swedish stir-fry 52 / Crayfish soup 78 / Kohlrabi with sunflower seed and dandelion leaf pesto 84 / Chilled cucumber soup with beetroot yoghurt granita 88 / Grilled char with fennel, dill and redcurrants 90 / Hot smoked salmon salad with gravlax dressing 92 / Carrot salad 94 / Pickled mackerel 3 ways 96 / Smashed potatoes with green sauce 102 / Red cabbage and apple coleslaw 104 / Midsummer salad 110 / Peas, potatoes and chicken in a pot 116 / Poached chicken with quick pickled strawberry salad 120 / The chocolate cake the dog ate 126 / Midsummer meringue crowns 130 / Blueberry soup with caramelized nut clusters 138 / Yellow pea soup 165 / Potato and pea dumplings 170 / Pan-fried duck breasts with elderberry sauce and buttered spinach 172 / Venison 'saltimbocca' 176 / Prune and walnut soufflé 192 / Fresh curds with salted caramel sauce 194 / Dark chocolate buttercream biscuits with sea salt 202 / Rachel's caviar (without knäckerbröd) 214 / Salt-baked beetroot – two ways 220 / Stewed spinach eggs (without toast) 232 / Gravlax poke bowl 234 / Quick turkey and lingonberry stew 240 / Rice pudding soufflé 260 / White chocolate and berry coconut mountains 264 / Lemon and dill parfait 267 / Glögg poached pears with citrus Chantilly cream 274 / Glögg 280 / Pink pickled onions 286 / Apple chutney 286 / Eldercapers 287 / Pickled cucumbers 288 / Pickled mushrooms 288 / Pickled mustard seeds 289 / Lingonberry jam 290 / Lingonberry sauerkraut 291 / Lingonberry jam and seed crackers 292 / Roasted carrot ketchup 293

Dairy Free

Lemony caraway cabbage salad with grilled prawns 22 / Crayfish 109 / Peas, potatoes and chicken in a pot 116 / Oat cookies 124 / The chocolate cake the dog ate 126 / Rachel's caviar 214 / Gravlax poke bowl 234 / Glögg 280 / Pink pickled onions 286 / Apple chutney 286 / Eldercapers 287 / Pickled cucumbers 288 / Pickled mushrooms 288 / Pickled mustard seeds 289 / Lingonberry jam 290 / Lingonberry sauerkraut 291 / Lingonberry jam and seed crackers 292 / Roasted carrot ketchup 293

Vegetarian

Burnt leek whipped butter 24 / Swedish crispbreads 28 / Spring cabbage vinaigrette 30 / Horseradish and cheese dumplings 37 / Beet à la Lindström 40 / Cream bun cake 57 / Roast rhubarb and custard magic cake 60 / Chocolate balls 64 / Swedish marmalade biscotti 66 / Almond and lingonberry buns 68 / Cardamom bun bombe 72 / Kohlrabi with sunflower seed and dandelion leaf pesto 84 / Chilled cucumber soup with beetroot yoghurt granita 88 / Carrot salad 94 / Smashed potatoes with green sauce 102 / Red cabbage and apple coleslaw 104 / Midsummer salad 110 / Västerbotten pie 118 / Oat cookies 124 / The chocolate cake the dog ate 126 / Midsummer meringue crowns 130 / DIY wedding cake 134 / Blueberry soup with caramelized nut clusters 138 / Mini princess cake 140 / Blueberry breakfast pie 144 / Plum Tosca cake 146 / Roasted butternut squash waffles 154 / Brown beans on toast 162 / Toasted pearl barley mushroom risotto 166 / Autumnal Buddha bowl (without spelt) 168 / Swedish bean balls with butterbean mash 182 / Crunchy cardamom hearts 189 / Prune and walnut soufflé 192 / Apple and cheese spelt buns 198 / Dark chocolate buttercream biscuits with sea salt 202 / Raspberry and rye cookies 204 / Crispy kale and lingonberry salad 212 / Salt-baked beetroot – two ways 220 / Rye spelt flatbread 222 / Stewed spinach eggs 232 / Celeriac hasselback 'ham' 236 / Yellow pea falafel with red cabbage and dill 248 / St Lucia saffron buns 254 / Pear and gingerbread pie 262 / White chocolate and berry coconut mountains 264 / Lemon and dill parfait 267 / Peppermint and chocolate profiteroles 268 / Ginger bread and blue cheese biscuits 272 / Glögg poached pears with citrus Chantilly cream 274 / Praline and parsnip cake 276 / Hazelnut and apple cakes 278 / Glögg 280 / Spelt pudding with cinnamon honeycomb 282 / Beetroot flatbreads 285 / Pink pickled onions 286 / Apple chutney 286 / Eldercapers 287 / Pickled cucumbers 288 / Pickled mushrooms 288 / Pickled mustard seeds 289 / Lingonberry jam 290 / Lingonberry sauerkraut 291 / Lingonberry jam and seed crackers 292 / Roasted carrot ketchup 293 /

Tack så mycket

To the most supportive and loving husband. I don't know how you put up with my recipe disasters, the highs and lows of writing and altogether madness of putting a book together. Tack! And thank you for letting me and the team descend on the house for a week and cause photoshoot chaos.

To my ever-so-hard-working recipe testers, my mum and Frankie Unsworth. Frankie, you always have a way of making my dishes look so effortlessly delicious.

To David Loftus for capturing my life in Sweden like no other person could. You have a magic way with your camera.

To Lizzy Kremer and Harriet Moore for always being encouraging and cheering me on.

To the fantastic team at Penguin Random House, from my supportive editor Ione Walder, the talented art director John Hamilton and designer Sarah Fraser, to Sales, Production, PR, Marketing, and so many more. Without you the book would simply be some files on my computer. Thank you, Caroline Pretty, for doing such a thorough job on checking the copy.

To Linda Berlin, you really got my love of combining old/new Swenglish plates, cutlery and other knick-knacks. To Barbro Lidström for lending us all your beautiful props and Karin Hossack for the beautiful ceramics.

To the lovely hard-working food assistants Hedvig Billengren Lindenbaum and Katja Palmdahl.

To Niklas Ekstedt for the delicious meal at your wine bar, Tygge & Sessil, Robin Delselius for the utterly moreish cinnamon buns at your lovely bakery, Rosendahl for the summery backdrop for some of the photos and Devol Kitchens for the beautiful kitchen at the Khoollect studio and Rickard at Grand Trip Sweden for helping us find the perfect snowy Stockholm archipelago backdrop. And to Pele, Isabelle and Amanda for being model guests at my picnic.

About Rachel Khoo

After graduating from Central Saint Martin's College of Art and Design in London, a passion for pâtisserie lured Rachel Khoo to Paris, where she obtained a pastry diploma from Le Cordon Bleu cookery school. Before long, she was travelling the world, working on culinary projects for clients large and small and hosting cooking workshops in locations as far-flung as London, Paris, Milan, Sydney and Buenos Aires, while also developing her career as a food writer. This led to number-one bestseller *The Little Paris Kitchen*, which was published by Penguin in 2012 and translated into thirteen languages. The accompanying BBC2 TV cookery series turned Rachel into a household name, not just in the UK but also in the many other countries in which it aired, including Australia, Brazil, Hong Kong and the USA. Rachel has presented several subsequent cookery series for BBC Worldwide, and regularly writes recipes for the London *Evening Standard*, *The Times* and the *Guardian*, among other publications, as well as consulting for hotels, restaurants and blue-chip clients. Her popular website, Khoollect, is an online community of food and lifestyle inspiration, with a newly opened creative studio and workshop space based in London. In 2016 Rachel moved to Sweden, where she now lives with her Swedish husband and their baby. This is her sixth cookery book.

www.rachelkhoo.com /

rachelkhooks / rkhooks / rkhooks / rachelkhoo / rachelkhooks /

MICHAEL JOSEPH

UK | USA | Canada | Ireland | Australia

India | New Zealand | South Africa

Michael Joseph is part of the Penguin Random House group of companies whose addresses can be found at global.penguinrandomhouse.com.

First published in Great Britain by Michael Joseph, 2018

Set in Eksell Display copyright © Letters from Sweden, 2018 and DIN
Colour reproduction by Born Group

Printed in Italy by L.E.G.O. S.p.A

A CIP catalogue record for this book is available from the British Library

ISBN: 978-0-718-18891-7

www.greenpenguin.co.uk

Penguin Random House is committed to a sustainable future for our business, our readers and our planet. This book is made from Forest Stewardship Council® certified paper.